DANISH PAINTING
THE GOLDEN AGE

DANISH PAINTING
THE GOLDEN AGE

A LOAN EXHIBITION FROM THE
STATENS MUSEUM FOR KUNST, COPENHAGEN

INTRODUCTIONS BY
HENRIK BRAMSEN
ALISTAIR SMITH

CATALOGUE BY
KASPER MONRAD

THE NATIONAL GALLERY, LONDON
SUPPORTED BY CARLSBERG
5 SEPTEMBER–20 NOVEMBER 1984

FRONT COVER: (Detail from cat. no. 63) Christen Købke *A View of One of the Lakes in Copenhagen* (1838)

BACK COVER: (Detail from cat. no. 75) P. C. Skovgaard *Bleaching Linen in a Clearing* 1858

Grateful acknowledgement is made to the Statens Museum for Kunst for permission to reproduce the majority of the photographs in this catalogue; also to the following Danish institutions: Den Hirschsprungske Samling (cat. nos. 49, 52); Ny Carlsberg Glyptotek (cat. no. 55); Den kgl. Kobberstiksamling (figs. IV, VIII, IX); Det kgl. danske Kunstakademi (figs. III, V, VII); Nationalmuseet (figs. I, II); and Statens Kunsthistoriske Fotografisamling, which acted as photographic agent for Valdemarsslot (fig. VI). We are thankful to the photographers Hans Petersen, Jørgen Watz, Lennart Larsen and Wermund Bendtsen.
Outside Denmark, we owe thanks to Vienna, Kunsthistorisches Museum (fig. XII); Paris, Musée du Louvre, (fig. XIII); London, The Drapers' Company (cat. no. 83); Cambridge, Mass., Fogg Art Museum (fig. XIV)

Copyright © The National Gallery and Authors 1984
Published by order of the Trustees
ISBN 0 901791 93 8
Publications Department
The National Gallery, London
Exhibition designed by Robin Cole-Hamilton
Catalogue Edited by Alistair Smith and Diana Davies
Translated by Jan Bredsdorff
Designed by Tim Harvey
Printed by Balding + Mansell Limited, Wisbech

FOREWORD

It is a great pleasure, as well as an honour, for the National Gallery to be allowed through this exhibition to reveal to the public of our country the achievements of Danish painting in the late eighteenth and early nineteenth centuries: a "golden age", where for once use of the adjective is no cliché.

The revelation of the quiet but effective and individual art of that period normally comes only to the visitor to Copenhagen, walking through the rooms of the Statens Museum for Kunst, or visiting the Ny Carlsberg Glyptotek or the Hirschsprung Collection. Thanks to the generosity of all three institutions, it is possible for the revelation to take place in London for a few weeks; but our major debt of gratitude must be to the Statens Museum for its friendly response to our wish to borrow and its massive support in terms of loans. To the Director, Dr. Lars Rostrup Bøyesen, and to the Keeper of Painting, Dr. Bente Skovgaard, the Gallery is deeply indebted. Their enthusiasm and kindness – quite apart from their scholarly knowledge – have made this a happy international collaboration in every way. To walk round their museum with them, looking at these and other paintings of the same period, being encouraged to choose for this exhibition, was a memorable experience for my colleague, Alistair Smith, Keeper of Exhibitions and Education, and myself. I must also thank the Director of the Ny Carlsberg Glyptotek and the Director of the Hirschsprung Collection for the loans they have kindly made.

For the text of the catalogue, with its absorbing introduction to a school of painting too long under-appreciated outside Scandinavia, we are greatly indebted to Henrik Bramsen and Kasper Monrad. For the considerable labour involved in the provision of photographs for this catalogue, we are grateful to Berthe Bülow-Jacobsen.

The National Gallery is extremely grateful to Carlsberg for so generously supporting this exhibition, in particular the catalogue, and we should record our appreciation of the interest of the Managing Director, Mr. Michael Iuul, and the Marketing Director, Mr. Simon Arnold. We have also had a most welcome contribution, gratefully acknowledged, from PRIVATbanken, London, towards publicity and transport costs. Sophus Berendsen A/S, Copenhagen, has supported the Danish work on the catalogue, for which we are thankful.

Within the Gallery, where so many staff members have inevitably been involved with such a major project, I must single out a few people, while expressing thanks to all. The Head of the Design Studio, Robin Cole-Hamilton, has shown all his usual flair and patience, combined with enthusiasm for the works to be displayed. In the Press Office, Sarah Brown has been unflagging in commitment, with equal enthusiasm. A considerable debt is owed to Christopher Brown, Deputy Keeper, and in charge of Public Relations, for his energetic and successful approaches to sponsors and the thought he has given to publicity for the exhibition. To Alistair Smith I feel

particularly indebted, since it was he who first conceived the idea of mounting this exhibition, to which he has given so much time and thought throughout its gestation. He did not need to open my eyes to the freshness and originality of Golden Age Danish painting, but he helped me to a keener appreciation of its variety and its strength.

We hope visitors to the exhibition will see and enjoy all these qualities, and thus share our gratitude to those who made it possible.

Michael Levey DIRECTOR, THE NATIONAL GALLERY

FOREWORD

This exhibition is the first large-scale attempt to present a chronologically limited but highly important chapter of the art history of our small country to a discriminating public in a big country whose activities have travelled along a cultural highway for generations. It naturally gives rise to some self-examination among those persons on the Danish side who are responsible for the making of the exhibition.

One of the questions that arises is this: will the British viewer sense that these intimate paintings of modest size are not by-products, or uncritical parrotings, of artistic achievements in larger countries? Will he recognise that they are personally experienced, observed and interpreted in a particularly Danish way, and given a form that in Denmark has deep roots? The logical response must be a question that is considerably easier to pose than to answer: what is this particularly Danish style?

A kind of answer is possible by referring to the art made in the first half of the last century in those countries that Denmark is best compared with, for geographical and spiritual reasons – neighbouring countries such as Sweden, Norway and Germany. A quick glance at the art of these nations will soon convince one that, apart from certain similarities determined by the period, Danish art indisputably bears a distinctive character. Is this due to a sober-mindedness that, with its lack of a sense of dramatic effect, approaches the unimaginative? Is it the strange mixture of modesty and ingenuousness which attracts the present-day spectator who is tired to death of the sophisticated and over-complicated? Is it the sharp precision of form, the light-filled blondness and freshness of colouring, that so fascinatingly suggests that we are on virgin soil at the beginning of a development that could lead us to fairer lands?

The truth about the special character of the Danish Golden Age is presumably to be found in some of the above mentioned qualities, and in a number of others that are better left to the individual spectator to define. In fact, why not let art preserve its wordless secrets? If the innermost nature of pictorial art could be expressed in words, it would not be pictorial art. If the great Norwegian historian of civilisation, Harry Fett, is right in describing "art as a people's tax return", then with this exhibition Denmark has completed her tax return.

In the field of art, the major responsibility for this great and rich development largely rests on the shoulders of one man – C. W. Eckersberg who, through his art, paved the way for the triumphal progress of naturalist perception, and through his thirty-five years of teaching at the Royal Academy of Art in Copenhagen decisively influenced several – and it is no exaggeration to say highly talented – generations of students. It is interesting to note, however, that Eckersberg did not receive his initial impetus on Danish soil. The paintings he did before leaving for Paris in July 1810 at the age of twenty-seven were not much better than run-of-the-mill. But his education in a kind of neo-classical naturalism in David's studio gave him the ability to fully profit from the inspiration of art and nature, colour and light in Rome, where he

stayed for three years (July 1813–May 1816). The impressions accumulated during these six years were the basis of his pioneering the style that we consider to be fundamentally Danish. During the remaining thirty-five years of his life he never again left Denmark, apart from a few sea voyages undertaken for the study of maritime subjects. As a matter of curiosity it may be mentioned that during such a voyage, in May 1839, he stayed in London – for half-a-day. For the new and supremely formative processes that marked his maturity, he depended totally on his own inner resources, although one should not disregard a certain interplay between the master and the best of his many students.

During the first half of the nineteenth century, the country outside Copenhagen hardly existed on the cultural map – all intellectual life took place within the protective embankments of the capital. There was a small population – from the 102,000 inhabitants in 1801, the number gradually grew to 129,000 in 1845 – and in a sense it is surprising that such a limited population could develop such a rare concentration of great personalities, such as the writers Hans Christian Andersen and Adam Oehlenschläger, the philosopher Søren Kierkegaard, the physicist H. C. Ørsted, and Bertel Thorvaldsen the sculptor, the painters Eckersberg and Christen Købke, the composer Weyse, and the theologian and educator of the people N. F. S. Grundtvig, to name but a few of the more outstanding in different fields.

The theory that a ''Golden Age'' necessarily arises as the end product of a long tradition and broadly favourable socio-economic conditions must be thoroughly disproved. In the field of pictorial art the tradition was particularly short. A truly organised Danish art life began only with the secure establishment of the Royal Academy at Charlottenborg in 1754, and throughout its first decades both teaching and artistic production were done by ''imported'' – and often splendid – foreigners. Only with Abildgaard and Jens Juel did native Danes begin to assert themselves. And as far as the socio-economic background is concerned, it was somewhat meagre.

Throughout the eighteenth century, Denmark had enjoyed palmy days in over-seas trade resulting in an economic boom, but towards the end of the century misfortune began to ravage the country, a country that was hard put to find a footing in the complex political schemings of the time of Napoleon. In 1794 Copenhagen suffered severely when Christiansborg Palace burned down in a fire that also destroyed a number of Abildgaard's major decorative works. In the following year a major fire destroyed a great number of citizens' houses. During the Battle of Copenhagen in 1801, the Danish navy was forced to its knees by the British, commanded by Nelson and Parker, and in September 1807, after a lengthy siege, the city was once more set alight by the bombardment of English troops, with three hundred buildings being destroyed and 1600 seriously damaged. In fact, no less a person than Eckersberg depicted these terrible events in several of his early works.

The sad result was that the Danish fleet, the pride of the nation, was towed off to England. Finally in 1813, a poverty-stricken Denmark had to declare national bankruptcy, and the following year through the Treaty of Kiel she lost Norway.

This is not the place to give an account of all the misfortunes that that generation of Danes had to live through, but merely to show that *Danish culture did not thrive because of prosperity, but in spite of adversity*. And that in itself is quite an encouraging experience.

Works by the Golden Age painters were acquired for the Royal Collections from the very beginning. With the Constitution of 1849 these collections became state property although they remained on public view in the picture gallery of Christiansborg Palace. In 1884, however, Christiansborg was burned down, and to house the now homeless art collections a new and monumental building, the Statens Museum for Kunst, was inaugurated in 1896.

During the subsequent eighty-eight years the collection of Danish Golden Age art has been constantly extended and improved. It is today by far the largest and most important of its kind, a luminous pearl in a museum offering very many other attractions.

A distant great-grandfather would probably find it hard to forgive his descendant, working as a museum director almost two hundred years later, for willingly, indeed gladly, sending the priceless Golden Age treasures of his national gallery for exhibition in a building outside which the hated Nelson stands on his column. Dear great-grandfather: Forgive. Please understand that later and more meaningful events have eroded old enmity. Understand that when our English friends in 1984 wish to open their new exhibition room with Danish Golden Age art, the main Danish museum of art not only has a duty, but also an interest, in showing the best, because it has by far the largest and finest collection in this field.

Dear, disaster-ridden forefather, be appeased by the fact that British and Danish museum staffs have cooperated in the friendliest and most confident way, which we on the Danish side have felt as a great source of inspiration, and for which we express our most unreserved pleasure and thanks.

Lars Rostrup Bøyesen DIRECTOR, STATENS MUSEUM FOR KUNST

THE CARLSBERG FOUNDATION

In 1876 Jacob Christian Jacobsen, the founder of Carlsberg, established the Carlsberg Foundation, handing control to nominees of the Royal Danish Academy of Sciences and Letters. The Foundation, supported in perpetuity by the profits of the brewery, has evolved in three ways.

First came the establishment of the Carlsberg Laboratory – now part of a Research Centre of international standing which has made outstanding contributions to the study of chemistry, physiology and genetics. Then came the development of a National Portrait Gallery at Frederiksborg Castle, a former residence of the Danish Royal Family until it was damaged by fire in 1859. J. C. Jacobsen, who felt that art should be the property of the people, stepped forward to turn the building into a Danish National Historical Museum housing great collections of portraits, paintings and sculptures of national importance.

His son, Carl, set up the New Carlsberg Foundation in 1902 as an adjunct to the original body. From 1882 the public were admitted to view Carl Jacobsen's growing art collection in exhibition halls near his home, but it soon became evident that new premises were needed, and plans were drawn up for the Ny Carlsberg Glyptotek to be built in the centre of Copenhagen.

Opened in 1897, it now houses one of the world's finest collections of ancient Greek and Roman works of art, along with a distinguished selection of French, Danish and Dutch paintings, and various items of international acclaim such as sculptures by Arp, Calder, Degas, Giacometti and Moore. The Ny Carlsberg Glyptotek has generously lent cat. no. 55 (Købke) to this exhibition which Carlsberg has supported.

INTRODUCTION

HENRIK BRAMSEN

GOLDEN AGE

The "golden" label adorning this exhibition is, in its present context, neither very old nor very original. It is borrowed from Danish literary history where, after no more than occasional use, it formed the title of a book, published in 1890, about Danish poetry of the first half of the nineteenth century. Valdemar Vedel, the author of the book, apologised in his foreword, saying that the term was chosen for want of a better one and that he found it far too high-flown. Bad taste, one might say.

The book claimed that modern intellectual life, and in consequence genuine Danish poetry, came into being only after 1800. What lay prior to that was good enough in its way, but was not truly Danish. Only after the year 1800, it was said, did the Danish national mind gain its true, poetic expression. The thought was not new, but here it was given an effective platform. It was romantic and patriotic and stirred the heart.

The "golden" label came to be transferred to pictorial art of the first half of the nineteenth century, which was similarly assumed to express the national soul with particular purity. Fortunately, it was also possible to refer to Thorvaldsen's *Jason* which, shortly after 1800, had strode with helmet and golden fleece, like a gladiator into an international arena. He was to be succeeded by many equally bright and optimistic statues, which offered solace to a severely stricken nation.

In the sphere of painting, however, this period lacked a figure to equal Thorvaldsen's glory. Jens Juel had died in 1802, N. A. Abildgaard had retired into his shell and died in 1809, and something of a vacuum resulted. Hopes were pinned on J. C. Dahl who during the years 1811–18 won great acclaim. But these hopes were shattered – Dahl preferred to live outside Denmark, in distant Dresden. On the other hand, Eckersberg returned from Rome in 1816 with a new style and fresh greetings from Thorvaldsen. The general opinion, formed only after a considerable time, was that he was the man who found the true path and who made it accessible to the many who were to follow.

It is a simple and bright tale, possessing neither background nor perspective, like one of Thorvaldsen's reliefs – a modern version of the antique myth of the golden age, humanity envisaged in its original state, happy, and living in peace off the fruit of the land.

Denmark's golden age, however, was not quite so simple, bright and harmonious. The background was dark, the perspective diffuse. The country had been at war, and with catastrophic results. The ancient union between Norway and Denmark had been shattered. The economy was in a shambles. The rich grew poor and the poor even poorer. Had the painters of those days been told that they represented a golden age, they would have replied that they were not aware of it.

And once these difficulties had been overcome, others appeared. An increasingly strong political wing wanted freedom and democracy; the government replied with

censorship and police. A growing tension between the Danish and almost equally large German segments of the community led to the bloody civil war of 1848–50. The official religion was in confusion. The painters struck an ambivalent attitude. Some withdrew to a form of quietism, others used their painting to comment on the situation, a situation marked, by and large, by uncertainty and turmoil. Christen Købke, for example, went through three distinct phases of style during his short life.

With a little effort, however, it is possible to see the painting of the period as having a predominantly peaceful, innocent and refined character, justifying its now preferred honorific name. Yet it is important to remember that it was not a beginning but more like a conclusion. This art did not rise from nothing, but was based on the firm foundation and the rich soil prepared by its predecessors. It is the late, aromatic fruit of a deep-rooted plant.

Its status and importance in the larger context of European art are open to discussion, but one thing is certain: these painters created their art almost exclusively within the green ramparts and black moats of Copenhagen. This was where they lived and worked, and this was where many found their preferred subjects. Even the landscape painters left town only to gather impressions to work on back in Copenhagen. It has been said of Christen Købke that he never went further from his home than where he could be back for dinner.

The term "Copenhagen School" is thus appropriate. That might be seen as an inferior concept as compared to the national. It would be today, but it was different then and had been so for many years.

COPENHAGEN

Hafnia Metropolis et Portus Celeberrimus Daniae was how the city was described when a new panorama was published about 1600. It has the ring of a fanfare from His Majesty's oboists, and intentionally so. This was the time when the city was expanded, fortified, enriched and adorned. It was supposed to live up to its designation as capital of two kingdoms (Denmark and Norway), two duchies (Schleswig and Holstein), and in addition the overseas lands.

In Copenhagen the king had his palace and his court. Here, too, was the central administration, the garrison, the navy and the university. Trade and industry were granted royal privileges. Here were to be found the power and the glory *and* the money. Here was the centre that attracted the best from all the king's countries. Naval heroes and poets came from Norway, merchants and antiquarians from Iceland, soldiers and civil servants from Holstein, and from Denmark peasants with bacon and eggs. Artists came from everywhere – for a time especially from Schleswig.

But in addition, many people came from foreign countries: artisans, statesmen

and queens from Germany; Jews from Poland and Portugal; Huguenots from France. In the street many languages, from Low German to Yiddish, could be heard, and the king was in his palace speaking German and French as well as Danish. It was his task to give visual expression to the destiny and importance of the city.

It began as early as 1596 during the young king's coronation, which took place in Copenhagen and lasted several days. On this solemn occasion the old (and old-fashioned) palace of the city was decorated with a fancy and modern steeple. This signalled the start of energetic construction all over town. The unique steeple, created of the intertwined tails of four dragons, is still one of the city's finest architectural monuments. In addition, churches in a severe style inspired by the Old Testament were built – evidence that the city was a new Jerusalem and the king "the new David".

He was succeeded by his son, and his son again, and so forth, a regularly alternating pattern of Christians and Frederiks. They all contributed to the preservation and improvement of the city. During the reign of the sixth Christian, the time was ripe to carry out old plans for a new palace, destined to function as the absolute centre of the capital, and the residence of the autocratic king.

Not that the king himself led an extravagant life; on the contrary, he had particularly austere habits. He was a short man of frail health. As he was also pious, conscientious, industrious, honest and a model husband, it is little wonder that he never became popular. But the building of a magnificent palace was a holy duty to Him by whose mercy power had been placed in the hands of the king.

The king also decided what the palace was to look like. He chose *le goût léger*, by way of a kind of Austrian baroque in a civilian shape. This corresponded with the policy of peace promoted by the king, furthered by means of shrewd diplomacy and subsidies gleaned from the Great Powers in connection with peace treaties. A sum from England, earmarked for military purposes, was used to fund the building of the palace.

The palace was put into service in 1747, but the interior was not then finished. Work was to continue during the almost fifty years that the palace existed. French artists were called in, working in the styles of Louis XV and Louis XVI. French paintings of various subjects were bought, the line being drawn at nudes. Even *putti* had to be appropriately draped. Puritanism and piety were the moral rule here, as they were also, through habit and tradition, to become the rule in national art.

The palace was given a tower and steeple (fig. I), which was unusual for palaces at the time. The idea was to show that this was where the Christian monarch resided. The bishop confirmed this at the inauguration by referring to the Book of Kings (I, chapter 9, verses 1–5), which speaks of the House of God and the House of Solomon. The palace was dubbed "our Zion", and it was claimed that neither St. James' (then

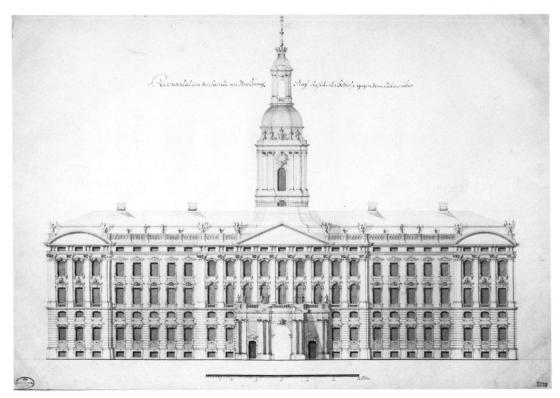

Fig. I Copenhagen, Christiansborg Palace. Built in 1733–45 by E. D. Häusser

the royal residence in London) nor the Louvre (the equivalent in Paris) could equal it. At the king's funeral, the bishop preached on the theme of King Jotham who built the high gate on the House of God, and built castles and towers (Chronicles II, chapter 27, verses 1–4). An English visitor made the somewhat less grand comment that the palace was "too splendid and too magnificent for a king of Denmark".

But there was more to come. Yet more towers and steeples were added. A new steeple, in the English style, graced the Church of Our Lady. It rose 400 feet, the same height as that of the Church of Our Saviour (consecrated in 1750) which still dominates the skyline in its spiralled, green and golden glory (fig. II). At the very top, Christ stands on the globe as an image of the highest wisdom, reached only by means of a narrow and tortuous path. In his book, *Voyage au Centre de la Terre*, Jules Verne offers a fascinating description of an ascent to the top of this steeple.

THE KING ON HORSEBACK

The palace had hardly been put into service before new plans were under way, this time involving an entire town, a northward extension of Copenhagen. The occasion was to be the tercentenary of the royal family, a splendid event that was to be celebrated and commemorated by means of a monument.

The town, or rather that part of the town, was arranged around a large octagonal open space, with four elegant and identical mansions that four rich noblemen had been induced to build. This defined the highest social level. Further mansions were built in the neighbourhood, in addition to many houses of more moderate size and elaboration.

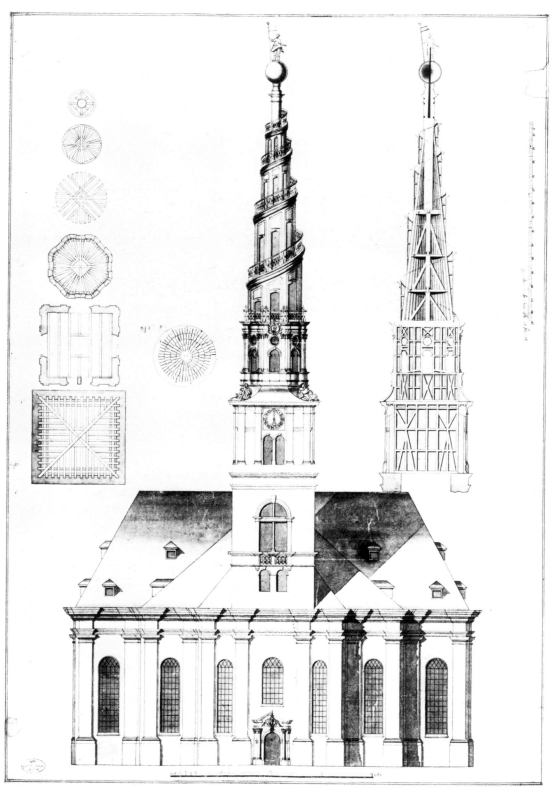

Fig. II Copenhagen, the Church of Our Saviour. The spire built in 1749–52 to a design by Laurids de Thurah

[15]

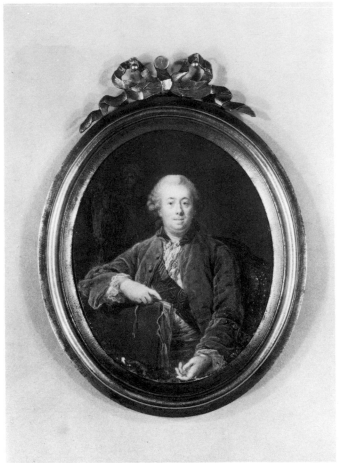

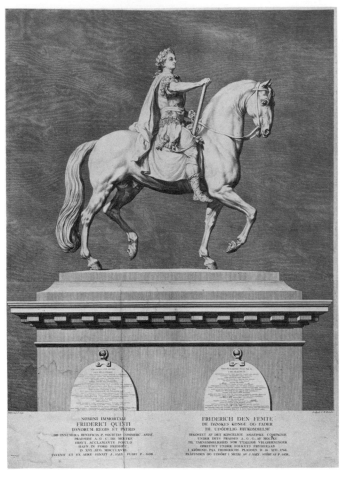

Fig. III Cornelius Høyer: *J-F-J. Saly*, 1769

Fig. IV J. M. Preisler: *Frederik V on Horseback*. Engraving after Saly's statue of 1755–68

In the centre of the open space the king was to have his equestrian statue. An overseas trade firm was persuaded to pay for this. It was to be of international calibre, so the great Bouchardon was asked to give advice. He recommended his compatriot, J. F. Saly (fig. III), as the ideal man for the job.

Saly arrived in Copenhagen in 1753 and remained until 1771, largely occupied with the erection of the statue. It turned out to be remarkably similar to Bouchardon's statue of Louis XV. Today, this could have led to a legal problem, but in those days originality held no virtue in itself. Saly recognised that Bouchardon's statue was a modern classic which could not be improved in the given context. It could therefore confidently and without hesitation be imitated, on condition that the result was technically and artistically faultless – which it is.

The king is in Roman imperial garb, without saddle or stirrups (fig. IV), crowned with laurels; in his hand is a baton. His posture is majestically erect, his countenance mild and gracious. The statue still stands where it was placed, although it is now green with verdigris and worn with age. The surrounding area remains more or less unchanged, a charming open space – extensive yet light, elegant and modestly decorated. Something of this, and of the atmosphere of the statue itself, is to be found later in the Copenhagen school – no bombast, but the desire to let the world know that this is a civilised regime headed by the gentlest, wisest and most pious of kings.

The king faces God's House, the vast domed church that was planned as the final touch to the central axis of the entire complex. As a special favour and a subsidy for the Norwegian marble industry, the church was to have been built with marble. The foundation stone was laid on the last day of the Jubilee celebrations, but then, after a number of difficulties and trials, it was decided to carry out a project by N. H. Jardin, a French architect who had been specially commissioned for the task. His project was on the finest French neo-classicist lines and looked promising, but construction was stopped in 1770 with the walls ten metres high. And this is how it remained for a hundred years, a picturesque ruin in the centre of town. Finally a dome was built, as originally planned.

But Jardin *did* leave his mark on the city, his most interesting work being a barrack. It is built in a severe Spartan style, in yellow brick and sparsely ornamented, but of perfectly harmonic proportions. The ground-plan is in the shape of a mirrored monogram of the letter F, yet another grand tribute to the crowned Frederik V.

The tables at Frederik's wedding banquet in Copenhagen had been of the same shape. His bride was an English princess, Louisa, a daughter of George II, and tribute was paid to her with a reference to the Vikings' plunder of her country:

But nowadays we see another feud
All Denmark is conquer'd and subdued
By British lineage, though not by arms.
A blessed Princess does it by her charms.

The long-felt interest in ancient national history suddenly swung into fashion. There was an urge for self-justification, and independence in every way. That was one of the reasons for engaging fine and costly foreign artists. They were to serve the king and the state not only directly by their art, but also by teaching the locals – thereby making themselves redundant.

This move towards independence in the arts was consolidated through the establishment of the Royal Academy in Copenhagen in 1738. It consisted of a gathering of artists under the chairmanship of a prince or other dignitary. The purpose was to make artists of young people and then to reward the best with medals and money with which they could travel abroad. Apart from certain subsidiary subjects, only drawing was taught. To begin with, drawings by the masters were to be copied, later plaster casts would be drawn and finally nude models. The models were full-time civil servants, issued with royal livery to wear when off duty. The programme was rigid, and the carrying out of it incredibly boring and, ultimately, of very questionable value.

Of greater importance, perhaps, was the opportunity for young students to be apprenticed to established masters. If we see the art of painting as a basically

traditional form handed down from master to apprentice through the ages, then the history of art ran its true course in the painters' studios, rather than in the drawing classes of the Academy.

COURT PAINTERS

The Academy regulations were restrictive in other ways. Only history painters could win a medal and thereby money with which to travel. Many found this unreasonable, but only a few protested.

Among the rebels was Vigilius Erichsen (fig. V), a talented young portrait painter. Having been turned down, he consequently wrote to the Academy saying that the exclusion of the art of portraiture showed a lack of understanding of the meaning of art. The painting of a portrait required more than merely reproducing a likeness; in any case portraiture was just as important at court as history painting. He would, however, like to try to do a history painting – on condition that he might make use of Nature, she who teaches everything. In other words, he wanted to use a model, which was normally not allowed.

The story ended with Erichsen slamming the door of the Academy behind him. Perhaps the first to do this, he was definitely not the last. In 1757 he left for Russia, where he became an esteemed court painter. Among other things he did some outsize paintings of Catherine II. One of them shows her on horseback in military uniform. In another she is clad in silk before a mirror which faithfully reflects her less than noble profile. They are among the most honest and unsentimental, yet nonetheless dignified and impressive royal portraits of the period. Erichsen's reputation is well-founded, for he was able to handle both large formats and fine detail.

He returned home in 1772, and the empress soon commissioned him to portray another powerful, albeit less formidable lady, the Danish Queen Mother. Along with others she was to adorn the palace in St. Petersburg. The painting has since returned to Denmark and is now to be seen at the Statens Museum in Copenhagen. Precisely calculated and severe in style, it is also admirably restrained in its white, blue and gold colouring. Something of its razor-sharp, bright-as-day and disciplined conception prefigures Eckersberg, fifty years later. This also applies to the use of ''Nature'', i.e. the given subject. Eckersberg must have seen paintings by Erichsen, although he never mentioned them.

In Copenhagen, the attractive and rewarding position of First Portrait Painter to the Royal Court had already been occupied by Carl Gustaf Pilo, a Swede. He hadn't come at royal behest, but had arrived in a less dignified manner – fleeing from an affiliation case at home. This didn't prevent him from being employed and gradually rising in the ranks.

Fig. V Vigilius Erichsen: *Portrait of Peter Cramer*, about 1772–78

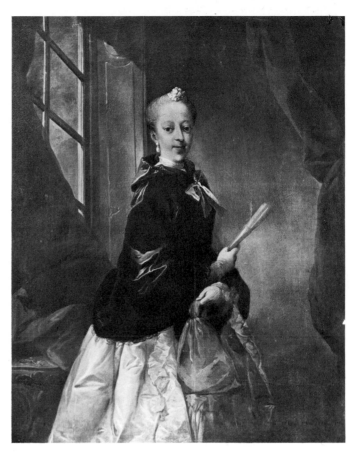

Fig. VI C. G. Pilo: *Anna Margrethe Juel*, about 1759–61

In the 1740s and 50s, Pilo was mainly occupied with painting portraits of the king and queen, who were portrayed as frequently as Roman emperors. They appear godlike, distant, mild, wise and almost incorporeal, floating on multicoloured clouds of silk. Later interpretations emphasise this and the setting becomes even more romantic and dramatic. In his portraits noblewomen appear in a cold light, smiling demonically as though looking forward to haunting the corridors of a manor house (fig. VI). Pilo also painted colleagues at the Academy in a Rembrandtesque, subdued light. There are "night thoughts" in these latter paintings, exemplifying a kind of modernism not discernible in his work at court.

Pilo lost ground to Louis Tocqué, who was in Copenhagen from 1758 to 1759, busily painting portraits of the rich, the noble and the beautiful. Compared to his refined, elegant paintings, Pilo's work may have appeared slightly old-fashioned. Tocqué is quoted as saying that Pilo painted *en turque*. He probably didn't intend it as a compliment, but if he meant to refer to a Turkish military band with a variety of instruments and tonal qualities, the comparison is not far off.

HOMER AND OSSIAN

Despite its evils, the Academy meant funds for those selected, so that they could travel in Europe. Paris was frequently their destination, but Rome was a must. The idea was borrowed from the French and their *Prix de Rome*. Young foreign artists

often encountered greater difficulties than did the French, who had found a home at their Villa Medici. Loneliness, a difficult climate, bad lodgings, lack of money and illness consumed time and energy. Some even died.

In a letter from Rome, the Danish scholarship holder N. A. Abildgaard wrote: "With the exception of my eating meat, I lead the life of a Carthusian. I spend many a day without speaking as many as four words, and whom should I speak to? I already know what my compatriots want to say, and the Italians can't talk about anything but food and drink . . . Scholarly people are not readily found here, there may be an occasional one among the monks, but they are very rare. I see whatever foreign artists are here, as far as circumstances permit . . ." These foreign artists would have been fashionable company since they probably included people who were to achieve fame, such as J. H. Fuseli and J. L. David. Unfortunately, we hear no more of them from Abildgaard.

In his paintings in Rome he devoted himself to great passions, expressed through the human body and its plastic abilities, strained to the limit. He was strongly inspired by classical antiquity, which he saw as dramatic, multicoloured, mystical and erotic. Nourishing his imagination by reading antique poetry and plays, he often used subjects from these in his later paintings. One of his favourites was *The Golden Ass*, a rather racy narrative by Apuleius.

Only the subject-matter, not the style or atmosphere, differed in his other favourite motif: the Nordic, "Gothic" past. Ossian was enthroned side by side with Homer. On the other hand, he flatly rejected contemporary French art in which, according to a letter from Paris in 1777, he "found only an inexperienced boldness that conceals the imperfections of this nation and gives offence to the thinking spectator, who does not view a painting as he would an embroidered cloth." Instead, poets of antiquity, Celtic bards and Nordic minstrels moved in with harps and bagpipes.

Abildgaard read English, others had to make do with translations. Edward Young's *Night Thoughts* was published in German in 1754. Ossian was published in 1760–3 and was translated into German a few years later. The first Danish edition of Shakespeare was in 1788. In *Hamlet*, a connection between the Nordic spirit and Shakespeare was to be found, although one critic regretted that the author knew so little about Denmark.

While in Rome, Abildgaard had a copy of Saxo's famous medieval *History of Denmark* sent to him. He wanted to find motifs for those pictures from ancient national history that he expected to be commissioned to do for the Great Hall of the palace in Copenhagen. But nothing came of it. The king preferred pictures of his ancestors and their good deeds. Abildgaard worked on these for years, but his interest in antiquity never faded. He continued to cultivate the Greeks, the Romans,

Shakespeare and Ossian in pictures of "wild pathos and night-black darkness, pale moonlight and baying dogs".

But he *was* artist to the royal court, and like a Renaissance court artist, his abilities went further than painting pictures. He illustrated books, drew satires, designed furniture, houses, monuments, theatrical costumes and so on. Maybe he was at heart a man of the theatre. The figures in his paintings, with their violent movements and tense postures, could be thought to resemble modern ballet – on occasion they appear just as unbearably mannered. His lament, that his name disappeared when his great paintings (with the exception of three) went up in flames with the palace in 1794, has a Neronian ring. He laid away his brushes – only to take them up again later.

Just after the year 1800 he painted four big paintings for his own room, scenes from Terence's comedy *The Andria* (cat. no. 6). He had prepared for them by studying the ancient theatre. The pictures show a stage and the city of Athens in stone and wood. The light is the light of Copenhagen, which during these very same years was becoming very Greek, with elegant white houses erected in 1795 after the Great Fire. A block of buildings, reminiscent of the architecture seen in his Terence paintings, was, in fact, partially constructed within his own lifetime. Built in the years 1805–15, it houses the present-day Law Courts, in themselves something of a theatrical performance. The vast vestibule, supported by columns, is awe-inspiring. The next-door prison, connected by means of not one but two Bridges of Sighs, speaks its own sombre language with heavy rustic work and barred windows. Here, the clanking of chains is made audible.

Abildgaard is best grasped when his art is viewed as theatre, alternating lyrical episodes with black humour and absurdity, and with peculiar dogs playing important parts. A genuine misanthrope, he kept his love for dogs. Some appear in his pictures from Terence's comedy and are well worth studying. When his clever dog Giordano died, he had a beautiful tombstone made with an inscription beneath the name: "A model of fidelity. Born in Rome in the second year of the reign of Pope Pius XI. Died in Copenhagen in that strange year when a pound of sugar cost 43 *skilling*." Learned scholars have determined that Giordano lived to become an extremely old dog.

PORTRAIT OF VIRTUE

In spite of all the privileges granted history painting, and in spite of all the younger painters' desperate attempts to follow the proper procedures in this *haute école* of painting, the Academy remained lifeless, an artificial nightingale singing for the sole pleasure of the emperor and his court.

Portrait painting, on the other hand, although not as respected, was alive and well. Here, it was more a case of seeing and painting, than of ruminating. Here was

direct contact with real people. Not that they were all equally inspiring, but at least they were somewhat better than that unavoidable prop of history painting, the professional model. It was the land of the living, and remained so until the new landscape unrolled beneath Constable's clouds.

Copenhagen had a good tradition in this area – there was always something for the young ones to learn from. In young Jens Juel's portraits we thus find obvious traces of Pilo and Tocqué adjacent to what he picked up during his years in Hamburg. He had returned from there in the mid-1760s, and appears soon afterwards to have started to satisfy a great deal of the vast demand for portraits. When one of the older portrait painters kindly offered him guidance, he politely turned down the offer, saying that he really didn't have the time.

One of his early portraits shows a young man with grey eyes and a strong and darkly shaded jaw (cat. no. 1). It is said to be the likeness of Jacobson, the medallist and seal engraver, who at the time would have been about fifty. The portrait shows, however, a younger man. And wouldn't Juel have supplied a colleague with tools of the trade to indicate his profession? But whoever the sitter might be, his is a fascinating physiognomy. The warm colour is set off by the grey, powdered(?) hair, while its brightness is emphasised by the dark background and further underscored by the black scarf. The lips borrow extra colour from the red costume, and the three-cornered hat gives the somewhat carelessly painted hand a meaningful function. Juel was just the man to replace the old guard in all their pomp.

The reputation of the young painter went all the way up to the golden halls of the palace, from where, in 1767, he received his first royal commission for a portrait. His model was as unusual as it was restless – the big hyena in the royal menagerie. The commission must have been one of the bizarre ideas of the young, mad king. The picture was duly painted and can be seen today at the Statens Museum for Kunst. True to his nature, Juel has done what he could, not just to get a likeness, but also to make the creature look kind.

A few years later the palace gave him a somewhat more savoury model, the young queen herself, cousin to the king and sister of George III. For such a fashionable sitter it appears that he felt the need to emulate the style of the specialist in royalty, Pilo, employing spotlights on the round face and the full bosom. Warmth and smoothness are specially emphasised by the blue silk and the brown fur. The sense of an all-too-divine monarch has been done away with; instead we have a chubby and lively girl with cherry lips and white eyelashes.

Juel can't have had much time for his Academy duties, but in 1771, after considerable dispute, he was given a medal for a history painting which is of breath-takingly poor quality. He was also to have received a travel grant, but there was no money available. Instead, resolute and wealthy noblemen and noblewomen at

court came to his aid with the necessary funds. He was gone for a full nine years, painting portraits and learning from artists wherever he went. He spent a particularly long time in Geneva, among other things painting the enchanting portrait of Madame de Prangins, who resembles a doll waiting to be wound up to dance on the lid of a music box (cat. no. 3).

Eventually, he returned to Copenhagen, to a secure life and social respectability. There was a steady stream of pictures from his studio; occasionally they sprang forth a little too rapidly. His spirit was not always equal to the demand. But the best of them are good, marked by his feeling for people in loving togetherness – man and wife, mother and child, or an entire family in nature – rich and happy, but first and foremost good. Goodness and joy emanate from these pictures, from the individuals, from the groups, from the segment of nature surrounding them and from the flowers they carry.

Occasionally flowers appear on their own in pictures where Juel's sweetness and earnestness outdo the many who had made a speciality of the flower piece. The same applies to landscapes, which he painted for his private pleasure and to pass the time; they are marked by his joy for describing nature. Some of them are imagined, others show real locations; some are clear, bright and calm, others are agitated by a tendency to drama. Their distant inspiration lies in the landscapes of Rubens, but they are generally more subdued and mildly didactic. In *A Thunderstorm brewing behind a Farm-House in Zealand* (cat. no. 4), the cattle hurry towards the protective walls of the farmhouse, to be met by the farmer's wife whose erect pose is to remind us of the agrarian reforms of the period, their benefits for the peasants, and thus for the entire nation.

The painting of the boy on his way to school (cat. no. 5) also speaks of good sense, enlightenment and liberalism. The school is seen in the background – the building still exists. It was a so-called ''Philanthropinum'', with the idea, derived from a German model, that all learning should be achieved through games. The curriculum also included physical education and sex instruction. In fact, the children can be seen in front of the school doing exercises. Former pupils were heard to say that the school was fine, except that they didn't learn anything.

It was ambitious to show a portrait figure running at full speed, and in any case it allowed the artist to give free rein to his own graceful rhythms. We are to understand that here we see a really good boy who loves school and runs to it full of eagerness to learn diligence, obedience and sense.

It was to be Juel's last great picture. He died in the year he finished it, leaving behind him a world painted like a latter-day garden of Eden – inhabited by good, happy and true people, preferably in the midst of nature, among flowers and trees, in soft light and fragrant air. ''Were angels to paint,'' said one of his admiring successors,

"I doubt that they would do it much better."

Cornelius Høyer, a miniaturist, was a contemporary of Juel's and a resident of Copenhagen. He was greatly prized by royal courts all over Europe, where small portraits were still very much in demand, and where exquisite quality was also appreciated (fig. III). His art led him to travel a great deal, and he who had a tendency to despair in the domestic environment, thrived in the great world.

He wrote to a friend that "whoever loves beauty must, now and again, leave his place in order to invigorate himself. When I begin to admire the best work of my dear colleagues, the time has come for me to leave them. That is my unfailing thermometer."

His statement is unkind and disloyal, but it touched on a sore spot in the long-practised national policy of independence. Indeed, there was a period around the year 1800 when it was hard to see who was to carry the torch.

INTERMEZZO

The Academy in Copenhagen at least had the advantage of having free tuition, a fact that strongly contributed to attracting to the capital budding artists from the states of North Germany. Some of them were later to become prophets in their own country.

One of them was A. J. Carstens, although it must be added that he was from Schleswig and thus a subject of the Danish king. But he chose to become German, and was one of those who slammed the Academy door behind him.

Caspar David Friedrich was another young German. Little is known about his stay in Copenhagen in the years 1794–8. He was later to be regularly in touch with Copenhagen, through J. C. Dahl among others, and he had a brief but appreciable influence on young Danish landscape artists of around 1840. Yet another was Philip Otto Runge, who lived in Copenhagen from 1799 to 1801. We know a great deal about his stay from his letters, which also give much information about the Academy and its artists. He appears to have been mainly in touch with German circles, and was a guest of Mrs. Frederike Brun, the Madame de Staël of the North. She held literary and musical *salons* that he attended, and which undoubtedly made their impression.

Runge doesn't appear to have been influenced by Danish painters. But then, they were miles apart. On the one hand there was Jens Juel, no more and no less than an eminent portrait painter, and N. A. Abildgaard, who was full of ideas but to some extent lived in the past. And on the other hand there was Runge and the other Germans, painter-philosophers and painter-poets. The Danes were not so meditative. They had other things to think about.

The royal palace burned down in 1794, and the fire provoked vivid descriptions – especially of the way the tower lurched and fell in an inferno of embers and flames.

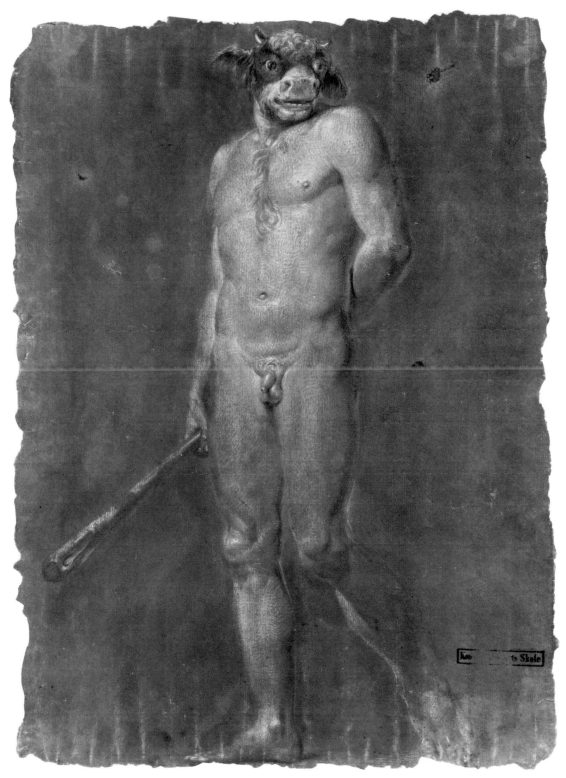

Fig. VII N. A. Abildgaard: *Minotaur*

The following year another fire destroyed a great part of the city, but it was soon rebuilt, elegantly clad in white. 1801 saw the Battle of Copenhagen, and in 1807 the city was bombarded by the English, who succeeded in hitting the steeple of the Church of Our Lady.

The Battle of Copenhagen was depicted by a painter who, like a true war correspondent, risked life and limb by climbing up inside the steeple of the Church of Our Saviour to make sketches. Another young painter, C. W. Eckersberg, gave truthful descriptions of the bombardment and its terrible consequences. He was also a versatile supplier of portraits, landscapes, city views, marine paintings, as well as of series of moralising images about fallen women and the like – some of them intended for reproduction.

In his paintings, he copied Jens Juel in particular – in his own, as yet, clumsy way. So did other painters, and Juel's style was prolonged for a period, achieving, in the mid-1820s, a very beautiful Indian summer with a number of portraits by the young Constantin Hansen. At a *salon* arranged in 1815 on the occasion of the coronation, one of Juel's big conversation pieces was shown and was much admired. In 1828 an exhibition of his work was held, the first of its kind.

Nor was Abildgaard forgotten. His grand style and pathos had its own renaissance around 1835–40 when, after a cheerful interlude, there was a return to a more serious tone. Here, the protagonist was the sculptor H. E. Freund, a great talent although overshadowed by the celebrated Thorvaldsen. Freund had returned from Rome in 1829 to become a source of great inspiration for the younger painters.

Around the year 1800, incidentally, Abildgaard had done a number of drawings from the life, in black and white chalk on paper covered with greyish distemper. Characterised by a strong plasticity and an alluring, melancholy half-light, they came to be used as models by students right up to 1850. In one of the drawings he was inspired to substitute the model's own head with the head of a bull (fig. VII).

In 1811 a talent finally came to town that was believed to be able to span the void. He was the young Norwegian landscape painter J. C. Dahl, who grew to become a master within a few years. There had been no one like him before. With great gusto he described the big, old trees, the rich vegetation of wild plants, the changing light and the clouds drifting across the landscape. 1818 marked, however, the end of his time in Denmark; and thereafter he settled in Dresden. But he maintained close ties with this country, regularly exhibiting in Copenhagen, painting Danish landscapes, partly sketches of sky and clouds, partly landscapes saturated with ''Ossianic'' atmosphere. He had numerous followers in Denmark, and is the herald of what is known as the national school of landscape painting.

C. W. ECKERSBERG

The year before J. C. Dahl came to Copenhagen, C. W. Eckersberg had left town on his grand tour. He was to stay in Paris from 1810 to 1813 and in Rome during the years 1813 to 1816.

In Paris he spent about a year at David's school, where the students sketched or painted from nude models. In his letters home he discussed this, and thereby the meaning of "Nature". "We paint from Nature", he said about the school, meaning the life model, deliberately placed for study. When David demonstrated this, he drew the students' "attention to the beauty of Nature". Nature, then, was that part of the visible world the painter had decided to describe. It was also classified, the finest Nature being "the external features of God's masterpiece, Man".

Artists, of course, could always *draw* from all sorts of things in order to practise, as artists had always done – but when it came to painting David advised young artists to "perpetually look at the antique and the greatness of the old masters, in order with their eyes to imitate Nature". A certain help was given by the models, which were carefully selected to correspond to the classical ideal. At David's school there was "one like Hercules, another like a Gladiator, a third like a young Bacchus or Antinous". If the models didn't resemble the ideal exactly, the artists were expected to carry out the necessary adjustments as they went along. Nor was their work meant to be a mere demonstration of anatomy, rather the aim was to exist in a sphere governed by the eternal laws of beauty and truth. Eckersberg didn't always succeed in this transfiguration.

A thorough analysis of form and colour was fundamental *chez* David. This is visible in Eckersberg's *Two Shepherds* (cat. no. 7), which are studies from the life done up with a landscape background and a title. Here, we have tendons, muscles, skin and hair, examined with an eye as keen as an anatomist's scalpel. This was as vital to art as anatomy is to the doctor, without being the art of medicine itself.

Eckersberg bowed to antiquity and to Raphael, but found that his contemporaries had their advantages. First and foremost came David, the master, and then especially Canova and Gérard, both of whom he loved dearly. They possessed that grace and elegance that he prized so much, and at the same time their works were true to life. So is Paulus Potter's *Bull*, which was then on show in Paris. Had Potter wanted to paint man, he said, he would have been the greatest painter ever.

Eckersberg learned a lot in Paris, including bad habits. In his biblical compositions he seems unable to crowd enough people in. He also had a tendency to make play with an excess of coloured reflections and shadows.

After his arrival in Rome his style became more succinct. He used fewer persons and suppressed coloured reflections and graceful, sometimes over-seductive, lines. The change is evident in the portrait of Thorvaldsen from 1814 and in a small portrait of a lady (1815). His own comment on the Thorvaldsen portrait was that it was not in

the usual portraitist's style, and Thorvaldsen and other fellow artists made the comment that it was no longer "very French".

Nowadays there is a tendency to point at the German Nazarenes in connection with Eckersberg. It is true that they swarmed all over Rome – the problem is that his pictures bear no resemblance to the Germans'. But it is also true that certain romantic ideas floated about everywhere during this period. They manifested themselves through the inspiration of older, so-called "primitive" painting, as well as in an appreciation of Greek vase painting and archaic Greek sculpture. What artists found attractive about Greek painting was that, as far as they imagined, it wasn't composed in depth, but was flat like a relief. At the turn of the century in Paris, a group of painters calling themselves *les penseurs* or *les primitifs* had proposed the idea of painting with light shadows, without strong transitions between light and shade. Eckersberg may have heard of this idea, and in Rome the soil was fertile for it. In any case he developed a style of his own, with bright shadows, little depth and clear and distinct colouring.

Eckersberg's Roman views are accounts of architectural and picturesque wanderings in the eternal city. The "modern" (i.e. baroque) is generally ignored, however. All that counted were the remains of antiquity. He also found beautiful the common middle-class house, which he probably saw as a direct descendant of the ancient Roman house. But then in every handsome, tanned Roman could be seen a classical bronze god, "a demigod dressed in rags".

He called his pictures "sketches", which they presumably were at one stage. But most of them are now fully finished paintings. Some of them were partly done from the motif in the open air. His attitude toward this was the same as when he drew or painted from nude models. In both cases, it was a question of form and colour in their ideal, unchangeable state. The light in his views is thus clear, homogeneous and still, the atmosphere rarefied – and there can be a stony calm.

The greatest and most detailed of the views is that showing the Colosseum with the three arches opening on a panorama of the city (cat. no. 11) – an effect proven by time, having been employed by Hubert Robert who had died a few years earlier. The foreground and brickwork are painted with a certain freedom, and may have been partly done on the spot. There is a warm tone to this passage, in contrast to the colder background. The houses are well described although slightly obscured by mist. "A storm is brewing", it has been said, but like the picture as a whole, the background enjoys sublime, dignified and complete rest.

The bright and crisp colour of Rome is seen in the portrait (of 1817) of Mrs. Løvenskjold with her daughter, which has a clear blue predominating (cat. no. 12). Three years later, when Eckersberg painted the two Nathanson sisters in Copenhagen, the colour became comparatively subdued and the composition more

traditional (cat. no. 13). It might remind one of tombstones of the sixteenth century, or of the portraiture of that time in general. Maybe there is a trace of Holbein in the severe pose of the figures and in the detail of the many accessories. The young ladies are as chaste, cool and severe as vestal virgins. "With an earnestness worthy of a better cause, the elder sister diverts herself with the parrot of the house." The colouring is simple, with gourd green and apricot yellow predominating.

During these years Eckersberg painted other portraits, but fewer thereafter. Part of the demand came to be fulfilled by other artists, and by C. A. Jensen in particular who had come home in 1821 to achieve success with his bright technique, his often elegant colouring and lively characterisation.

Eckersberg, nevertheless, had his hands full painting history pictures for the palace, and altarpieces for village churches, although marine painting became his preferred field. He loved ships – good, perfect, faultless, well-equipped ships. He was something of an expert on the various types and their special characteristics. In his pictures he treated them like dancers, poised on a stage constructed by means of linear perspective and set off against a background created by aerial perspective (cat. no. 19).

Five years later, in 1833, he painted the charming little picture of the deck of a Danish corvette (cat. no. 20). The subject has an intimacy that was new to him, and could be due to the example of younger painters. The colouring is refined with a dominant green, and greyish translucent sails. The wind has filled them, so the ship must be assumed to be moving, but it conveys the immediate impression of supreme stillness.

THE COPENHAGEN SCENE

Around 1830, Lady Macbeth and Ossian still appeared in the annual exhibition of paintings. Then they gracefully bowed out, disappearing into the twilight of mythology and history. The stage was occupied by hearty citizens of Copenhagen and other folk, who for a while took up all the limelight.

This was typical of the period. People were said to be no longer able to bear the sight of tragedies, preferring light comedy with songs and witty dialogue in a contemporary setting. This by no means reduced the demand for decency and virtue. The art, said one noted arbiter of taste, lies in "emphasising the spiritual aspects of sexual difference, thus making it palatable". The old spirit of puritanism and pietism from palace and city was preserved, and applied with new vigour.

"A simple, democratic national feeling predominates", said Valdemar Vedel, "especially after the loss of Norway. What a bragging and baying there was about Nordic heroism and feats of valour! Heads were filled with such ideas by the

reawakened heathen past, by the phenomenon of Napoleon; and not even the events of 1801 and 1807 could cure them. But in the years 1810 to 1814 the people felt how small they were, and now, after 1814, they feel this doubly."

By 1830 the wounds were more or less healed, and life went on within the ramparts of the now madly overpopulated city. Painters began to show an interest in urban life, using streets and market-places as the locations for merry or touching scenes. But the citizens could also move about without anecdote, as M. Rørbye observes in his street scene from 1831 (cat. no. 45). The "set" here is the best possible – the street outside the new city gaol with its expressive and threatening architectural forms. People of all kinds appear against this background. They go at full sail, heave to or put about and so forth, moving like the ships in one of Eckersberg's liveliest marine pictures. We have the poor and the rich, debtor and money lender, judge and criminal, seduction and innocence – and the mysterious man with the lamp. Characters in search of an author.

The necessary author, or rather authors, were in fact found in the shape of those painters who responded with pictures that had a narrative point, who contributed towards Copenhagen's *comédie humaine*. We are given the tale of the industrious but poor young widow, evicted by the evil landlord in favour of the rich lady and her fat pug, and of the paramour who enters the room and sends the husband on his way under false pretence, while the faithless wife smiles wickedly. A figurine of Cupid on the fireplace points out the theme for those slow on the uptake. We see drunken sailors tumbling up the steps from one of the city's numerous basement bar-rooms, placed there because of the general lack of space and the cheap rent. They still exist, as do many small basement shops, and are very popular. When the public health authorities once threatened to ban them because the ceilings were half an inch too low, Copenhagen was on the verge of revolution.

The painter was Marstrand, and he and his friends were all acquainted with the work of William Hogarth. Later, in Rome, he and others were to continue with their satirical and sentimental descriptions of street life. He had been a student of Eckersberg, but soon betrayed his master's ideals. Rørbye was also a student of Eckersberg and faithful to a degree. He painted winter landscapes – Eckersberg always gives us summer – and cultivated romantic moonlight. J. C. Dahl had led the way in this, but perhaps Caspar David Friedrich is an important influence since, in 1821, he had exhibited two moonlight pictures in Copenhagen.

Rørbye was willing and accustomed to travel, like Hans Christian Andersen, his contemporary. He was among the first to visit Greece and Turkey, bringing home attractive and lively pictures (cat. nos. 46 & 47). His courage had been even greater when he visited the remote and unknown western coast of Jutland. Here he painted the wide, deserted beaches, and the flying sand settled on the surface of his canvases.

For a while it was also fashionable to show artists at work. They are seen in their studios, casually dressed in the middle of meticulously arranged disorder. After the older artists' attempts to assimilate with the well-to-do citizenry, the young ones took the opposite direction, the goal being *épater la bourgeoisie*. Their impudence was rewarded. People enjoyed themselves at art exhibitions, which they hadn't done for a number of years. The young painters had mainly learned from their Dutch predecessors in the genre field. Jan Steen has been indicated as the direct inspiration for a certain picture showing a battle painter at work. This work consists of painting a general's uniform without a general inside. A marvellous joke, like the minute figurine of Napoleon, a skull bearing the painter's beret, and other amusing paraphernalia.

About the same time young Wilhelm Bendz had contributed greatly to merriment in Copenhagen with several pictures, among them *A Young Artist examining a Sketch in a Mirror*, of 1826 (cat. no. 40). The artist is unaware that we have almost entered his room, filled with stuff that, together with the odd effect of the mirror, gives it a crawling life of its own.

Bendz was one of Eckersberg's most gifted students, but the relationship is not so evident in this picture since it is somewhat lacking in light. He doesn't appear to have been wholly apprenticed to the old master until 1827, in which year he painted a very big, very light picture of a sculptor at work. Other pictures, too, from the same year and thereafter, display strong colour and light, from which other young painters were to learn.

Most of them were not in touch with Eckersberg until 1828 or later, when they had already studied with teachers like the old professor C. A. Lorentzen and the portrait painter Hans Hansen, both of whom died in that year. Hansen was one of Jens Juel's former students, and couldn't stand Eckersberg's style. He spoke disparagingly of Bendz's picture of the sculptor from 1827, praising at the same exhibition a picture by his own son Constantin. Constantin Hansen doesn't appear to have had the same success as Bendz, but nor had he, according to the disappointed father, chosen an "optical effect", which Bendz evidently had, and then the "peaceful calm" in his son's picture "could only attract those spectators who had a feeling for this spirit in art" – in other words, the few with good taste.

This marks a division in the new art. On the one hand, there is the loud and varicoloured style upheld by Marstrand and Bendz; on the other, the gentle, mild and dignified style that Constantin Hansen and his friend Jørgen Roed had been educated in. Only after 1828 were they in touch with Eckersberg, learning a great deal from him, but more from the young Christen Købke who displayed his remarkable talents during this period.

These painters were the first to be given the task of describing old Danish palaces

and churches. This came about on the initiative of learned historians who conceived the idea in a spirit of nationalism. Købke painted the cathedral in Aarhus in 1831 (cat. no. 48), Frederiksborg Castle in 1835 (cat. nos. 59 & 60); Constantin Hansen painted Kronborg Castle in 1834 (cat. nos. 26 & 27), Jørgen Roed the cathedral in Ribe in 1836 (cat. nos. 37 & 38). The latter picture does not show the cathedral as it looked, but as it would look if certain unfortunate additions of a later date had been removed.

They all went on the customary journey to Italy, where Constantin Hansen stayed a full nine years, from 1835 to 1844. He painted beautiful studies with refined colour and a soft, moving light; also some pictures of Italian street life in a precisely composed, plastic style. In his picture of the man reciting *Orlando Furioso* at the Molo in Naples (cat. no. 30), painted in Rome in 1838–9, he concentrates on a large and varied assembly in expressive, plastic poses. Each figure is like a statue. It is not an amusing picture, as most of the then popular descriptions of Italian street life were, or wished to be, but it is not unwitty. The reciter, in particular, and his braces are worth noting, as is the attitude of his arms, which finds a visual echo in the lighthouse and in the smoke that slowly rises from the volcano.

The previous year Hansen had painted his picture *A Group of Danish Artists in Rome* (cat. no. 29). The situation is typical inasmuch as compatriots stuck together and had only few links with other nationalities. Rome was like a suburb of Copenhagen. But the figures are statuesque; even their gestures seem to be cast in bronze. Through the years, this picture has evoked many comments of varying profundity. Some have maintained that the artists looked miserable because there was cholera in Rome. Others have reproached the artist for not letting his characters show solidarity with the severely stricken population. Some bright person once remarked that the picture resembled Raphael's *School of Athens*. The similarity could be deliberate and intended for the amusement of the cognoscenti. We can't put it past Hansen – he was not as serious as people believed. The picture can be seen as a gentle travesty, with best wishes to the dead lion from the live dog.

Hansen became less subtle as the years passed, or did he? The picture of the small Elise Købke (cat. no. 34) raises some doubt. Is the monumental marble tub, which is a cup of tea with milk and sugar, in deadly earnest?

In any case we later see Constantin Hansen employ his subtlety on the most solemn and official occasion, and monumentally so. In 1860–4 he painted the National Assembly which took place in 1848 to draw up a "free constitution" for the country. A sketch for the picture showing the room is in the exhibition (cat. no. 35). The picture shows innumerable politicians and other dignitaries gathered in a hall at Christiansborg Palace. The hall is constructed according to a simple system of perspective, with the lines merging at a certain point in the background just above the head of a certain person. This head is more or less indistinguishable in the crowd,

but to those in the know it is emphasised. The man is N. F. S. Grundtvig, priest, poet and spokesman of national and spiritual rebirth. At the time he was not a member of the assembly, but his faithful disciple, the painter, has – with a simple trick learned from Tintoretto – pointed him out to the initiated or maybe to himself alone as the true protagonist in this historic event.

CHRISTEN KØBKE

The Roman works of Eckersberg caused a stir when they went on show in Copenhagen. They were something new, something radical. The old were in tears, the young in doubt. Peder Hjort, a critic, tried to straighten things out with a thorough analysis. He concluded that Eckersberg was a fine painter, that he had made honest and successful attempts to break away from the demoralising mannerisms of the French school, and that the light in his Roman views greatly resembled intensified moonlight.

It wasn't the strong light itself that he objected to, more the fact that it went hand in hand with an absolute, almost fossilised immobility, and with the sort of rarefied air which only white marble figures could breathe. Hjort was a disciple of Friedrich von Schelling, the herald of German nature philosophy. Schelling had declared that although Winckelmann, prophet of German neo-classicism, had put the soul back into art, he had not, by so doing, awakened the idea of a live and creative nature. Lofty works of ancient times, Schelling said, had taken the place of nature. But nature should, he said, be the immediate object of the artist's perception.

The demand for intense, liberating study of that nature which "actively forms and characterises", as Hjort put it, was to find its most inspired expression in Christen Købke's portraits from the early 1830s. They are in clear contrast to the cool, distant and slightly archaising portraits by Eckersberg around 1820. In these pictures, Købke scrutinised the shape of faces as closely as an astronomer studies the surface of the moon. Indeed the round, radiant face of Mrs. Høyen resembles the full moon itself (cat. no. 53).

Købke had prepared for his task for a full eight years, having begun at the Academy at the early age of twelve. This was not unusual, however – it seems that young boys were placed there just as they might be apprenticed in any workshop or office. We have no knowledge whether the young Købke displayed greater talent or eagerness for drawing than other children. His father, a rich baker, probably had academic ambitions on behalf of his children.

In addition to attending drawing classes at the Academy, Købke was apprenticed to an old professor of painting, moving on to Eckersberg when the professor died.

Eckersberg let him copy some paintings by older masters. Other students did the same, applying themselves especially to royal portraits. These copies could supply the student – or the professor – with much needed extra income. But the main reward was that the student could learn more about painting technique and the nuances of colour. Købke also examined pictures by Bendz, among them the very big, bright picture of a sculptor's studio that had caused a stir at the 1827 exhibition. In 1830 he portrayed Bendz himself.

The picture of the interior of Aarhus cathedral is from the same year (cat. no. 48). The previous year he had made some studies that were used for the picture. Made when Købke was no more than twenty-one or twenty-two, its composition is remarkably supple within the constricting narrow format, with long vertical lines, light vaults above and small figures below, and the chandelier on its long chain descending like a spider on its thread.

In the picture of the Academy collection of plaster casts (cat. no. 49) – also from 1830 – it is the similar interplay of white and greyish shades that caught his attention and which became part of a colourful composition full of effect and elegance; the black in the man's costume is set off against the grey and white, with the yellow rag adding a final festive touch. Where did he get it from? Possibly from C. A. Jensen, whose portrait of Mrs. Hohlenberg from 1826 displays a simple, refined palette in grey, white and blue (cat. no. 23). Købke's portrait of Mrs. Plöyen (1834) has similarly simplified colouring (cat. no. 56). But he may also have made a note of Dutch church interiors, with a red or blue figure in the midst of all the grey and white. A red and yellow royal footman in a grey street may also have sparked off his colouristic imagination. Be that as it may, he has given it imaginative form. The yellow rag stands out like summer lightning in an overcast Copenhagen sky.

The charming *View from a Store-House in the Citadel of Copenhagen*, of 1831 (cat. no. 50), would not have achieved so genuinely idyllic an effect without its dynamic disposition of form and colour. The heavy beams and planks, greenish and brown, open up the deep, green perspective, which in turn protectively encloses the fine little figure in red, the colour accentuated by the black belt and the little black ball hanging from it. It is an imaginative and coolly thought-out composition, loaded with poetry.

There is the 1832 portrait of his colleague Sødring (cat. no. 52) smiling kindly towards us as painters generally do in earlier portraits. The colour is very light – white background, black costume, and white shirtsleeves that fold and light up – rather as in the self-portrait of young Juel that Købke could see at his master's. Here the effect of the colour is pointed by the little red case on the table behind the sitter.

The exquisite and refined blond colouring reaches an extreme in the small portrait of little *Ida Thiele* (cat. no. 51), also painted in 1832: a fairy-tale of golden hair, dark

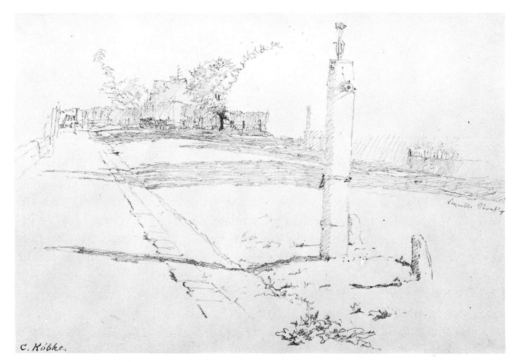

Fig. VIII C. Købke: *Study for "A View of a Street in Copenhagen, Morning Light"*, 1836

Fig. IX C. Købke: *Study for "A View of a Lake looking towards Østerbro"*, 1838

[35]

eyes, a fine red mouth, and a red dress on a background of violet.

With this painting, Købke seems to have reached a high point from which he was to set off in other directions. In a letter of the time, he said that he had seriously weighed what it was that a painter should and could produce with the means given him. He concluded that he could only express himself with little if he took the total impression as his point of departure. His thoughts aren't radiantly clear, but in his pictures we can register a movement towards a grander and more severe style. This had him worried. In 1834, when he painted *The Northern Drawbridge of the Citadel of Copenhagen* (cat. no. 55), he wrote to a sister: "It was really high time that I pulled myself together, having almost taken leave of my senses because of my weakness and inability, but then before I truly began, I remembered those words of wisdom: *The Lord is strong in the weak*, and so I grasped God with all my might and took the attitude that it was no concern of mine what he wanted to come of it, as long as I worked with my best will and insight."

The larger scale and more severe style are seen in the portrait of his sister of 1835 (cat. no. 58). He has described his work on this picture in a letter to another sister; and from this and other letters we gather that he generally did his large pictures in a state of great inner tension and self-discipline, in order that the results might be true, pure and strong. And he succeeded. Form and contour are pure and supple, the colours correspondingly simple and full: the red dress, the green apron and the almost black background. In the 1837 portrait of an artist friend he goes one step further and makes do with black, white and *caput mortuum*. His only altarpiece is from the same year, very original and quite different from most. It shows Christ and Nicodemus, and is an heroic attempt to outdo Rembrandt.

But in the dark, such lights as his great *A View of a Street in Copenhagen, Morning Light* (1836) are lit (cat. no. 61). It was painted at home, on the basis of drawings (fig. VIII) and local observations, and is about the joys of everyday life – light, air, daily work – about forms and colours in light and in shade. It should be taken in piece by piece. The shaded part to the right, beneath the poplar trees, is singularly charming.

Købke was a poet. In 1838 he painted *A View of One of the Lakes in Copenhagen* (cat. no. 63), based on a small painted sketch and some drawings, having changed the sketch through the addition of the girls on the bridge, the flag on the mast and the boat on the lake. It is a tale of serene, joyful expectation; the flag, the only thing in motion in the picture, is an echo of the girls' stirred hearts.

Here we have the "solemn calm" that a contemporary philosopher mentions as the mark of his much-admired C. D. Friedrich, whose style was visibly to impress younger artists around 1840. Købke and others were to transform it according to the traditions of their school and the contemporary tendency towards a more down-to-earth "poetic realism".

In 1838 Købke left for Italy. It was not so much Rome as Naples which by now was a favourite with artists and the public. He copied antique murals and made painted studies for a series of pictures of Capri that he was planning. Before his departure, he had prepared by copying his compatriots' paintings of the island. The final result was a number of large, romantic pictures with a lot of blue. One of them was intended to win him membership of the Academy, but was rejected. This shouldn't have happened, although the picture was, indeed, bad. In general he painted several less successful works during these years. He seemed to lack energy when working on large paintings.

On the other hand, a number of studies from these last years of his life show that his gift for seeing and experiencing was undiminished; indeed that he was more receptive than ever to the stirring light, the drifting clouds, the poetry of pure, living nature. Thus, at the age of thirty-seven, he took leave of this world, with credit.

DEAR DENMARK

We are nearing the end of our saga of the Golden Age. If we must pin its close down to a particular year, it will have to be 1848 – a memorable year in European politics as well as on the domestic scene. In Copenhagen, Christiansborg Palace had been built for the second time, and here the last, stunted shoot on the old royal stem granted a new and free constitution, under much pressure and amid popular rejoicing.

In the same year, the Germans in the southern part of the realm started a rebellion which was fought down after three years of civil war. But this didn't result in peace; the period was marked by tension and fanaticism. A new wave of nationalism emerged, and painters had the task of giving it visual expression. In 1844 one philosophical art critic declared: "Art does not mimic nature; a work of art to the greatest possible extent produces the ideal." This ideal was love of one's country, and it involved the description of typically Danish nature and typically Danish people; painters were meant to portray the Danish national spirit – heightened and purified. That, as well as "the Nordic spirit" in general, was marked by "a serene depth, innocence, simplicity, chastity and power". Nations further south, on the other hand, were "fundamentally depraved, insidious and cruel, and lacking in honesty and conscience" (V. Vedel, 1890, quoting respectively a poet and a bishop).

Christen Købke died in 1848. Patriots had pinned their hopes on him, but he had turned somewhat renegade, had gone abroad, and after his return home he had painted big, blue pictures of Capri instead of using his talents in the description of nature in his homeland.

The patriots' spokesman in the field of art declared in 1844 that it was a question of "minting the Nordic spirit in stone and colour". It was no longer a matter of "the

preference and inclination of the individual, but of that desire in which we all unite, and in whose satisfaction we all find common joy". But there's a long way to go: "Look at our exhibitions! Almost everything places domestic life first, retiring into a shell instead of opening up the heart to great, inspiring and communal delights."

This rallying call was accompanied by a strict policy of favouritism. The rejection of Købke by the Academy may have been a simple example of this, or perhaps was prompted by some kind of revenge. Young artists, however, rallied to the flag. One of them was Johan Thomas Lundbye, a new favourite with the patriots, a fine and full-blooded artist of nervous disposition, and an almost maniacally untiring writer of diaries, letters and of personal confessions in which truth and fabrications are hard to distinguish. He also wrote manifestos and declarations for which he himself supplied the sole audience. In 1842, for example, he wrote: "As a painter, I have made it my aim to paint our beloved Denmark, in all its simplicity and modesty – what beauty is to be seen in the fine lines of our hills, so delicately undulating . . ." It seems that he wanted to express classical ideals in the national landscape with the emphasis on "grace" in the Raphael sense. And grace is what marks the landscapes which he conceived on the lines of the nationalist manifesto, such as *Open Country in the North of Zealand*, 1842 (cat. no. 69). It was based on a number of studies and sketches; and constructed through long, lingering rhythms in the lines of the landscape and their echo, the clouds; as well as the vast space with the wide view and the steeple of the village church in the distance.

Lundbye knew Købke quite well, but felt that the eight years separating them was "a distancing difference in age". But he admired Købke as a painter, a fact which shows in his studies and sketches. Among these we have the picture (1837) of the strange twelfth-century church with five towers, in Kalundborg (cat. no. 68). It shows only four, the fifth one having collapsed ten years before. To his diary he confided the secret that he "loved to play about with the rich oil colours". It was almost as though it was indecent to show in public the results of this sensuous delight. His finished pictures were always covered with the softening veil of idealism, called in later and more brutal times "dryness". His *Open Country* gives us Paradise in the summer costume of the beloved motherland; the distant church steeple evokes memories of national and Christian history. For him, a landscape preferably called forth historical associations, or was to be perceived through them. "Nature cannot awaken mankind, it awaits the magic word of deliverance in order to appear in its full meaning" (H. Steffens: *Der Schlossbrand*, 1827). Alexander Pope described the Forest of Windsor as the place where great kings were born, and where the oaks in the forest became timber for the English navy. How was he to know that England, for instance in Copenhagen in 1807, would sustain herself in other ways?

The conquest of the landscape was triggered off by historical castles and palaces,

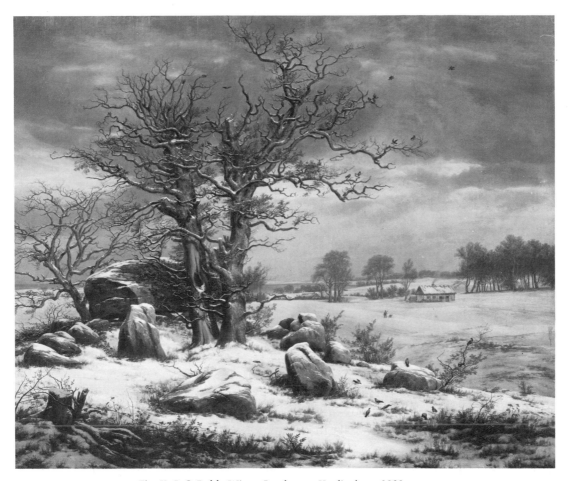

Fig. X J. C. Dahl: *Winter Landscape, Vordingborg*, 1829

old churches and ancient monuments. In England Salisbury Cathedral and Stonehenge were the famous monuments that the painter illuminated historically with his constantly changing light. In the Nordic countries we find something similar. As early as 1750 a modest view-painter had decided to give his pictures an added interest by placing an unspecific cairn in an appropriate place. The same artist painted Roskilde Cathedral in twilight with dark clouds; the tombs of old kings!

The true pioneer of the romantic landscape was J. C. Dahl; he did in fact paint Roskilde Cathedral and Frederiksborg Castle, both in moonlight and twilight; in 1830, he exhibited a monumental picture, with an ancient burial mound, snow and the darkness of winter (fig. X). This made a great impression on young painters. Lundbye took up the idea, using a cairn as the central motif in an 1839 landscape now in the Thorvaldsen Museum. This and other similar pictures constitute the Nordic version of heroic classical landscape painting – with ancient ruins, herdsmen and cattle. Lundbye also let sheep settle on an ancient burial mound. Around 1840 he painted a number of solemn landscapes with endless views, and with distorted perspectives which allow hills to attain the scale of mountains and convert bays into oceans. In 1842 he painted a very large picture, from a drawing by P. C. Skovgaard, of the medieval castle tower in the town of Vordingborg, seen in a looming perspective so as to make it appear impressively tall. Black birds flutter about the cap of the tower, while the houses, people and animals at its foot have been made very small, as though

Fig. XI J. Th. Lundbye: *The Goose Tower in Vordingborg*, 1842

they were under pressure from the beating of history's mighty wings (fig. XI).

Lundbye and Skovgaard were best friends, although very different. Lundbye was a neurotic, intellectual doubter, Skovgaard more robust. Lundbye praised him for possessing the courage which he felt he himself lacked.

One of Skovgaard's early pictures, from 1839, is a landscape with a subject from the then deserted, wild and unknown northern Zealand. It speaks for itself, with its low, overcast sky above the windswept forest – the only living creature being a fox. Here, the spirit of Ossian stirs once more, but then it drifted westwards and made its mark on Dankvart Dreyer's landscapes from Jutland. He also ventured out to the rough and wild North Sea coast, an expedition with so many hardships that it is hard to imagine today. He was succeeded by the slightly younger Vilhelm Kyhn who outlived them all and remained loyal to the ideals of his youth until the very end.

Skovgaard, on the other hand, turned monumental, with big luxuriant and paradisical forest pictures, with trees like columns and vaults in the cathedral of nature: Here, the "organ tone" or "sound of the harp" that Lundbye often talked of, was heard. Here, "the heart is opened to great, inspiring and communal delights."

Lundbye was abroad in 1845 and 1846, travelling in Switzerland and Italy, in spite of frowns from the patriots. According to them it was necessary to stay at home

in order that one's pure, Nordic soul remain untainted, otherwise one might lose it completely. But he resisted them and kept an extensive diary of the journey. He had a more than pleasant time but was also very homesick.

Generally speaking, he was a complex character, doomed to introspection and to the cultivation of his fear, his melancholy, his pietistic heritage and his urge for self-denial. In all this he was influenced by his compatriot and fellow citizen of Copenhagen, Søren Kierkegaard. He knew him as the great "peripatetic", glimpsing him in arcades if they happened to be at hand, otherwise in the narrow streets and the finer cafés of the town. Lundbye drew him wandering about in this manner; the drawing is not good, and neither Lundbye nor anyone else ever drew or painted his portrait satisfactorily.

Lundbye read a great deal, and the works of Kierkegaard were part of his reading. Mentioned in his diaries, they probably contributed to his cautious retreat from the patriotic movement and from its spokesman in the field of art, N. L. Høyen. Lundbye himself tells how he had for a time considered him an oracle, and then came to ask why every word from his lips should be the real and the only truth. In his entry for 16 December 1844, directly inspired by Kierkegaard's first major work (published in 1843), he wrote that he now faced "the great Either – Or", the choice being far simpler in theory than in practice; the next time he drank wine, he said, he would drink to the New Year's resolution that he might have the courage to choose, and to choose himself, "as Søren says".

Lundbye became a victim of the national choice in 1848 opting to fight the rebellion with arms. He was among the many who died. Købke died the same year, and with that some of the glitter left the gold.

THE DANISH ACHIEVEMENT IN PAINTING: THE VIEW FROM BRITAIN

ALISTAIR SMITH

Danish Golden Age painting is not well known outside its own country. There is very little published on the subject in English. This lacuna is not the result of any lack of quality in the paintings themselves but is rather an example of the way that, in the world of art, certain areas can be overlooked for a time. Because of Denmark's relative isolation, the painters of the Golden Age had little influence beyond their own country and it is perhaps for this reason that they have not yet received their full place in general histories of nineteenth-century art.

Just as this exhibition aims to provide for the British public a sample of the Danish achievement, so this essay hopes to make clear, if in brief, the main characteristics of the school, as seen from this side of the North Sea.

* * *

"A conscientious observation of the Fine Arts now appeared to be desirable, and I set forth early to inspect all the recommended objects. The pictures were (in 1872) scattered over various places, but the most notable were preserved in the Royal Cabinet of the Palace of Christiansborg . . . I passed the Rubenses and Rembrandts to reach the Danish school, curious above all to trace the national development in the home product. *There seemed to have been no painting of any importance or true Danish character until the nineteenth century.*"

When describing his visits to Denmark in 1872 and 1874, Edmund Gosse, Britain's best known Scandophile of the nineteenth century, opened his account of the country's paintings with the above passage. He went on to mention four painters by name – Eckersberg ("a sound, humdrum, prosy master"), Marstrand ("a more impetuous spirit"), Jørgen Sonne and Niels Simonsen, "all notable in the history of Danish art, but they hardly touch the field of Europe". In other parts of his account he mentions Abildgaard, Lundbye, Skovgaard, Julius Exner, Wilhelm Melbye, P. S. Krøyer, the sculptors Bissen and Jerichau, and, naturally, Thorvaldsen, Denmark's international success of the time. No mention of painters more lauded today – no Christen Købke, no Constantin Hansen, no Rørbye, Bendz, Jensen, Roed or Dreyer, and no mention of the *Golden Age* by name (for reasons which Henrik Bramsen gives). Yet, despite the fact that the twentieth century reveres different artists, Gosse's main point has been consolidated, namely that it was in the early part of the nineteenth century that the Danish school achieved itself.

By today's standards, Gosse's most obvious omission is Christen Købke, now recognised as the best Danish painter of the period. Købke, however, commanded no great reputation in Danish cultural circles until around 1900 and only four paintings by him were in the Royal Cabinet when Gosse made his 1872 visit. One of them, *A View of One of the Lakes in Copenhagen* (cat. no. 63), was his first painting to become an "official purchase". Its treatment, after acquisition for the publicly displayed Royal

Collection, interestingly exemplifies some of the attitudes of the Danish Golden Age.

Bought in 1839, from the Academy exhibition of that year, the reigning monarch, Christian VIII, had it withdrawn from public view two years later and kept it thereafter in his private apartments. At this distance in time, it is impossible to analyse precisely the attitudes which resulted in the painting's acquisition and subsequent removal, yet both must have been distinctly coloured by the flag which Købke chose to make a central feature of his scene.

The red flag with the twin tail was in fact the mark of royalty. A decree had been issued in 1834, forbidding its display by unauthorised people. Thus the withdrawal of the painting may have been a form of suppression of a painting which showed the law being broken. Or can we assume that Christian loved the painting and simply wished to have it by him despite its demonstration of misdemeanour?

In any case, the painting has a distinctly narrative purpose, and the flag is a significant part of it. Købke took considerable pains to alter his early studies for the painting in order to enhance its narrative effect. The flag was an addition, and he replaced his original sunny daytime sky with the more pensive aura of late afternoon. On the jetty one woman puts her arm around her companion. The rowing boat seems to waver as it pulls away across the rich melancholy of the lake. A story is there, although deliberately unspecific. It expresses a nationalistic commitment in the quietest, most peaceful way. One could hope for no gentler assertion of love for one's country. Or as Gosse expressed it,

> "In all the collections and exhibitions of current art I could not help noting the discreet and indeed pathetic absence of any harking back upon the incidents of the recent war. In this matter, the contrast between Denmark and France was extremely striking. Hardly had the heel of the German been lifted from the stained soil of France than the painters and sculptors of the wounded country began to record the most picturesque incidents . . . The Danish tragedy was a more personal affair; it is a shocking thing if a burglar breaks into your house, and shoots your sons while he robs you, but it is not the subject for a painted picture . . . It is thus that we had to interpret the discretion of Danish art . . . Nothing was painted about the disastrous war, because it seemed too unnerving, and also, in a sense, too private."

Gosse was referring to Denmark's second war with Germany, of 1864, but he might have made the same observation about the disastrous episode in naval history in 1801 known to the British as The Battle of Copenhagen, or the subsequent British bombardment of the capital in 1807; or any number of smaller tragedies of the time, which did, in fact, receive overt expression in paintings but in such a manner that these paintings are today seen to be of little distinction. By some peculiar law of paradox, this desperate era has come to be known as the Golden Age and its paintings

exhibit, in the main, tranquillity, and an almost rhapsodic lyricism. They are images of wish-fulfilment, rather than documents of a peaceful haven in the midst of European upheavals.

Købke's painting, one of those which made a discreet nationalist reference, was accorded a review which emphasised its formal features rather than its narrative: "The calm summer's evening is splendidly expressed . . . it is all a charming idyll, at which we are pleased to linger."

It is instructive to recall a comparable painting by Caspar David Friedrich, the German Romantic artist who attended the Copenhagen Academy from 1794 to 1798 (fig. XII). His painting was conceived as an allegory of death. "The mist represents the enigma of death. The light which penetrates the mist is an expression of hope."

Købke's painting does not aim at the transcendental. It refers to grand issues only by implication. Its expression is of this world, which it renders with intensity and glamour. Without underestimating the story-telling element in this particular painting, it is true to say that narrative significance is not the essence of Danish Golden Age painting. Compared with their contemporaries, the Danish painters are more prosaic, their art based more on technique than idea. It is in the examination of the procedure of the originator of the school that the key to their art is found.

* * *

Eckersberg is easily seen as a father figure, since many of the Golden Age artists were his pupils. Yet he should also be recognised as something of a revolutionary, for he came to reject the mythological subject-matter of Abildgaard together with his style. Often described as being a "matter-of-fact" realist, when compared with the stylistic excesses of Abildgaard he is indeed so. Yet the time he took to paint a "natural" view like that of *Kronborg Castle* (cat no. 17) – only completed three years after his first study was made – shows that his procedure was almost equally artificial. As a result his paintings invariably have the polished, severe elegance of a piece of twentieth-century Danish design.

Eckersberg was trained as a history painter. Thus he was technically equipped to paint large compositions in which the figures would act out an allegory, the main weapons in his armoury being a command of the life model, and of perspective. Unsuited to history painting, as much by temperament as anything else, he found that these techniques stood him in good stead in other genres.

Interested in the particular rather than the general, he enjoyed the study of reality rather than the construction of abstractions, and in Rome he came to make what are the first true works of the Golden Age – small, highly lit studies of particular locations (cat. nos. 8 & 9). To create them, he made sketches on site, then developed the finished paintings in the studio, perhaps completing them on site. Significantly he applied

Fig. XII C. D. Friedrich: *Mist*, 1807

to these small paintings the compositional planning that was normally needed to organise vast acres of fresco. The harmony of proportion which the spectator feels in the face of an Eckersberg, the refined sense of interval which is so often uppermost in his views, are the result of the application of monumental techniques to miniature painting. Recently, it has been shown that Eckersberg carefully based his drawings on various proportional devices – despite his advice to "paint only what is there".

Eckersberg invariably used a miniature execution, in which the brushstrokes are not to be seen. This allows his forms greater emphasis, as does the high tone, which he discovered in the strong sunlight of Italy, and which he later perceived by the sea in Denmark. The strong colour aids the sense of a "hard-edge" composition. The effect is rather like that of predella panels of the Italian Renaissance – small, highly organised compositions in bright hues, with a considerable sense of the monumental.

Eckersberg's framing of a scene was individual and crucial. A painting like *The Starboard Battery and Deck of the Corvette "Najaden"* (cat. no. 20) produces the sense of a photographic "close-up" although it was painted in 1833, some years before the first photographic image was made permanent. It is quite possible that Eckersberg used some form of lens with which to focus on his motif – or that he employed a perspective-octant. The effect of both would be to truncate objects at the edge of the field of view, producing the impression that the artist had not laboured to decide on the most appropriate viewpoint, but had "seized" the scene almost at first sight. It produces not only a novel composition but a sense of informality and "immediacy".

The perspectival expression of *The Starboard Battery* can similarly be seen as "photographic". The tunnelling recession is the type of exaggerated effect which the photographic lens made visible to all. More important, however, is the suppression of all narrative, psychology and poetry, which reminds one of the working of the machine rather than the man. For an artist trained in the conventions of history

Fig. XIII P. H. de Valenciennes: *Sky Study at the Piazza del Quirinale, Rome*, 1790

painting, with its central supposition about drama and personification, it was a work of considerable invention to reject the one and discover the other. Eckersberg's paintings lack overt passion, avoid directly stated emotion. It is perhaps this emphasis on formal rather than emotional values that makes one feel that they possess a distinctly "modern" cast – that abstract values are uppermost.

Eckersberg established what can now be recognised as the speciality of the Golden Age: small-scale "sketches" with unusual perspective effects, rendered in high tones. A glance through the catalogue will suffice to show how many works of the period come into this category, the influence on Købke and Constantin Hansen being particularly obvious.

While rejoicing in Eckersberg's inventiveness and originality, we should be aware that he was working within a context, was very much part of his time. Comparisons have been made between his work and that of Pierre Henry de Valenciennes (fig. XIII); Købke could also be mentioned (cat. no. 54). As Kasper Monrad relates (see cat. no. 10), it is not known whether Eckersberg could have seen the Frenchman's small, fresh oil sketches, made in Rome in about 1790. Similarly, it is impossible to prove a positive link between Eckersberg's *Corvette on the Stocks* (cat. no. 16) and an astonishingly similar drawing by Corot (fig. XIV). Corot's works share several features with those of the Golden Age artists, yet it is hard to establish any precise connection.

Ultimately, one has to conceive of Rome as a great melting-pot in which the ideas exemplified by Valenciennes remained to influence Eckersberg. Thus although Eckersberg did not invent the outdoor oil sketch, he refined it and perfected a type of small-scale painting, similar in size to a sketch, which exhibits a crystalline precision abetted by daring colour contrasts.

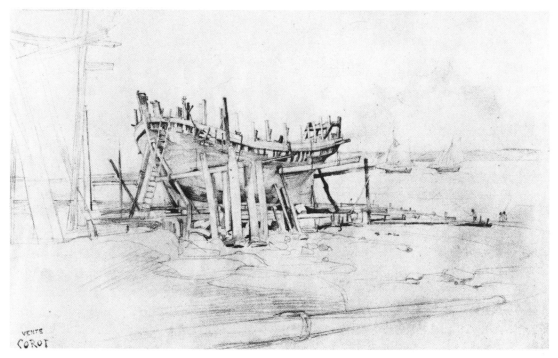

Fig. XIV J-B-C. Corot: *Boatyard at the Harbour Entrance, Trouville*, 1829

His place in history is as a teacher as much as an artist. He taught his followers perspective, and took them sketching out of doors – two things which were to become central to their work. Constantin Hansen's *Arch of Titus* (cat. no. 31) is a prime example of the work of the Eckersberg pupils. Sensitised to the importance of viewpoint, Hansen selected one which shows less of the arch's detail than would almost any other. While reducing the amount of documentation in the painting, it simultaneously increases the sense that we are witnessing the artist's own individual response. It conveys the feeling that he has stumbled into the Forum and noted his first astonished reaction to the scene from the angle which was immediately presented to him. If he documents anything it is temperature. The painting exudes heat like a cake fresh from the oven. Hansen's high tone and treatment of the effects of light have resulted in his sketches being hailed as precursors of Impressionism.

In his small sketches, his handling of paint is looser than that of his teacher, the impasto of highlights being visible. This more varied use of the brush produces an animated effect. This is an important feature of the works of the period. Such paintings by Hansen, Købke, Roed and Bendz possess great immediacy and freshness, conveying a sense of happy, inspired reaction to the motif – a feeling that they gloried in that segment of the world that they were painting.

Their ability to convey the glamour of buildings made them attractive to N. L. Høyen and others who conceived a longing to see the Danish Middle Ages revitalised in their works. Unlike the English Pre-Raphaelite Brotherhood, however, it was not the themes of the Middle Ages which they were exhorted to treat but rather its architecture (cat. nos. 37 & 48). The vivacity of Købke's colour and brush produced dazzling little works, sadly ignored in his own time, which favoured larger, more finished things. His small studies are nowadays much preferred to the larger end

products, but it was only late in the century that their quality was recognised. An analogy can be drawn with the way that Constable's sketches gradually came to be more greatly prized than his finished works.

Now recognised as the supreme Golden Age painter, Købke was conspicuously the period's most adventurous colourist, employing contrasts involving large masses of bright colour, often some variation on pink or red. His little painting of *Ida Thiele* (cat. no. 51) demonstrates this most clearly. Like Jensen, Købke realised the power that both the colour mass and the brushstroke could carry in a small painting. In Jensen's portraits we find amazing constructions – the hats of Freund (cat. no. 21) and Birgitte Hohlenberg (cat. no. 23). His clearly visible brushstrokes command greater areas of the canvas than they could in any larger work and the animation of Birgitte's image is partly achieved in this manner. Similarly, in his *Portrait of Ida Thiele*, Købke's technique reaches heights of daring and individuality in the freedom and beauty with which the girl's dress and head are constructed.

The subject-matter to which the Golden Age painters applied their art is also important to its final effect. As Edmund Gosse remarked, they shun heroics. With equal finality, they turned away from all mythology, concentrating on what they could actually see. Their subjects include landscape, seascape, architecture, the portrait and genre, all of them becoming tinged with the character of the last named. The landscapes of Lundbye and Skovgaard, while infused with an atmosphere of excitement, are as hospitable as an interior. Their nature does not terrify. While the open spaces are lent a spirit of gentleness, homely surroundings are seen to possess magic. The simplest everyday action (cat. no. 50) is purified and its significance heightened. It might be said that the Golden Age painters in their concentration on the everyday and humdrum gave a distorted picture of their time. Equally they might be seen to have concentrated on the essential, eternal aspects of life. The mark of good art is to make us see the familiar in a fresh way. Købke transforms familiar subject-matter for us – whether genre (his sister knitting), portrait (his friend Sødring) or landscape (his father's house). We can be grateful for the truthfulness inherent in his vision. He painted the things closest to him and painted them well.

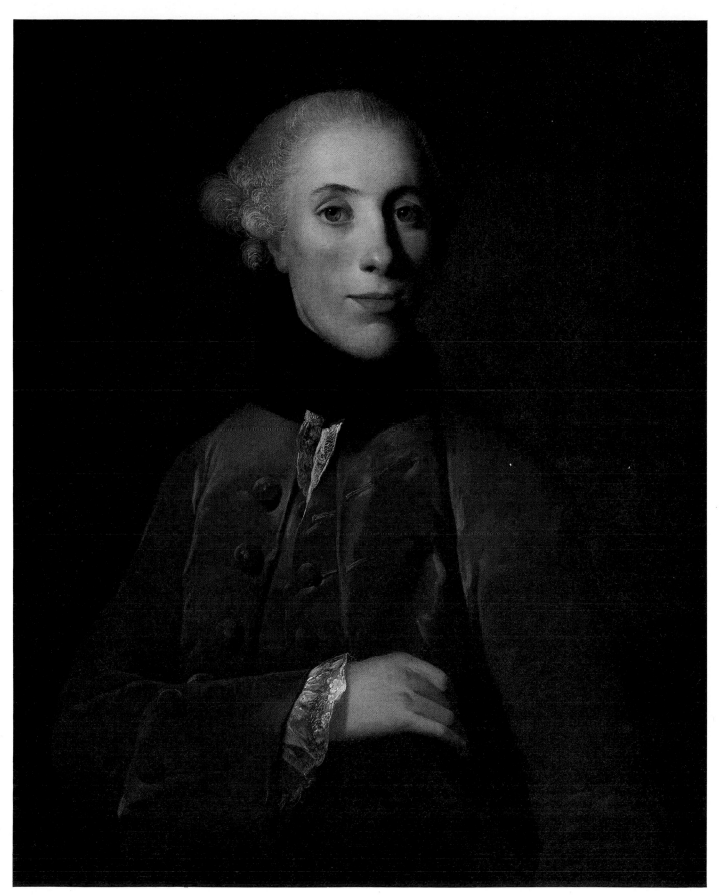

1 Jens Juel *The Court Seal Engraver Ahron Jacobson* (1767)

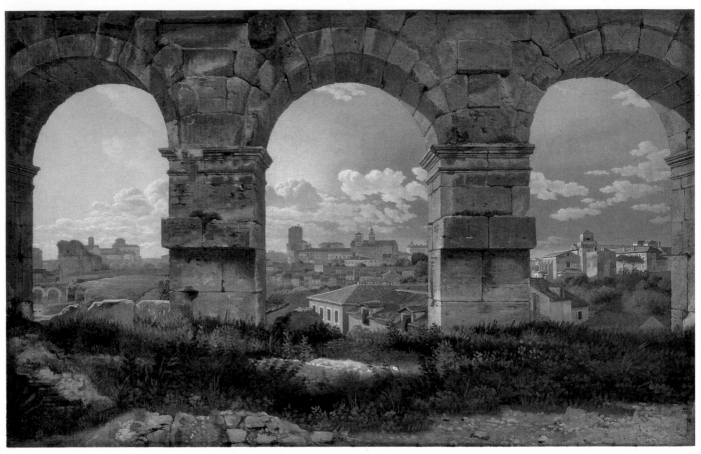

11 C. W. Eckersberg *A View through Three of the North-western Arches of the Third Storey of the Colosseum* (1815 or 1816)

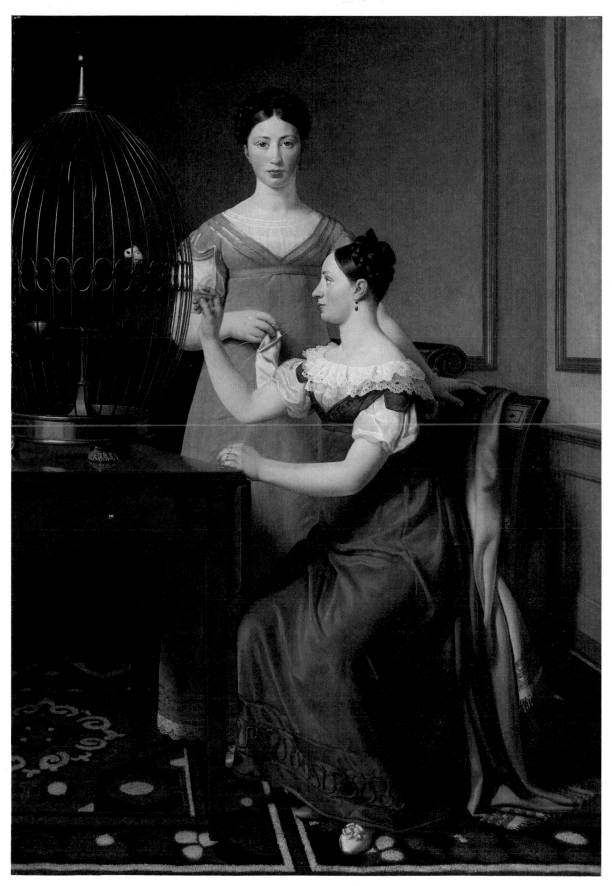

13 C. W. Eckersberg *Bella and Hanna. The eldest Daughters of M. L. Nathanson* (1820)

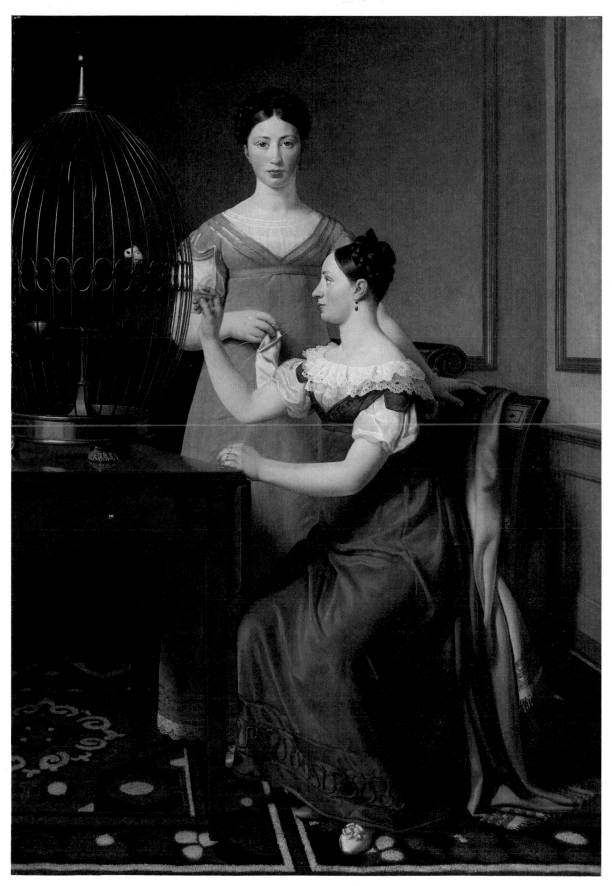

13 C. W. Eckersberg *Bella and Hanna. The eldest Daughters of M. L. Nathanson* (1820)

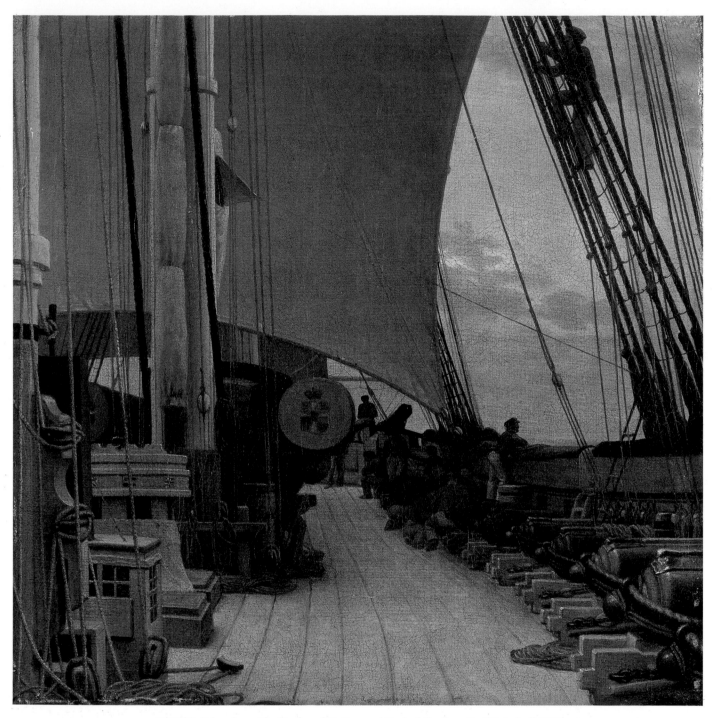

20 C. W. Eckersberg *The Starboard Battery and Deck of the Corvette "Najaden"* 1833

23 Christian Jensen *Birgitte Søbøtker Hohlenberg, née Malling* 1826

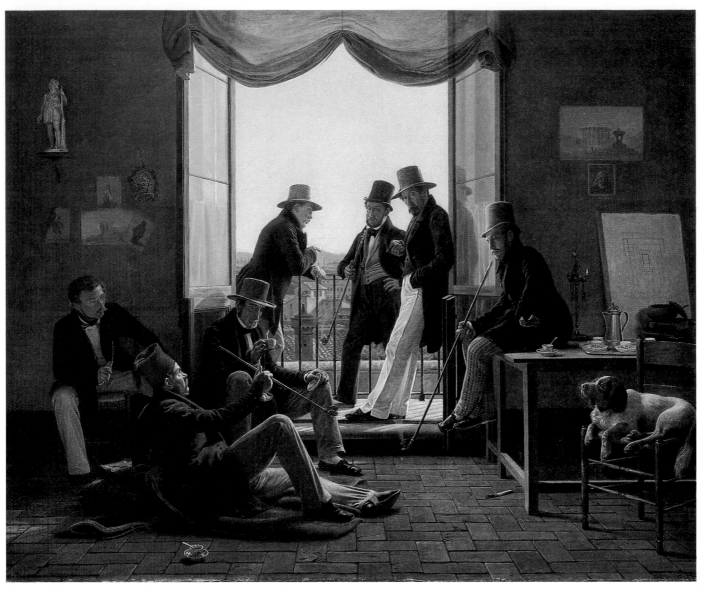

29 Constantin Hansen *A Group of Danish Artists in Rome* 1837

31 Constantin Hansen *The Arch of Titus in Rome* 1839

32 Constantin Hansen *In the Gardens of the Villa Albani* (1841)

39 Jørgen Roed *The so-called Temple of Poseidon at Paestum* 1838

43 Wilhelm Marstrand *The Waagepetersen Family* (1836)

46 Martinus Rørbye *Greeks working in the Ruins of the Acropolis* (1835)

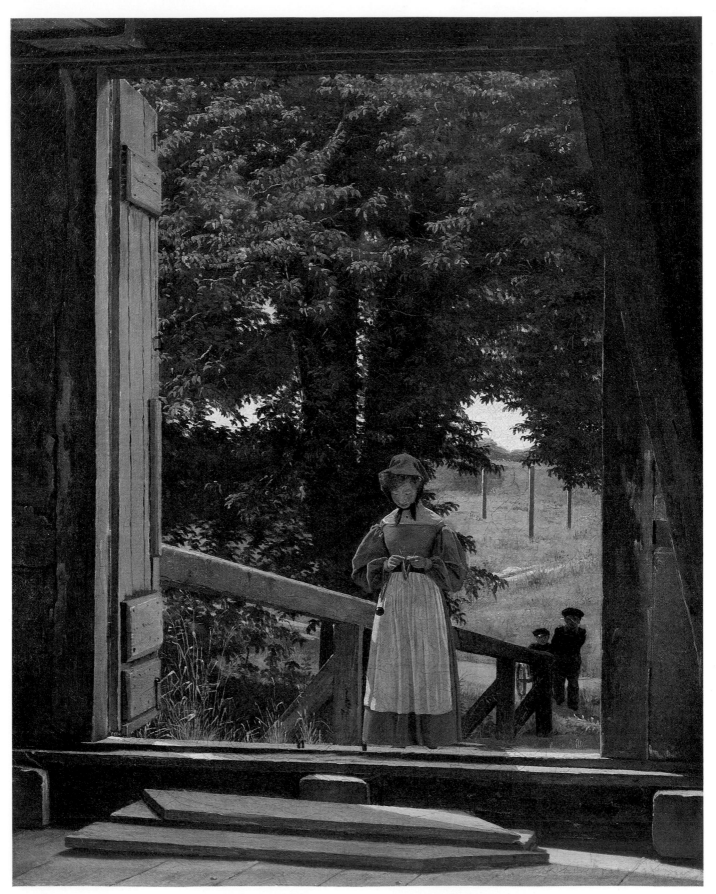

50 Christen Købke *A View from a Store-House in the Citadel of Copenhagen* 1831

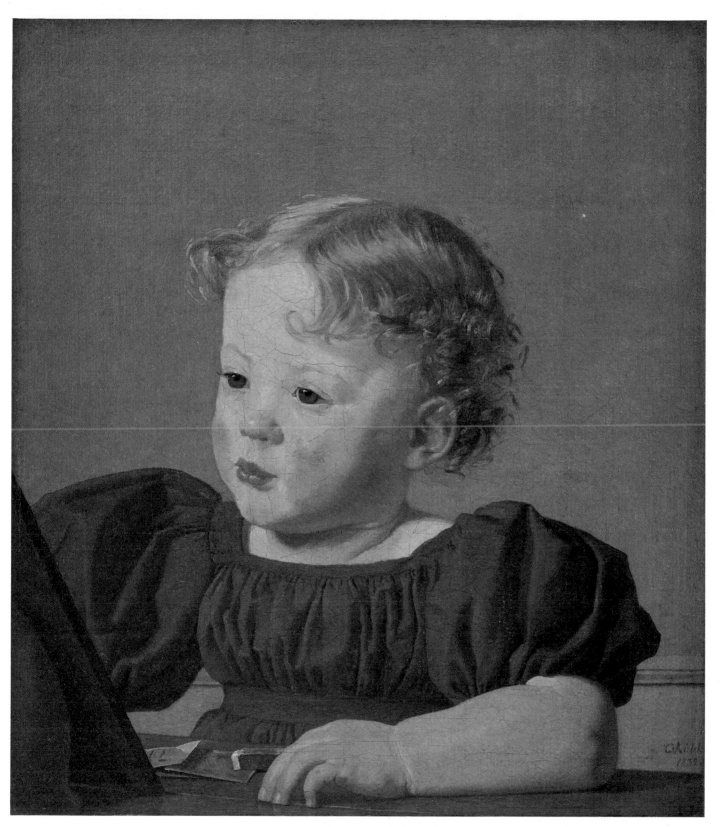

51 Christen Købke *Portrait of Ida Thiele* 1832

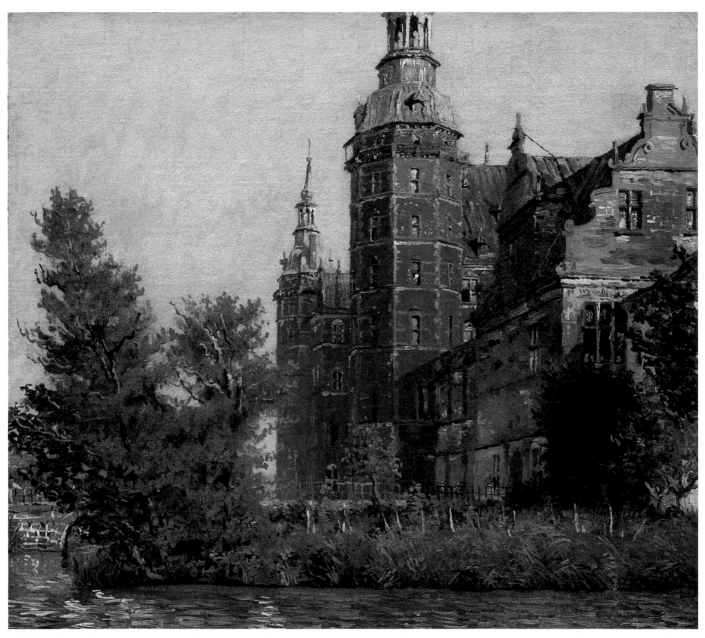

59 Christen Købke *Frederiksborg Castle seen from the North West. Study* 1835

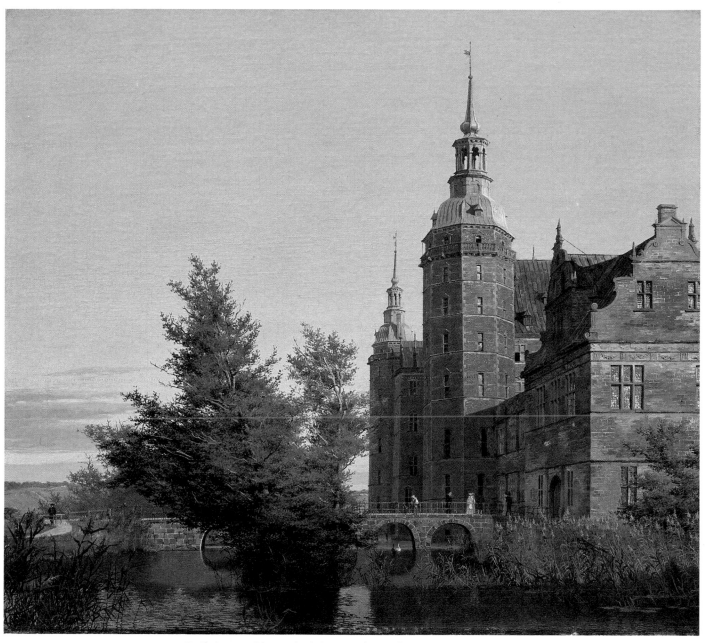

60 Christen Købke *Frederiksborg Castle seen from the North West* 1836

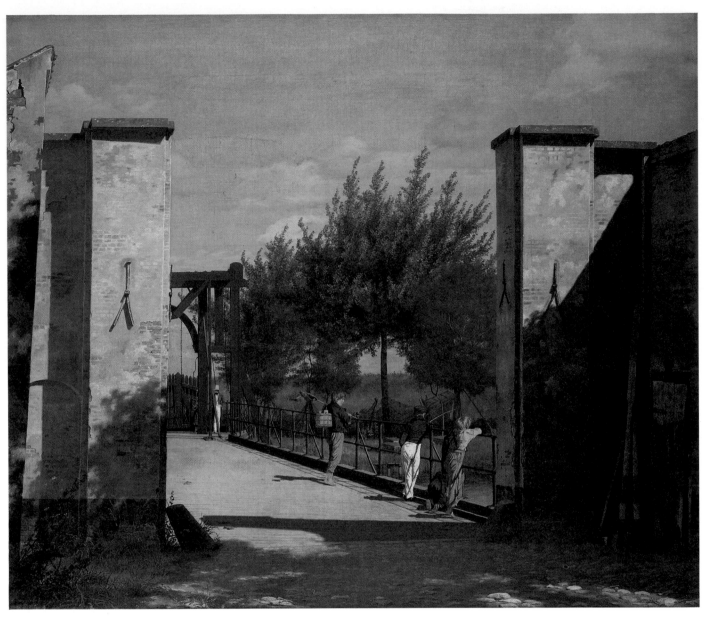

55 Christen Købke *The North Gate of the Citadel* 1834

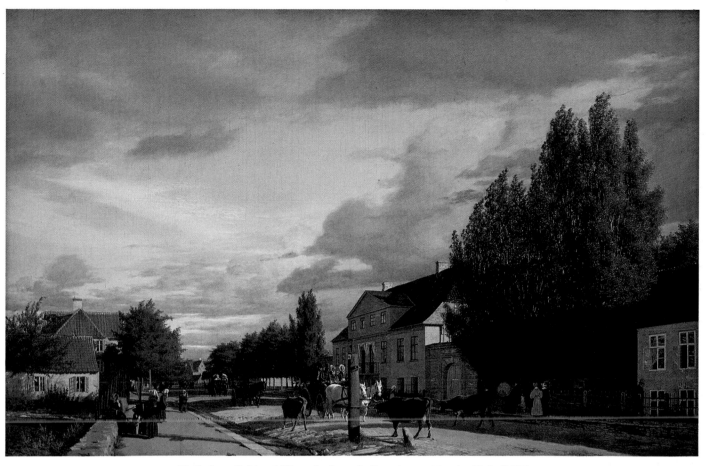

61 Christen Købke *A View of a Street in Copenhagen, Morning Light* (1836)

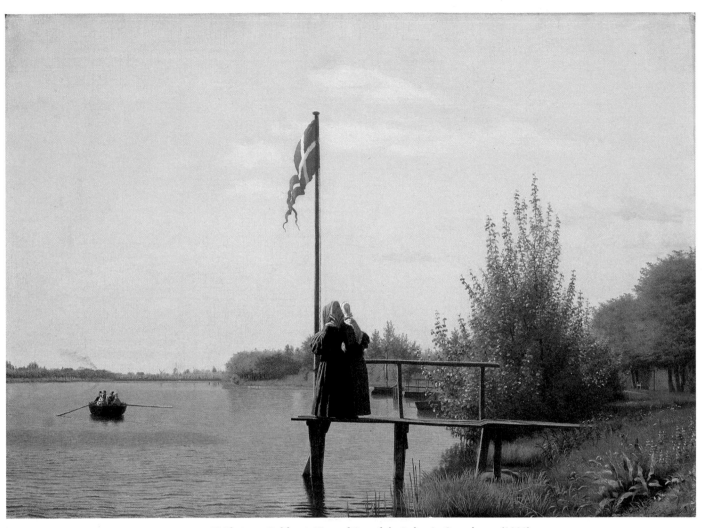

63 Christen Købke *A View of One of the Lakes in Copenhagen* (1838)

66 Christen Købke *The Garden Staircase to the Artist's Studio in his Father's House* (About 1845)

70 J. Th. Lundbye *Cows being Watered at a Village Pond, Brofelde* 1844

73 P. C. Skovgaard *An Oat Field* 1843

74 P. C. Skovgaard *View from the Artist's Dwelling in Copenhagen on a Winter Day* 1854

76 Dankvart Dreyer *A Footbridge over a Brook in Assens, Funen* (1842)

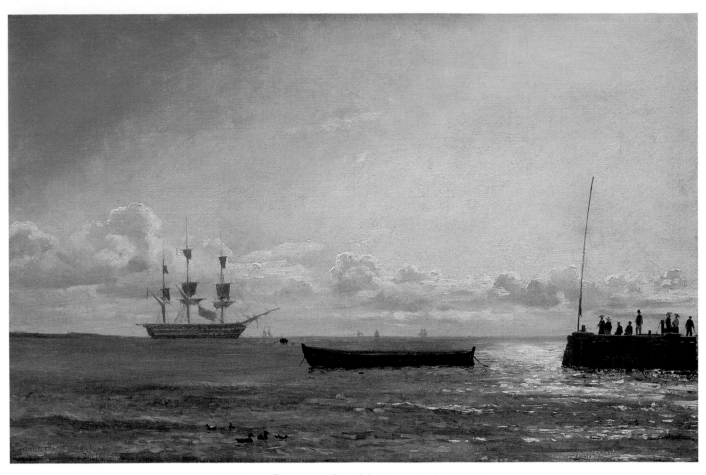

81 Emanuel Larsen *A Ship of the Line at Anchor* (1847)

CATALOGUE

KASPER MONRAD

Dates of paintings given in brackets are those deducible from various sources
Dates without brackets result from inscriptions on the paintings
Literary references are restricted to standard works
and to publications in English and other non-Scandinavian languages

Jens Juel: *Self-Portrait, c 1773–74*

JENS JUEL 1745–1802

Jens Juel stands as the first Danish painter to break away from the rococo style. His elegant yet matter-of-fact realism heralds the Golden Age. The most prominent portrait painter in the latter half of the eighteenth century, he also won importance as a landscape painter.

Juel had his first education as an artist in the commercial town of Hamburg, around 1760–5. He was thoroughly trained in the tradition of seventeenth-century Dutch realism, which was to have a decisive influence on him. In many ways he had already completed his training by the time he was admitted to the Academy in Copenhagen around 1765–6, and he was soon spending more time painting portraits of middle-class citizens than attending classes at the Academy.

By 1770, he was well on his way to becoming the favourite portrait painter of the aristocracy, and it was thanks to funds from a number of titled ladies that he was able to embark on his Grand Tour in 1772. Rome was his destination, and he reached it in 1774 after stops in Hamburg and Dresden. In 1776 he went to Paris, intending to make the journey to Denmark via Switzerland. In fact, he stayed in Geneva for three years, being occupied with portraits of the circle around Charles Bonnet, the natural scientist.

On his return to Copenhagen in 1780 Juel was very much in demand. Almost all his sitters were from the aristocracy and royalty, and only during the economic boom of the 1790s did he once more paint townspeople. Just about every person of influence was portrayed by Juel, his studio being ironically dubbed by his contemporaries "Juel's portrait factory". He taught at the Academy from 1784, becoming a professor in 1786, but he had no students of importance except for the German painters Caspar David Friedrich (student at the Academy 1794–8) and Philip Otto Runge (who was in Copenhagen from 1799 to 1801).

Juel's development as an artist was very much influenced by the nature of his clientele. His middle-class portraits from the latter part of the 1760s are evidently influenced by realism in Dutch seventeenth-century painting, and also by Chardin. His portraits of the nobility from the years around 1770 are, on the other hand, more rococo in inspiration. The increasing realism in his work after 1780 reflects not only the effects of his travel abroad, but also the intensifying influence of the middle class in Danish society. He showed a great ability to adapt his art to new currents.

Juel's importance for painters of the Golden Age was clearly demonstrated when, in 1828, the opening exhibition of the *Kunstforening* (the Copenhagen society for the organisation of art exhibitions) showed a large selection of his paintings. In the catalogue for this exhibition N. L. Høyen, the most influential art historian of the time, wrote: "The extent to which he was a favourite of his contemporaries is evidenced by the number of his works that are to be found everywhere, and he was undoubtedly much deserving of this popularity. As an artist, he was a true child of nature, although not always able to avoid being influenced by the style of his time. In general, his precise vision and his healthy and fine feeling for Nature truly showed that he was born to be an artist."

REFERENCES: Ellen Poulsen: *Jens Juel*. Copenhagen, 1961
Ellen Poulsen: "Jens Juel. Master Portrait Painter", in *The Connoisseur*, February 1962, pp. 70–5

1 The Court Seal Engraver Ahron Jacobson (1767)

Canvas, 77 × 61.5 cm
S.M.f.K., no. 4508a
Illustrated in colour page 49

With a look which is self-conscious and slightly distant at the same time, Ahron Jacobson gazes directly at the spectator. He was Court Seal Engraver, and Juel's painting shows him as an affable and smooth courtier, keeping his innermost thoughts to himself.

Ahron Jacobson (*c* 1717 – 1775) was of Jewish stock, born in Hamburg. He immigrated to Copenhagen about 1740 and was much in demand as a medallist. In 1749 the king appointed him Court Seal Engraver.

Both the composition of the picture and the artistic treatment show clarity and simplicity. Juel has not accounted for the man's surroundings, but by not shrouding him in mists the artist has departed from the convention of rococo portraiture, which at the time was still dominant in Denmark. Juel rarely offered a searching interpretation of character in his invariably kind portraits, but here he has successfully caught something of Jacobson's inscrutable nature. In 1941 the Danish art historian Christian Elling offered this description of the painting: "The facial expression is characterised with a uniquely clear-sighted certainty. The oddly catlike face with slightly arched brows and heavy-lidded, glassy eyes has a look that is both reserved and expectant. Juel's impression of this cautious and haughty man is uncompromisingly direct, and he has given it severe form."

The identity of the sitter is not documented, but has been accepted since the painting appeared in a sale in 1889. Juel is known to have made his models look younger and more handsome than they really were.

2 The Engraver J. F. Clemens (1776)

Canvas, 52.5 × 41.5 cm
S.M.f.K., no. 396

While in Paris in the years 1776–7, Juel met the Danish engraver J. F. Clemens (1748–1831), who had been living there since 1773. Juel painted this portrait of his friend at his workbench. He appears to have been interrupted in his work, holding a copper plate in one hand and an etching needle in the other.

Being an engraver, Clemens was instrumental in the dissemination of art to a wider audience. He engraved a number of reproductions of paintings by Juel and Abildgaard, and, after the turn of the century, also by Eckersberg. He accompanied Juel on his journey to Switzerland in 1777, and was to become, thirty or forty years later, a fatherly friend and adviser to the young Eckersberg.

The portrait of Clemens was very important to Juel. He brought it with him to Switzerland, where it greatly impressed Heinrich Plötz, the miniaturist. "When Plötz saw the three-quarter portrait of Clemens that Juel had painted in Paris, he was so taken by it that he immediately had it set on an easel and showed it to a number of people, and as everybody was delighted with it, Juel was very soon at work and in the most pleasant manner" (Høyen, 1828).

3 Portrait of Mme de Prangins in her Park, 1777

Canvas, 85.5 × 72 cm. Inscribed, bottom right: *Peint par. Juel peintr(e) 177(7)*
S.M.f.K., no. 4810

During a stroll in her park, the Swiss sitter Madame de Prangins is taking a rest on a stone. From here she has a view of the family manor and Lake Geneva.

The painting was done during Juel's three-year stay in Switzerland (1777–9), and shows the great importance of this journey for his art, for here he came in contact with Swiss nature worship. The imposing presence of the Alps had inspired not only the French-Swiss philosopher Jean-Jacques Rousseau, but also a number of his compatriots, among others the natural scientist and philosopher Charles Bonnet and the Alpine explorer Horace-Bénédict de Saussure, both of whom Juel portrayed. (Both paintings are now in the University Library at Geneva.)

Juel was gripped by this new interest in nature. He took up landscape painting in earnest, and excluded from his portraits misty or vague backgrounds, now showing his sitters in close contact with nature.

Madame de Prangins is, for example, completely surrounded by a very detailed description of the majestic trees, twining plants in the grass and the moss on the stones. In composition, Juel might well have been influenced by the English type of portrait which incorporates a landscape background – either through the Italian Pompeo Batoni in Rome, or via engravings of Gainsborough (it is unlikely that he knew the originals).

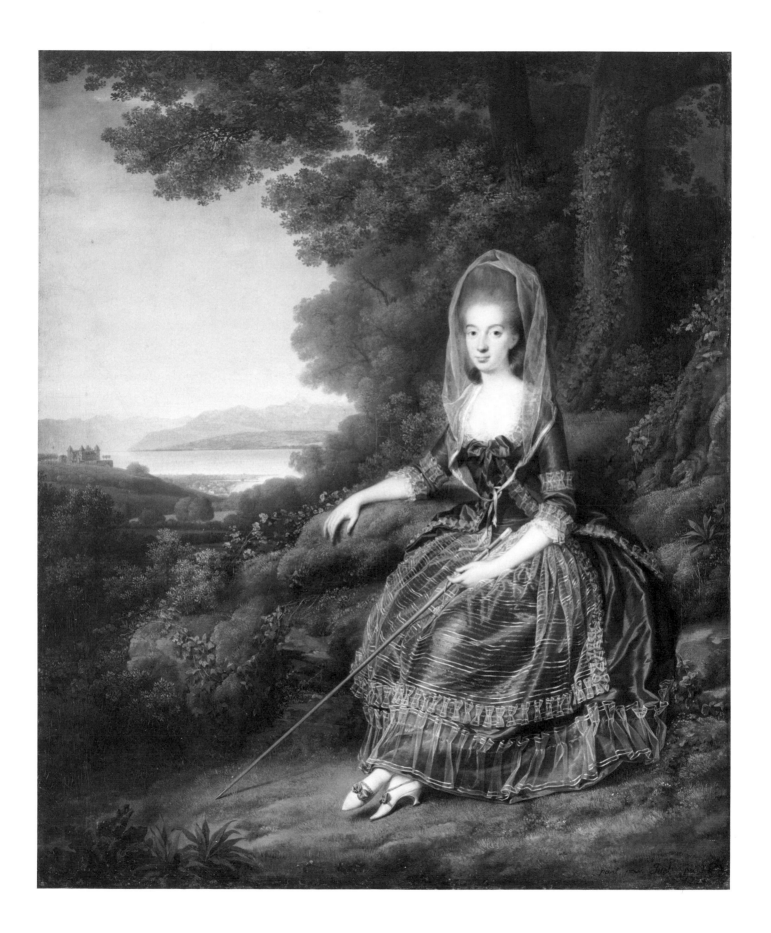

4 A Thunderstorm brewing behind a Farm-House in Zealand (1790s)

Canvas, 43 × 61 cm
S.M.f.K., no. 137

Juel has described a thunderstorm approaching a farm-house a few kilometres north of Copenhagen. Heavy rain clouds are gathering, and a sudden gust of wind shakes the leaves on the trees. A peasant hurries home. The picture reveals a fine ability to register the strange light that precedes a storm.

In the 1790s, in the midst of all his orders for portraits, Juel took up landscape painting seriously "of his own volition and in his own time", as a contemporary put it. There was no tradition of landscape painting in Denmark, and to a great extent Juel had to depend on older, foreign models. This is obvious in many of his early landscapes. But during his stay in Switzerland, in 1777–80, and again in Denmark during the 1790s, he found time to make studies from nature before painting his landscapes. This picture is thus one of the very first Danish landscape paintings in which the description of nature is based on personal experience. At the same time, a dawning Romantic attitude is evident.

The painting may very well have been done while the young German painter, Caspar David Friedrich, was in Copenhagen. It was acquired for the Royal Collection as early as 1829, and its lyrical account of its subject could well have inspired landscape painters of the 1840s such as Lundbye and Skovgaard.

The farmhouse in the picture is known to have been built in connection with an agrarian reform carried out on his estate during the years 1765–7 by Count J. H. E. Bernstorff (1712–72), the Danish Minister of Foreign Affairs. As a part of the effort to make agriculture more efficient and to make it possible for peasants to own their farms, separate fields belonging to the individual peasant were placed together and the farmhouses themselves were moved from the villages to the fields. The count thus anticipated the thorough agrarian reforms carried out in the 1780s and 1790s when his nephew, Count A. P. Bernstorff (1735–97), was Minister of Foreign Affairs.

Juel's wife was the daughter of Count Bernstorff's famous gardener. The painting was done for a landowner in Funen.

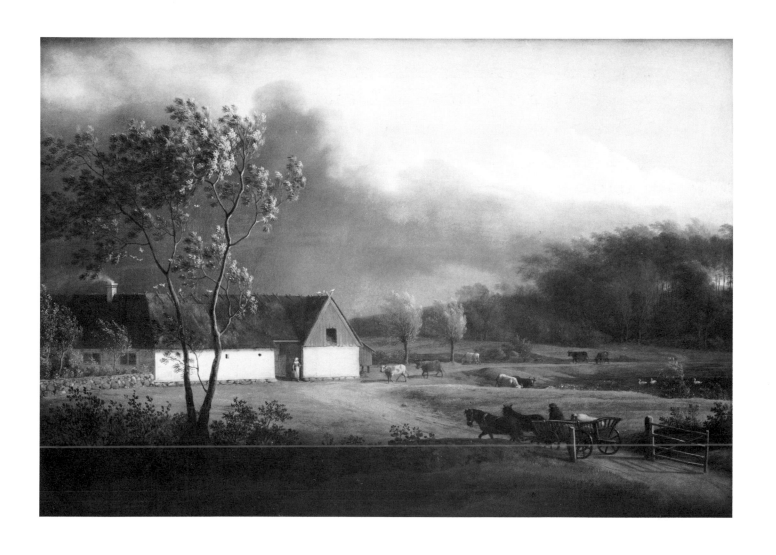

5 A Boy Running, 1802

Canvas, 180.5 × 126 cm. Originally inscribed on the reverse: *J Juel 1802*
S.M.f.K., no. 3635

The young nobleman, Marcus Pauli Karenus Holst von Schmidten, is seen running towards his school, visible in the background. The figure of the boy is moving and at the same time in balance. Moving figures are only rarely found in Juel's later works, but the painter undoubtedly learned from his thorough study of complex figures in ancient art which he made during his Academy years.

Like a number of Juel's late works, this painting has a certain classical quality. The landscape does not surround the person, but forms no more than the background, giving a relief-like touch.

After his return from abroad, Juel was not in direct touch with the international art of the time. Thus he apparently did not have first-hand knowledge of David's portraits. Whatever resemblances might be seen are more due to the general style at the time than to actual influence. On the other hand, Juel may have been introduced to English portraiture through his friend Clemens, who was in London between 1792 and 1795. An etching from Gilbert Stuart's *The Skater* (Washington, National Gallery of Art) could have been the inspiration for this picture.

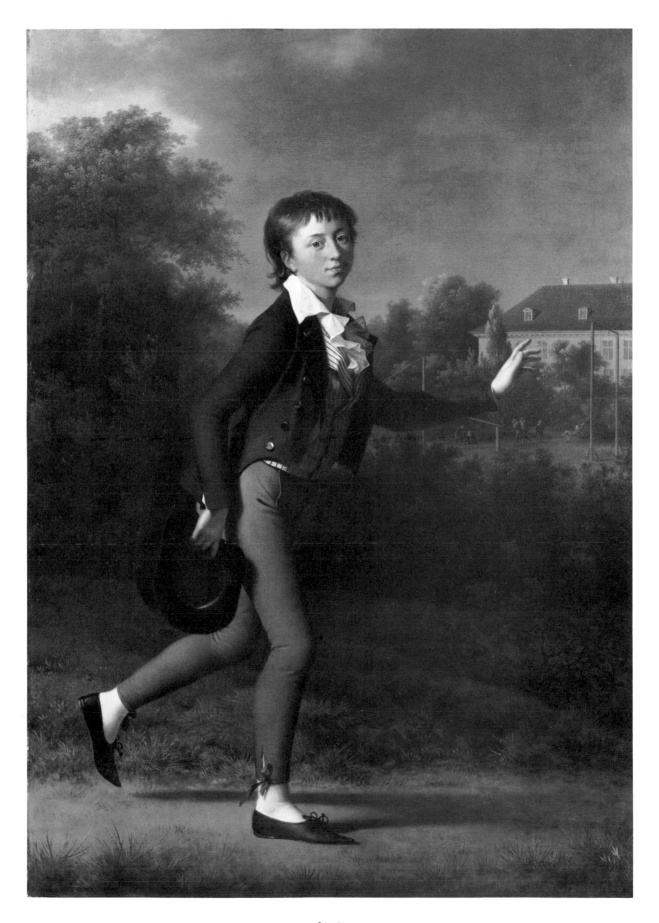

N. A. Abildgaard, 1794, by J. T. Sergel (1740–1814)

NICOLAI ABILDGAARD 1743–1809

Abildgaard was the most prominent neo-classic painter in Denmark, and he was the last to devote himself entirely to history painting. His powerful and unrestrainedly imaginative art contrasts strongly with the simple descriptions of reality that were characteristic of the Golden Age.

Abildgaard was educated at the Academy in Copenhagen in the 1760s, spending the years 1772–7 in Rome where he studied, in particular, ancient sculpture and Michelangelo. He became a close friend of the Swedish sculptor Johan Tobias Sergel, and through him probably met Henry Fuseli. There are many parallels in their subject-matter, and their styles of drawing are closely related. Many years later, for example, Abildgaard was to paraphrase Fuseli's *Nightmare* from an etched reproduction.

It is more uncertain to what extent Abildgaard knew of Jacques-Louis David, who was in Rome at the same time. Their artistic expression was essentially different, but they had one thing in common – a negative attitude to the autocratic regimes of their respective countries. Unlike David, however, Abildgaard never got the chance to openly vent his revolutionary attitude in his official art. Abildgaard's principal work in Rome was an ambitious painting of *The Wounded Philoctetes* (S.M.f.K.), whose powerful expression contrasts sharply with the neo-classicism practised by Anton Raphael Mengs and several of the Academy professors in Copenhagen.

Back in Copenhagen, Abildgaard was in 1778 appointed professor at the Academy and was also commissioned to do a series of large paintings for the royal palace, Christiansborg. This was to show the history of the royal line. He was to start with fairly recent history, which was not to his taste. During the 1780s, nevertheless, he completed ten paintings. In the early 1790s when he reached his favourite theme, legendary history, he suffered the disappointment of seeing the project abandoned. Important aspects of Abildgaard's art thus never found their expression in official paintings, and must be sought in his more private production.

In 1794 the palace burned down, and only three of Abildgaard's huge paintings were salvaged (the remainder are known only from preserved sketches). When, at the beginning of the new century he was encouraged to paint a second series of pictures on royal history, he had lost interest and did only one single sketch before his death.

Unlike Juel, Abildgaard was a retiring, reticent man, and his art was, consequently, appreciated only by a small circle. He all but reigned supreme as a history painter all his life, and only on a few occasions does he seem to have offered his students meaningful support. The exception to this rule was the sculptor Bertel Thorvaldsen, who had assisted him when in the 1790s he decorated one of the Amalienborg palaces for the king's brother, Frederik, the heir presumptive. Eckersberg, on the other hand, was probably not very attached to his teacher.

Abildgaard's furniture design was very important to a number of Golden Age artists, and his heroic style was also fundamental to Constantin Hansen's decoration of the University of Copenhagen Hall (cat. no. 33).

REFERENCES: Bente Skovgaard: *N. A. Abildgaard. Tegninger*. With an introduction in English. Department of Prints and Drawings, S.M.f.K., Copenhagen, 1978.
Nancy L. Pressly: *The Fuseli Circle in Rome. Early Romantic Art of the 1770's*. Exhibition catalogue. Yale Center for British Art, New Haven, Connecticut, 1979.
Patrick Kragelund: "The Church, the Revolution, and the 'Peintre Philosophe'. A Study in the Art of Nicolai Abildgaard", in *Hafnia*. *Copenhagen Papers in the History of Art*, No. 9, University of Copenhagen, 1983, pp. 25–65.

6 Episode from Terence: The Andria, 1801

Canvas, 157.5 × 128.5 cm. Inscribed, bottom left: *N. Abildgaard 1801*
S.M.f.K., no. 589

For his private residence in the Academy of Fine Arts at Charlottenborg, Abildgaard, in the years following 1800, did four largish paintings with subjects taken from the ancient comedy *The Andria* by Terence. It is a comedy in which, after many trials and tribulations, two young lovers are given the blessing of their parents.

For once, Abildgaard has not chosen a sombre subject for his pictures, doubtless because they were planned as a wedding gift for his young wife. But the happy union at the end of the play is only hinted at; instead, the painter has focused on those episodes in which the schemers do their best to hinder the happiness of the young couple.

In this scene, from Act III, Scene 2, the intrigue reaches a peak. The young girl has just given birth to a child, but the father of the young man refuses to believe the explanation offered by the masked slave. Not even the midwife's words of advice are able to convince him.

The play is supposed to take place in Athens, but the pictures show Abildgaard's own ideal city, a mixture of real and imagined architecture in the antique style. The street itself, with its deep perspective, is based on a woodcut from Scamozzi's edition of Sebastiano Serlio's treatise on perspective (1619).

The buildings are rendered in a way that shows the influence of Poussin, although it may well mirror the new Copenhagen that was being built under the supervision of the architect Christian Frederik Hansen (1756–1845). An element seen here which was new to Abildgaard's art is his depiction of nature. The cloud formations especially indicate this interest, and bring to mind Christen Købke's *A View of a Street in Copenhagen, Morning Light* (cat. no. 61). In this way, Abildgaard's late works heralded the true Golden Age.

REFERENCE: P. J. Riis: "Abildgaard's Athens", in: *Hafnia. Copenhagen Papers in the History of Art*. University of Copenhagen, 1974, pp. 9–27 (English text)

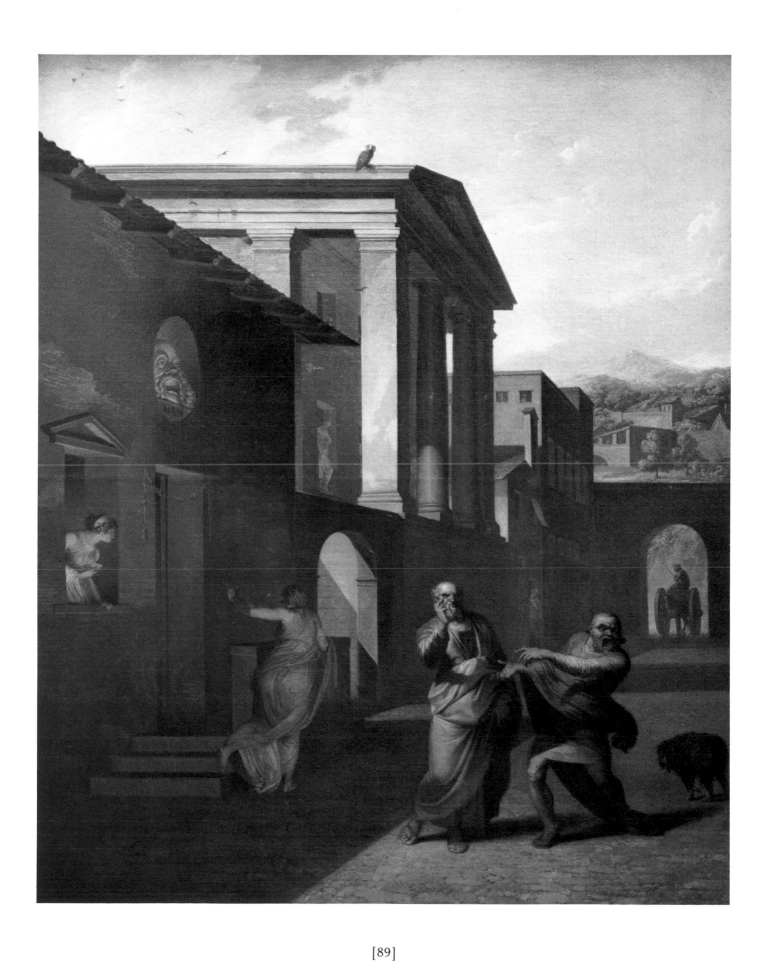

C. W. Eckersberg, 1832, by C. A. Jensen (1792–1870)

CHRISTOFFER WILHELM ECKERSBERG 1783–1853

It was Eckersberg who conclusively rejected the idealising art of the eighteenth century and who introduced a realism based on studies of nature and yet employed neo-classic compositional principles. Through his painting, as well as through his influence as an Academy professor, he thoroughly shaped the development of Danish art. Unlike Abildgaard, he was no visionary, but he was unsurpassed in the description of visible reality.

Eckersberg studied at the Academy from 1803 to 1810 as a student of Abildgaard, but never developed a close relationship with him. Indirectly he was also a student of Jens Juel, although the two never met. He had close contacts with Juel's widow, and married into the family twice. His first wife was Jens Juel's daughter Julie. After her death he married her sister Susanne, who also predeceased him.

During his travels abroad in 1810–16, Eckersberg did not follow Abildgaard's example by going directly to Rome, the traditional destination, but went first to Paris where, for a year, he was taught by Jacques-Louis David. This stay was vital to his development as an artist. But Rome, where he spent the years 1813–16, was where he truly matured. Here, landscapes and views came to play as prominent a part in his art as history painting.

After his return to Copenhagen he was appointed professor in 1818, and was given the great task of historical paintings of subjects from Danish history for the rebuilt royal palace of Christiansborg. At the same time he was much in demand as a portrait painter. The zenith of his career in this field did not last long, however, for as early as the mid-1820s C. A. Jensen took over his position as Copenhagen's favourite portrait painter.

Eckersberg remained an Academy professor until he died, and radically changed the system of education. He strongly emphasised studies from the life, and during the ensuing years the theory of perspective became one of the pivots of his teaching. Indeed, he produced a couple of textbooks on perspectival construction. He passed on his severely classical principles of composition to several of his students. In his later years, teaching took up a great part of his time, but there was one field through which he added a new dimension to his art at this time, and that was marine painting, which he took up in earnest after 1821, and especially developed during the 1830s and 1840s.

REFERENCES: Emil Hannover: *Maleren C. W. Eckersberg*. Copenhagen, 1898
Jorn Rubow: "Christoffer Wilhelm Eckersberg", in *La Revue française*, CLXXXVIII, May 1966
Bente Skovgaard, Hanne Westergaard and Hanne Jönsson, *C. W. Eckersberg og hans elever*. Exhibition catalogue. S.M.f.K., Copenhagen, 1983 (2nd edition 1984 with English translation of articles)
Erik Fischer (and others): *Tegninger af C. W. Eckersberg*. Exhibition catalogue. Departments of Prints and Drawings, S.M.f.K., Copenhagen, 1983 (2nd edition 1983 with English translation of the introduction)

7 Two Shepherds, 1813

Canvas, 53 × 42 cm. Inscribed, bottom right: *1813*
S.M.f.K., no. 1333

Two Arcadian shepherds have settled amid the ruins of an ancient temple, and are engaged in a relaxed discussion, the older shepherd explaining something to the young one. The painting is from the time of Eckersberg's stay in Paris, and it demonstrates his thorough training in studies from the life, first at the Academy in Copenhagen, later as a student of David in Paris. Eckersberg has clearly followed the advice of his French teacher about closely studying nature before antiquity and the great masters. This advice became a doctrine for him. Eckersberg had planned to use these studies as a history painter, but this painting shows that it was difficult for him to tear himself away from the rendering of visible reality, and the two men look more like contemporary models than ancient shepherds. Through the omission of any real action and the avoidance of any form of heroic rhetoric, Eckersberg has created a picture that corresponded better to his artistic temperament than would have a thoroughgoing mythological or historical painting. At the same time, the picture shows his aptitude for creating harmonious compositions, as well as exemplifying his considerable technical skill.

REFERENCE: Hannover, 1898, no. 125

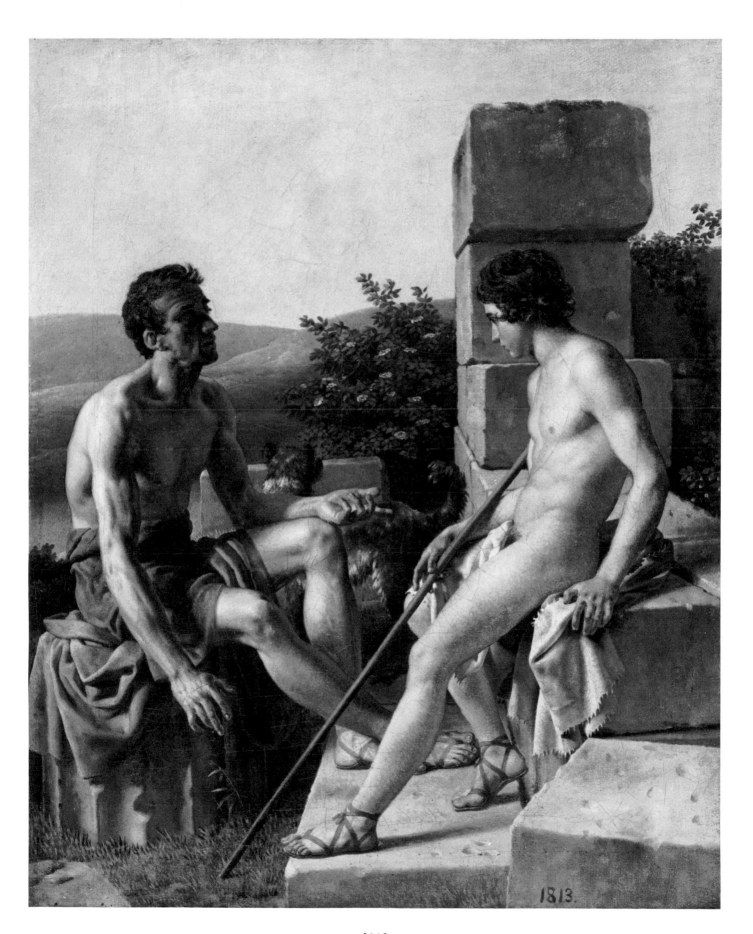

8 The Marble Steps leading to the Church of Santa Maria in Aracoeli in Rome (1813/16)

Canvas, 32.5 × 36.5 cm
S.M.f.K., no. 1621

From the foot of the Capitol Hill, Eckersberg has turned his eyes towards the church of Santa Maria in Aracoeli. To the right of the great steps we see the foot of the walkway leading to the Capitol, and to the left some of the medieval houses that were demolished a hundred years later, when the Victor Emmanuel Monument was erected.

The choice of subject is somewhat surprising. Eckersberg has avoided showing the stately buildings of the Capitol, concentrating instead on the far less picturesque motif of the church's bare, unfinished façade. Eckersberg did not want his views to offer a representative impression of Rome as a whole, preferring the simple structures of antiquity and the Middle Ages to the more fluid architecture of the High Renaissance and Baroque. The subject is chosen for its play of lines, created by the two sets of steps and the verticals of the buildings. The composition of the picture shows us Eckersberg as the severe classicist that his stay in Paris had made him. The description of the subject is, however, quite modern. In contrast to his teacher Abildgaard, Eckersberg made no attempt to recreate antiquity, but aimed to show the Rome of the day with its mixture of old and new architecture and its busy street life. In his perception of the subject certain parallels to the French painter Pierre Chauvin can be seen. Eckersberg admired him and saw several of his works, including some in Thorvaldsen's art collection in Rome (now in the Thorvaldsen Museum, Copenhagen).

Highly characteristic of Eckersberg is the consistent description of sunlight and shadows falling on the steps.

REFERENCE: Hannover, 1898, no. 193

9 In the Gardens of the Villa Borghese (1814)

Canvas, 28 × 32.5 cm
S.M.f.K., no. 1310

In the gardens of the Villa Borghese, Eckersberg painted a section of the aqueduct built in the years 1776–8 to convey water from the Aqua Felice aqueduct into the many fountains in the park. The simple form of this neo-classical structure, as well as its worn condition, is what attracted the attention of the classically orientated painter.

The pictorial space is contained by the wall running diagonally into the picture, and by the portal which, in spite of its opening, shuts off the background. The choice of subject and its hermetic treatment are comparable to contemporary graphic views of Rome, in particular those by Louis Pierre Baltard. On another occasion Eckersberg copied a leaf from Baltard's work, *Vue des Monuments antiques de Rome, et des principales Fabriques pittoresques de cette ville* (1800–2).

A detailed preparatory drawing for the painting exists (S.M.f.K.). It is dated 1814, and the painting was presumably done the same year. Around this time Eckersberg began not only to *draw* in the open air, but also to *paint* in front of his motive, and this marked the start of the nature studies of the Golden Age.

The Latin inscription on the gate (*Porta Egiziana*) originally read "NE QVEM MITISSIMUS AMNIS IMPEDIAT" ["in order that the steady stream may impede no one"]. The gate was destroyed during a siege in 1849, but the wall to the right is still there.

REFERENCES: Hannover, 1898, no. 150
Hans Edvard Nørregård-Nielsen: "Efter naturen", in *Meddelelser fra Ny Carlsberg Glyptotek*. Copenhagen, 1982, pp. 15–34
(summary in French)

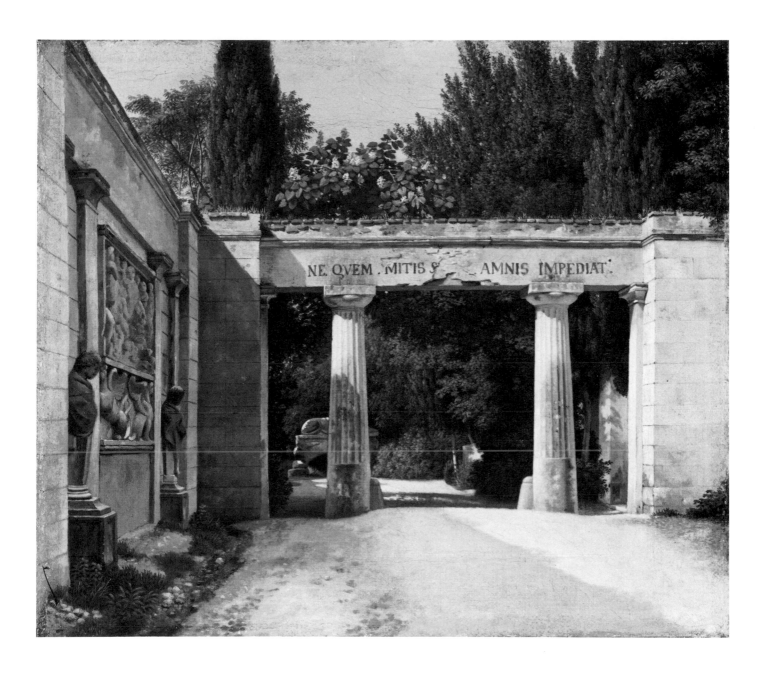

10 Fontana Acetosa (1814?)

Canvas, 25.5 × 44.5 cm
S.M.f.K., no. 2099

Just north of the old boundaries of Rome, Eckersberg painted Bernini's fountain at the spring known as the Acqua Acetosa, with the Tiber Valley in the background. It is one of the very few paintings from Eckersberg's Roman period in which the landscape plays the main part. Like the picture of the three arches of the Colosseum (cat. no. 11) the composition consists of a foreground which is parallel to the picture plane, and a quite separate background. The depth in the painting is achieved solely through the finely graded aerial perspective, not through the linear perspective which Eckersberg normally employed.

The painting is unfinished, and its fresh, sketch-like quality has caused speculation that Eckersberg could have been inspired by Pierre Henry de Valenciennes' small Roman studies from 1777–85 (now at the Louvre). It is most improbable, however, that Eckersberg had seen the French painter's small working sketches, despite the time he spent in Paris. Furthermore, the two painters have different perceptions of their subject. Eckersberg is more severe in his classicism, and his subjects do not appear to be so "casual" or *trouvé* as do those of Valenciennes.

It is quite likely, however, that Eckersberg knew and used the Frenchman's handbook for painters, *Eléments de Perspective Pratique, à l'usage des Artistes . . .* (1799–1800).

REFERENCE: Hannover, 1898, no. 206

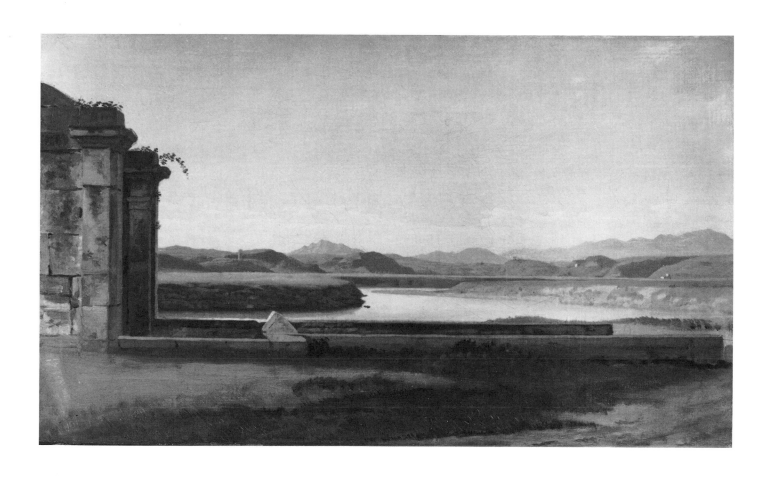

11 A View through Three of the North-Western Arches of the Third Storey of the Colosseum (1815 or 1816)

Canvas, 32 × 49.5 cm
S.M.f.K., no. 3123
Illustrated in colour page 50

Rome is seen through three of the arches on the third storey of the Colosseum. The description of the worn masonry of the building is a credit to Eckersberg's keen eye. No crack or plant between stones has evaded him. There is an almost paradoxical contrast between the quite broadly painted foreground and the fine detail in the background – a "reversed" perspective that indicates that the artist may have used a telescope when he painted the background.

The very limited space of the foreground and the strictly classical division of the picture by the three arches reveal the influence of Eckersberg's French teacher, David. The composition is especially reminiscent of *The Oath of the Horatii*.

When the painting was shown at the *Kunstforeningen* in 1828, Eckersberg gave it the following description in the exhibition catalogue:

"Through the arch to the left are seen the splendid ruins of the Temple of Peace [i.e. Maxentius' basilica] and behind that, in the distance, the Church of Maria Ara Celi. Through the middle arch is seen the so-called Nero's Tower built in the 13th century [i.e. *Torre delle Milizie*] at the foot of Mount Quirinal, and further back we glimpse the Palace on Monte Cavallo. Straight ahead through the right hand arch is the Church of San Pietro in Vincoli."

REFERENCE: Hannover, 1898, no. 164

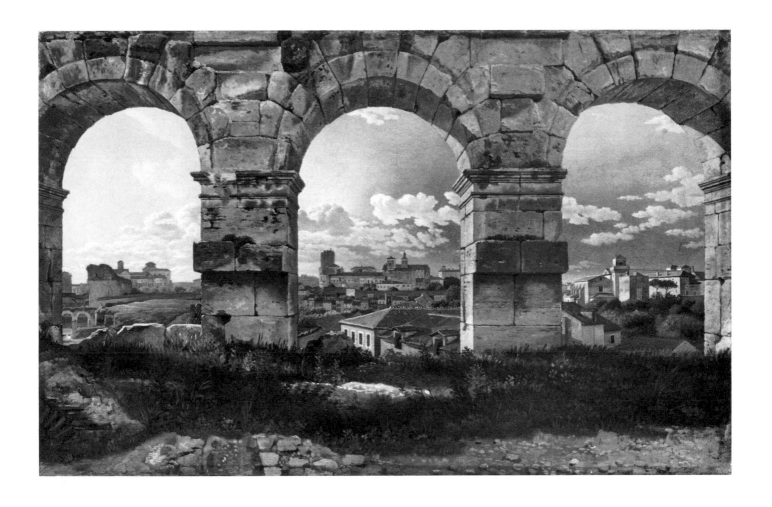

12 Sophie Hedvig Løvenskjold, née Baroness Adeler, and her Three-Year-Old Daughter Berthe Henriette (1817)

Canvas, 62.5 × 51.5 cm
S.M.f.K., no. 4022

After returning from Rome in August 1816, Eckersberg became very busy as a portraitist. During the spring of 1817 he painted eight portraits, one of them being this which, according to his diary, was completed on 20 June 1817. Eckersberg's fine reputation at this time is indicated by his clientele. He painted members of the royal family, several nobles and the most prominent townspeople.

The background for his success was that he, better than any of his contemporaries, was able to interpret the new middle-class outlook which had emerged during the Napoleonic wars and which had succeeded the nation's collapse in 1813. He depicted his models with a straightforwardness that corresponded to their own image of themselves. His unadorned realism is often amazing, as in this painting of a noblewoman and her daughter. He made no attempt to embellish but merely described what he saw. While Jens Juel had described the rich commoners as splendidly as he did the nobility, Eckersberg did the opposite – he described the nobility as simply as the commoners.

REFERENCE: Hannover, 1898, no. 218

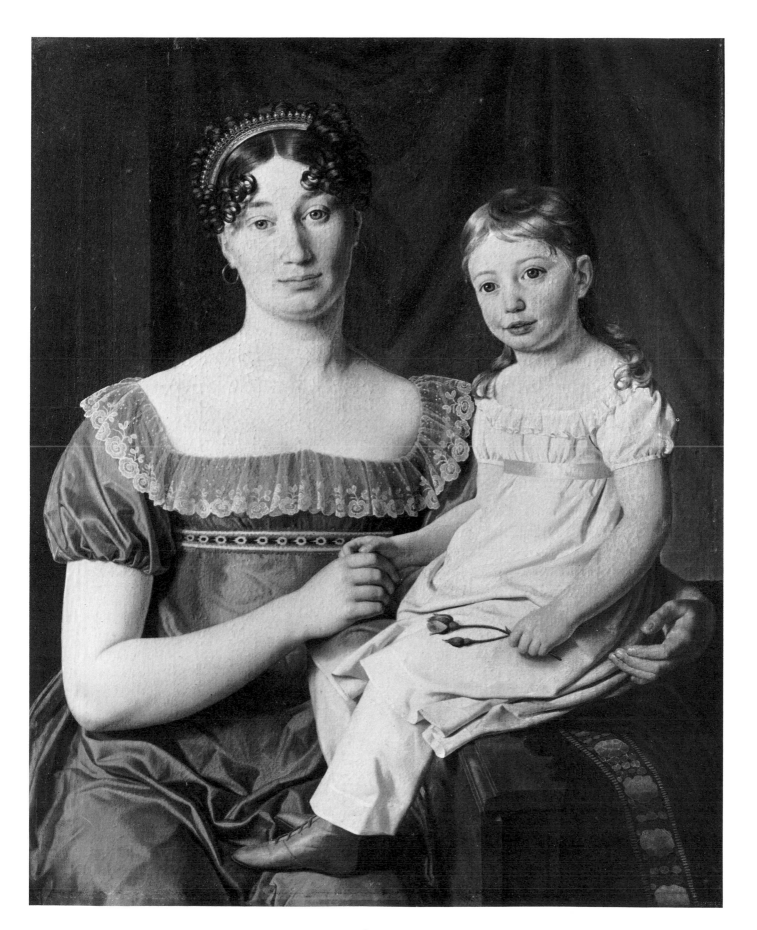

13 Bella and Hanna. The Eldest Daughters of M. L. Nathanson (1820)

Canvas, 125 × 85.5 cm
S.M.f.K., no. 3498
Illustrated in colour page 51

The two young girls were daughters of Mendel Levin Nathanson, a merchant who was one of the youthful Eckersberg's most loyal supporters. While the artist was on his travels abroad, his patron had ordered a large painting with a religious theme and a couple of pictures with mythological themes. But after Eckersberg's return, he commissioned two big portraits, each rather like a conversation piece. One of them (1818) shows the family (S.M.f.K.). The other is this portrait of Nathanson's two eldest daughters, from 1820. The client's changed interest reflects a general change in the times — mythological and religious themes gave way to the description of bourgeois reality.

The painting shows the two young girls in a room sparsely decorated in the Empire style, with simple panels, piers and furniture. Their dresses harmonise so well with the colours of the room that one is tempted to believe that Eckersberg had a say in selecting their clothes for the sitting.

The composition and the treatment of the sitters have a severity that is unusual in an Eckersberg portrait. The grouping of the two daughters — one full face, the other in profile — is comparable to Thorvaldsen's sculpture of *The Three Graces* (1818–20), for which the sculptor presumably did the initial studies while Eckersberg was still in Rome. In both cases related female figures are seen from different points of view, a variation on a theme. The shallow stage, too, almost like a relief, could be due to Thorvaldsen's influence.

A letter from Eckersberg to Nathanson, dated 18 April 1820, gives an account of the execution of the painting, and provides an image of the working conditions of this busy portrait painter:

"Concerning the picture of your two eldest daughters, this is nearing completion and I shall finish it forthwith. Long or short intervals between sittings will not interfere with the likeness, insofar as the painter works only with delight. I should have liked to complete this picture last autumn, but this was not possible. Since last New Year I have chiefly worked on the royal family picture, on account of the many visits and strange judgements of half-finished work that the artist has to put up with —"

Eckersberg started working on the painting in 1819, and on 12 May 1820 he wrote in his diary: "Completed the portrait of both the eldest Miss Nathansons."

REFERENCE: Hannover, 1898, no. 260

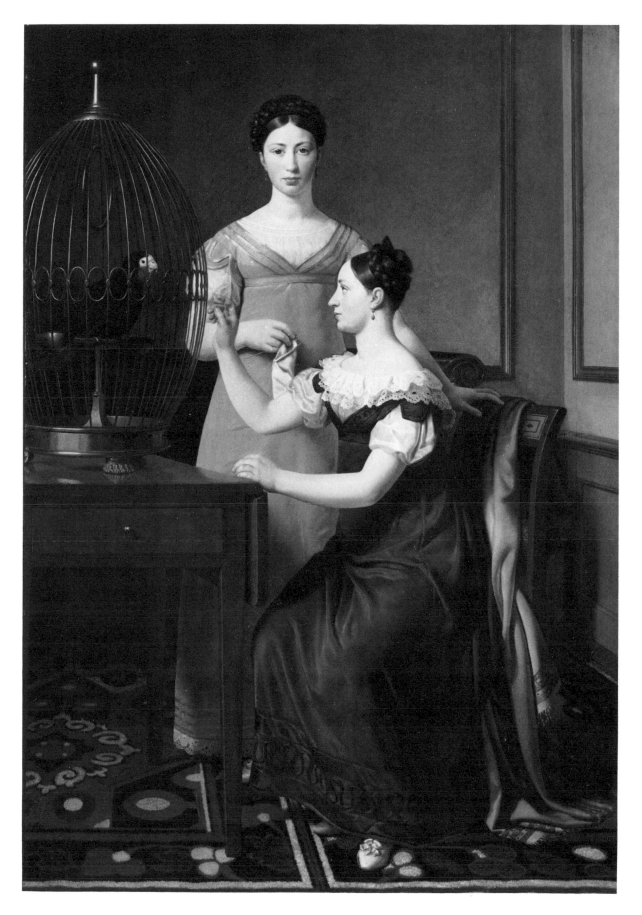

14 Frederik Wilhelm Caspar von Benzon (1820)

Canvas, 53.5 × 43.5 cm
S.M.f.K., no. 4558

Here, the sitter is a young nobleman, Wilhelm von Benzon (1791–1832), who had a civil service career, like so many of the same class. He was strongly interested in genealogy and thoroughly researched the history of the Danish aristocracy.

This shows Eckersberg the honest and competent portrait artist, who usually painted good likenesses, somewhat lacking in inspiration. He rarely offered a deep psychological interpretation of his model.

The man's pose gives the portrait a formal, official quality, which is not typical of Danish portraits of the 1820s or the early '30s, as painted by C. A. Jensen and several of Eckersberg's students.

The painting was commissioned together with the portrait of Wilhelm von Benzon's fiancée, Emilie Henriette Massmann (cat. no. 15). There is a great difference in the colouring of these two paintings, however. His red officer's coat is in sharp contrast to her delicate, light dress.

REFERENCE: Hannover, 1898, no. 262

15 Emilie Henriette Massmann (1820)

Canvas, 53.5 × 43.5 cm
S.M.f.K., no. 4559

The young woman, Emilie Henriette Massmann (1798–1864), was the daughter of a prominent clergyman and was engaged to Wilhelm von Benzon (cat. no. 14) when she sat for Eckersberg in 1820. The marriage took place in 1824. The picture is a companion piece to that of her fiancé.

The painting gives us Eckersberg at his best as a portraitist. The woman's fair skin and the white and yellow colours of the dress blend delicately and stand out brightly against the grey background. For once, realism has given place to classical overtones, which show the artist's knowledge of French portrait art. The woman's pose and the contours hint at the influence of Ingres. Eckersberg's relationship with him is one of the mysterious points of his stay in Rome. Although the two painters lived close to one another and must have met, and although Eckersberg definitely must have seen works by Ingres, the Dane never mentions the French master in his letters or diary.

REFERENCE: Hannover, 1898, no. 263

[109]

16 A Corvette on the Stocks (1828)

Canvas, 27.5 × 37 cm
S.M.f.K., no. 6439

Eckersberg regularly visited the naval dockyard in Copenhagen in order to study ships on the stocks. There, some time during the summer of 1828, he did a drawing of a corvette on the stocks (S.M.f.K.), and presumably shortly thereafter he started work on this painting, which was, however, never finished. Its sketch-like condition makes it possible to examine his method of work. First, the composition was determined and the details minutely described in the detailed drawing. The subject was then, with few changes, carefully transferred to the canvas on which, with rapid strokes of the brush, he indicated the colour scheme of the picture. In the case of this picture, he never got around to the final work on the detail. He was to take up the subject again twenty-three years later, this time in a vertical format, but that picture remained unfinished too, due to his failing health.

REFERENCE: Hannover, 1898, no. 407

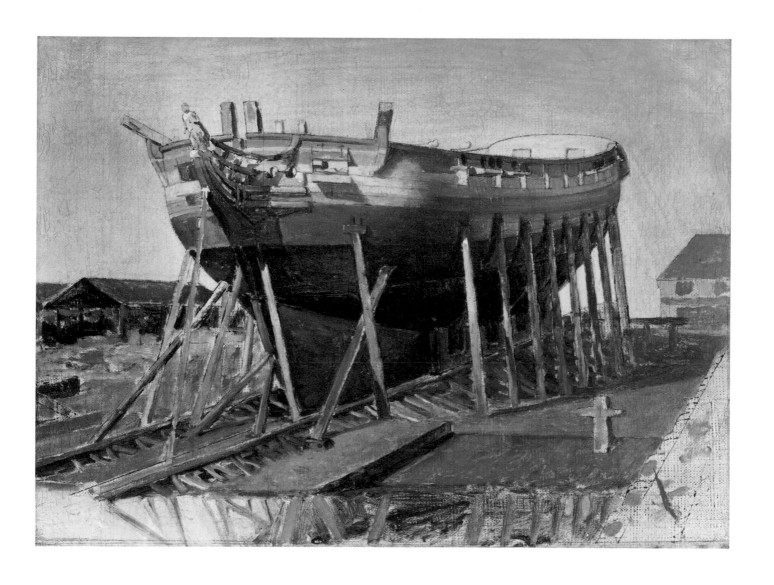

17 A View towards the Swedish Coast from the Ramparts of Kronborg Castle, 1829

Canvas, 47 × 66 cm. Inscribed, bottom left: *E. 1829*
S.M.f.K., no. 3241

The painting shows the view towards Sweden from Elsinore in north-east Zealand. In the foreground we see a corner of Kronborg Castle and part of the defence bastion.

From notes in the painter's diary we can follow his work quite closely. On 15 July 1826, he painted a small sketch for the picture: "Went to Elsinore. On the 15th from 9 till 2 o'clock painted a view of the flag station, the lighthouse and part of Kronborg and the Sound, the light at 1 o'clock." The note about the light shows how meticulous Eckersberg was in selecting the time of day with the appropriate light. About two months later, on 29 September 1826, he started work on the subject, twice as large, in his studio: "Began painting the flag station at Kronborg." But the painting was not completed that autumn, and he refers to it again only after a gap of two years. 18 December 1828: "Began completion of a picture started a couple of years ago, showing a view of Kronborg and the flag station." Almost one month later, on 14 January 1829, the picture was finished: "Completed a painting showing a view from Kronborg ramparts of the flag station, the Sound to the Swedish coast."

The tight composition of the picture, with the castle used as a *repoussoir*, shows how confident Eckersberg was with the classical landscape tradition emanating from Poussin and Claude Lorrain.

In spite of the length of time Eckersberg spent on the picture, he succeeded in retaining much of the freshness of his observation of the scene. In the finished painting, Eckersberg included ships at sea, soldiers at the cannon, and women bleaching clothes on the ramparts. None of this is seen in the sketch.

REFERENCE: Hannover, 1898, no. 409

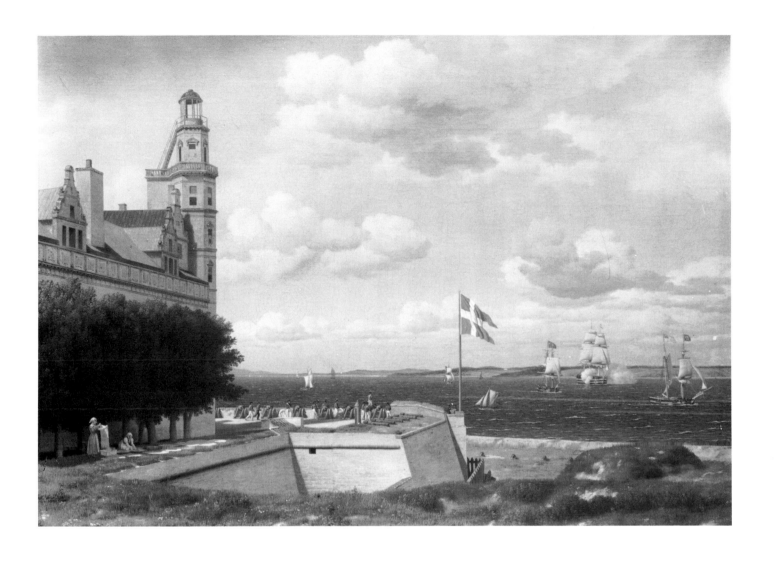

18 Renbjerg Tileworks by Flensburg Fjord (1830)

Canvas, 22.5 × 32.5 cm
S.M.f.K., no. 1350

During the years before he travelled abroad in 1810, Eckersberg was a diligent landscape painter. The pictures from these years were distinguished by a romantic atmosphere which was to disappear from his art during his stay in Paris. At the same time landscape painting became less important to him, and after his return home in 1816 he painted very few pure landscapes.

One of them is this painting, which he did close to his birthplace by Flensburg Fjord in Southern Jutland (just north of the present border with Germany). From the cliff, he had a view of the fjord and the hilly landscape. He made a note of the weather, as was his habit, in his diary entry for 1 June 1830: "Spent this day very pleasantly at Rennebjerg. Painted view of tileworks during the morning. There was a half gale, southwesterly, which brought some showers."

The following day he also painted there, and after a further three days' work at home, the painting was completed on 11 June. The red roofs of the tileworks contrast sharply with the blue and green modelling of the picture, and act as a focal point. Compared to Juel's atmosphere-laden description of a storm brewing (cat. no. 4), Eckersberg's painting is surprisingly matter-of-fact; he has merely registered his subject, and neither the drifting clouds nor the white-crested waves are meant to provide an atmosphere of drama.

REFERENCE: Hannover, 1898, no. 424

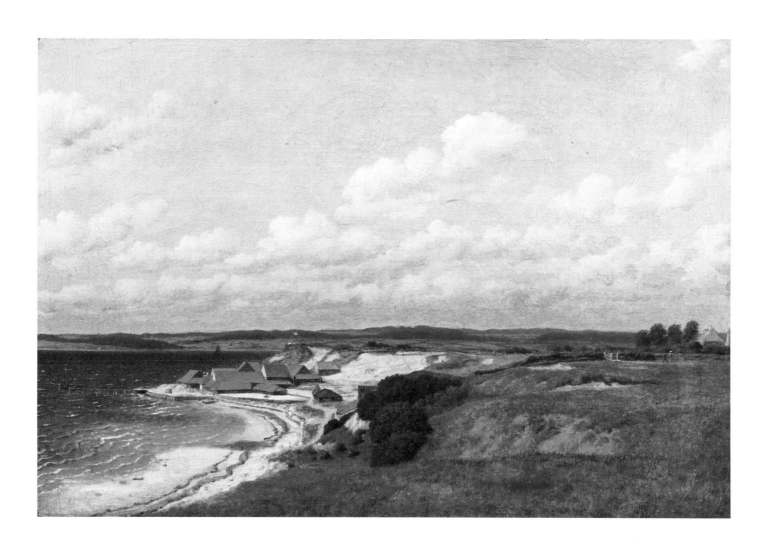

19 A Calm. A Rowing-Boat with Passengers pulling out to an American Man-of-War drying Sails, 1831–2

Canvas, 40 × 55 cm. Inscribed, bottom right: *E. 1831*
S.M.f.K., no. 6346

Marine painting was central to Eckersberg's art in the years after 1821, appearing to be his main interest in the 1830s and '40s. Surprisingly, Dutch marine painting of the seventeenth century was of little importance to him. His source of inspiration is to be found in popular prints.

In his youth he himself had earned money by making drawings for commercial publication, for instance for a book showing a number of different ships in various positions at sea. He thus followed a tradition widespread in Europe throughout the eighteenth century. The insistence on a very detailed account of the "anatomy" of the ships later became part of the procedure of Eckersberg. He showed the same almost scientific thoroughness in this field as in that other central interest – the study of light, and of air, wind conditions and cloud formations.

In this painting of an American man-of-war riding at anchor while the sails are drying, the two ships are placed roughly in the same way as in the prints. Eckersberg has chosen to show the ships in calm and clear weather, as he did in most of his other marine paintings. There is thus no drama or romantic atmosphere in the picture, the artist's matter-of-factness being once more foremost.

The painting was done at the turn of the year 1831–2, and must have been based on thorough studies done during the summer.

REFERENCE: Hannover, 1898, no. 449

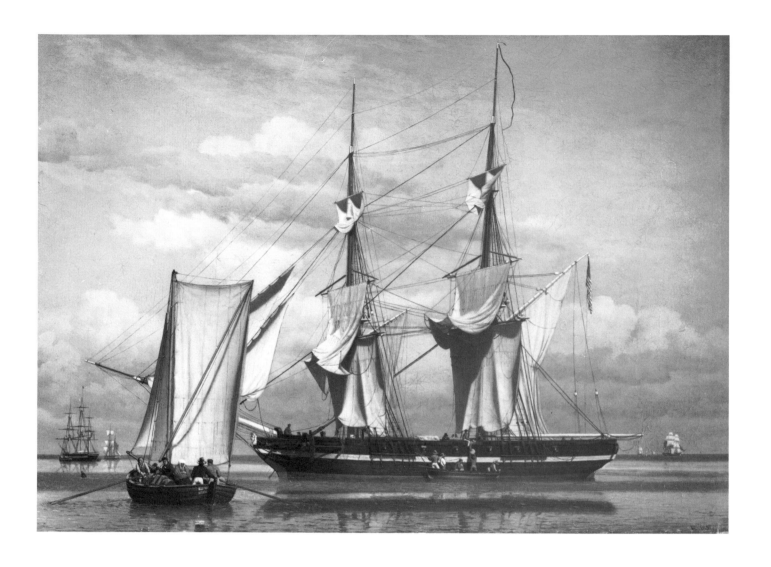

20 The Starboard Battery and Deck of the Corvette "Najaden", 1833

Canvas, 22.5 × 22.5 cm. Inscribed, bottom right (according to early evidence): *E. 1833*
S.M.f.K., no. 2060
Illustrated in colour page 52

After a two-week trip on the corvette "Najaden" in July 1833, Eckersberg painted this picture of a portion of the ship's deck. He shows the same interest in the many details of the ship's equipment as in his more traditional marine paintings. The complicated cordage is accurately reproduced. Eckersberg seems to have been greatly fascinated by that network of lines made up by the mast and the crossing ropes. The picture almost has the quality of an abstract composition, with the full curves of the big sail contrasting with the many straight lines.

There are few other paintings by Eckersberg in which a geometric composition dominates the picture to such an extent, although he did several drawings with a similarly abstract effect.

REFERENCE: Hannover, 1898, no. 478

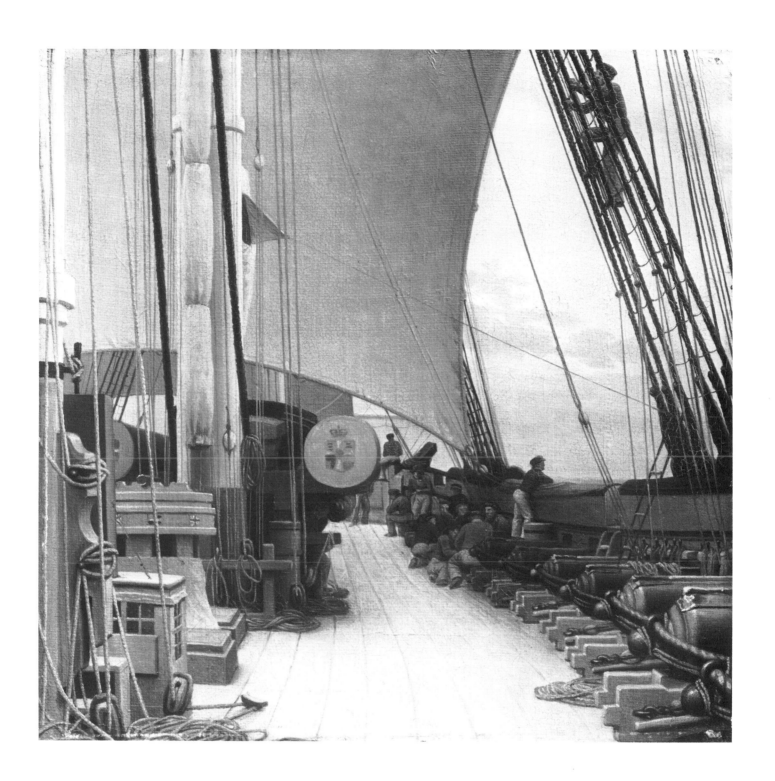

C. A. Jensen: *Self Portrait, 1836*

CHRISTIAN ALBRECHT JENSEN 1792–1870

C. A. Jensen was one of the most important portrait artists of the Danish Golden Age, and also one of the very few who devoted himself entirely to portraits. His light brush and immediate realism made him one of the portrait painters most in demand during the 1820s.

Jensen was taught at the Academy in Copenhagen during the years 1810–16 by C. A. Lorentzen, a minor portraitist. Independently, he studied older portraits, and while on his Grand Tour in 1817–21 he achieved his final manner. His journey took him via Dresden, where he attended the Academy for almost a year, and to Rome where he spent three years. Soon after his return, he had a large circle of customers, and around 1827 he was for a short time the busiest portrait painter in the country.

The years from 1825 to 1830 constitute his great period, both in popularity and artistic quality. But he never won comparable official recognition, being by-passed in 1829 for appointment as Lorentzen's successor.

In the 1830s he ran into considerable financial problems due to increasing family responsibilities, and the quality of his work fluctuated. At the same time he began to lose ground with his customers. Jensen tried to supplement his income by copying older paintings for the portrait collection at Frederiksborg Castle, and this brought disagreement with the curator of the collection, the art historian N. L. Høyen, who wanted exclusively original portraits. Thanks to the support of the Crown Prince, Christian VIII, Jensen continued to supply paintings for the Castle right up to 1847, including works of his own invention from 1840 to 1842 and onwards.

After 1837 he was also a regular traveller abroad, going mainly to England and Russia, in order to win commissions for portraits. Around 1848 he gave up painting almost completely. This was due partly to the fact that, on the death of Christian VIII, he lost his main support, and partly because during the Danish-German war in 1848 he incurred political disapproval on account of his sympathy for the cause of Schleswig Holstein.

From 1849 until his death, Jensen worked in the Department of Prints and Drawings, acting as museum conservator. Although he had no students as such, his paintings had an influence on several younger artists, Købke among others.

Contrary to the painters of the Eckersberg school, he showed no special feeling for the rendering of light. Jensen was not unreservedly favoured by art critics. His free brushwork and broad strokes often aroused opposition, although one critic in 1838 emphasised his "genius" in painting faces: "Each has been perceived in its own characteristic individuality . . . It might be said that in respect to the application of colours, the artist is too bold and spirited, but only occasionally."

REFERENCE: Sigurd Schultz: *C. A. Jensen. I–II.* Copenhagen, 1932

21 The Sculptor Hermann Ernst Freund (1819)

Copper, 20 × 13 cm
S.M.f.K., no. 1212

While he was in Rome in 1818–21, Jensen painted portraits of a number of his friends and close acquaintances, among them the sculptor Hermann Ernst Freund (1786–1840), who was born in Germany but educated in Copenhagen, being naturalised in 1811. Freund became Thorvaldsen's opposite; he was far more visionary and romantic, striving to introduce Nordic mythology into the art of the Golden Age. As a source of inspiration he was very important to several young painters, particularly Constantin Hansen and Købke.

Freund spent the years 1818–28 in Rome where he was strongly influenced by the Nazarenes. His romantic attitude as an artist is clearly evident in Jensen's portrait of him. He is dressed in an open-necked shirt with a "Byron-collar" and a big beret; his hair is long and curled. His face is bright with youthful energy and optimism, and his gaze is distant and full of inspiration.

The small portrait is marked by spontaneity. One is led to feel that the sculptor has been caught in the middle of a pause to reflect. The picture shows the young sculptor without the bitterness that he was later to feel when overshadowed by Thorvaldsen.

REFERENCE: Schultz, 1932, no. 25

22 Johannes Søbøtker Hohlenberg, a Governor of the Danish East Indies, 1826

Canvas, 23.5 × 19 cm. Inscribed at the left border: *C. A. Iensen 1826*
S.M.f.K., no. 4616

The young lawyer Johannes Søbøtker Hohlenberg (1795–1833) had his portrait painted by Jensen in 1826, around the time of his marriage. He had held a post at the Danish trading station Serampore, near Calcutta, for a couple of years, and in 1828 he was placed in charge of the colony. The small Danish colonies in India were of no importance to Danish trade after the Napoleonic wars, and Hohlenberg's duties were purely administrative.

Jensen's portrait of him shows him as a diligent and meticulous official. Small portraits such as this made Jensen one of the most popular portrait artists among the Copenhagen middle-class in the mid-1820s. His straightforward and immediate renderings of his models fulfilled his industrious and thrifty sitters' demands better than Eckersberg's grandly conceived portraits. The modest size of the paintings, too, reflects the lifestyle adopted by the middle class during the crisis that followed the nation's financial collapse in 1813, and the following year's defeat in the Napoleonic wars. This is pair to the portrait of the sitter's wife (cat. no. 23).

REFERENCE: Schultz, 1932, no. 105

23 Birgitte Søbøtker Hohlenberg, née Malling, 1826

Canvas, 23.5 × 19 cm. Inscribed, top right: *C. A. Iensen 1826*
S.M.f.K., no. 4617
Illustrated in colour page 53

Jensen painted, as a companion piece to the portrait of Johannes Søbøtker Hohlenberg (cat. no. 22), this portrait of his young bride Birgitte (1800–86). She was the daughter of the famous Danish historian and official Ove Malling, and like her husband she had a middle-class background.

The painting shows the artist's superior ability to pinpoint the character of a person. The young woman's youthful charm and spirits literally shine from the picture. The brushwork is unsurpassed, lively and precise at the same time, with the face meticulously done.

The picture is full of light, but in contrast to the slightly older Eckersberg, Jensen did not indicate the source of his light clearly. The colours of the dress and bonnet are finely matched, and he has used the circular shadow from the brim of the bonnet to frame the face.

The portrait shows the painter at his best. It is considered one of the very finest works of the Danish Golden Age.

The young woman went with her husband to India in 1826, but after his early death in 1833 returned to Copenhagen.

REFERENCE: Schultz, 1932, no. 106

24 The Scene-Painter Troels Lund, 1836

Canvas, 31 × 23.5 cm. Inscribed along the right edge: *C. A. Iensen 1836*
S.M.f.K., no. 1557

Jensen painted the now almost unknown scene-painter Troels Lund (1802–67) with his big scene-painter's brush in hand, as though he had been interrupted in his work. His pose is slightly tense, and his facial expression conveys the impression of a trim, resolute man. Jensen has balanced the slight tilt of the head amusingly with the slanting red beret. The portrait of Troels Lund seems more monumental than Jensen's portraits from the 1820s, although the picture is only slightly larger. But the pose and expression of the scene-painter produce the changed pictorial effect.

The painting reflects a general development in Jensen's portraits, as well as in Danish portrait art in the 1830s in general. Increasing wealth in Denmark in the years after 1830 was accompanied by greater monumentalism in art, portraits becoming larger and more stately.

REFERENCE: Schultz, 1932, no. 292

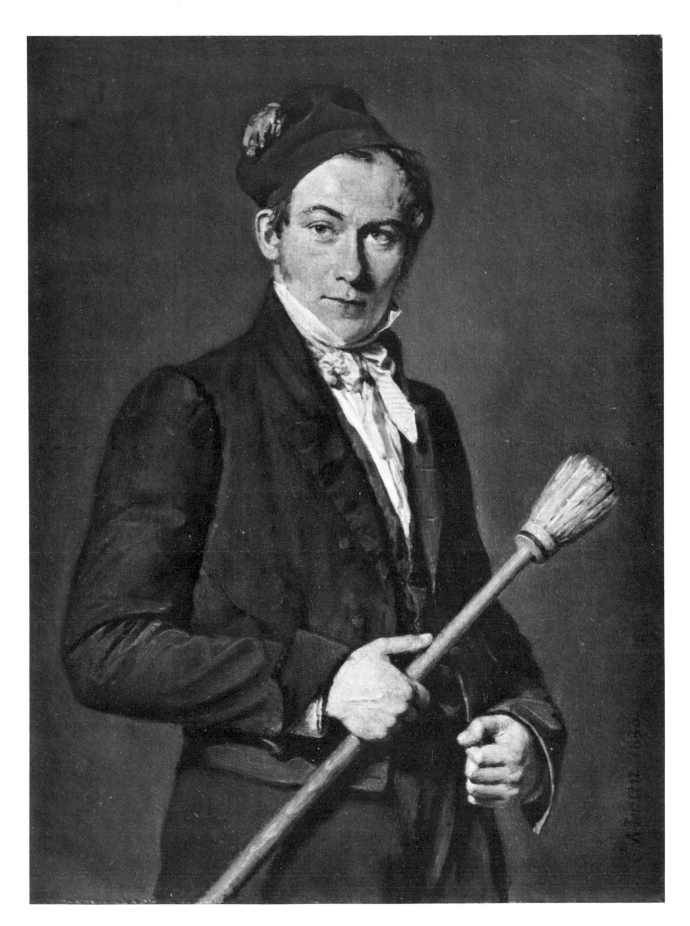

25 Andreas Gottlob Rudelbach, 1858

Canvas, 30.5 × 24.5 cm. Inscribed along the right edge: *C. A. Iensen 1858*
S.M.f.K., no. 2030

Having almost completely ceased to paint for several years, in 1858 Jensen did his last painting, this portrait of Andreas Gottlob Rudelbach, the pastor. He was encouraged by a friend to do it.

Rudelbach was a controversial theologian and an outsider in Copenhagen cultural circles. With rapid, broad brushstrokes the painter has conveyed a fine impression of the theologian's alert and mercurial disposition. The characterisation as well as the description of his vivid face set this portrait apart from other portraits of the Danish Golden Age. The unusually free technique is extraordinary for the period. The painting was done at a time when Jensen was totally out of favour with the public and with art critics. But it contributed to the reassessment of his reputation around the turn of the century, causing the painter and critic Karl Madsen to dub Jensen "the Frans Hals of Denmark": "With this splendidly soulful work, our little Frans Hals has taken a good stride closer to the great one." Today, the painting is considered C. A. Jensen's most outstanding work.

REFERENCE: Schultz, 1932, no. 402

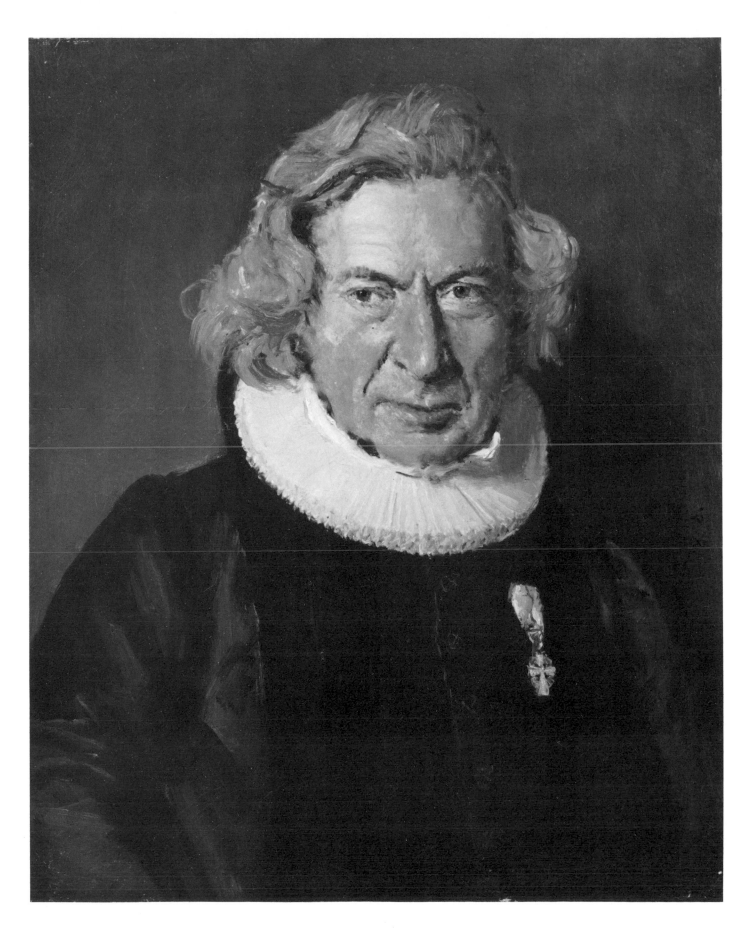

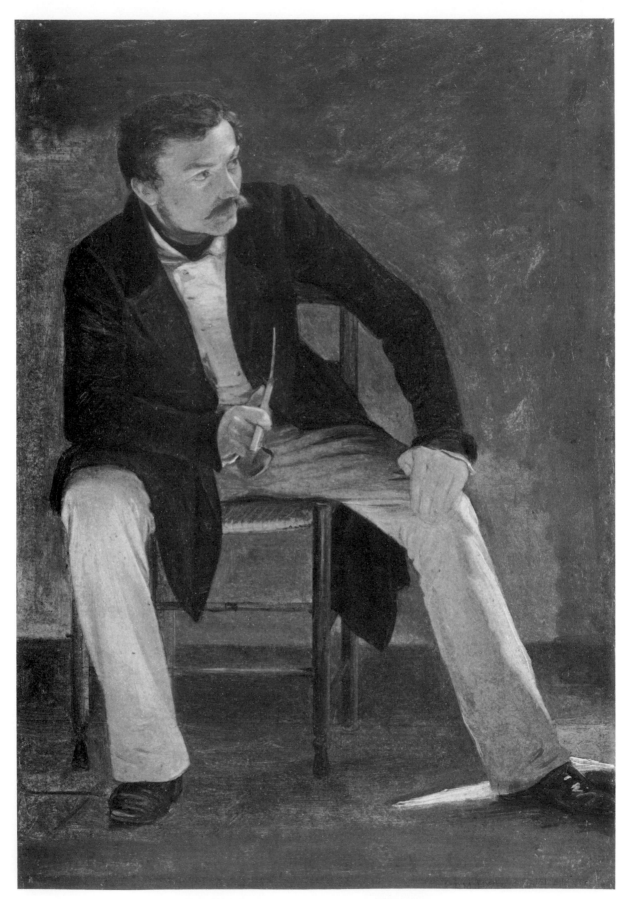

Constantin Hansen, 1837, by Albert Küchler (1803–86)

CONSTANTIN HANSEN 1804–1880

Constantin Hansen was one of Eckersberg's most prominent students. His main fields in painting were architecture, genre pieces and portraits, but he also made one of the few attempts of the Golden Age to revive history painting inspired by antiquity. Like Eckersberg, he stressed tight, clear composition, but he was a finer colourist than his teacher, using in his best studies effects that anticipate Impressionism.

Constantin Hansen received his first artistic training in childhood from his father, the portraitist Hans Hansen (1769–1828). It was intended that he be an architect, however, and he spent nine years enrolled at the Academy School of Architecture before transferring to the Art School in 1825. His architectural interests are evident in his later art.

In 1829 Hansen became a student of Eckersberg, and a close relationship developed. He continued at the Academy until 1833. At this time he mainly devoted himself to portraiture, but during his nine-year stay in Italy (1835–44) architectural views and crowd pictures became more important to him.

After his return to Denmark he started work on a large-scale fresco for the vestibule in the University of Copenhagen (1844–53). This attempt to revive interest in antique mythology was not in keeping with the prevailing current. Hansen lacked a feeling for the Romantic-nationalism which in the 1840s brought nationalist landscape painting out in full bloom, and which, in the early 1850s, gave new impetus to Danish painting of crowd scenes. After 1850 he was primarily occupied with commissions for portraits.

His last great task was the large group portrait of the Constitutional Assembly of 1848 (painted in 1860–4)

REFERENCES: Emil Hannover: *Maleren Constantin Hansen*. Copenhagen, 1901
H. P. Rohde: *En guldaldermaler i Italien*. Copenhagen, 1977

26 Kronborg Castle (1834)

Canvas, 28.5 × 42.5 cm
S.M.f.K., no. 6815

At approximately the same time as Købke really got down to painting at Frederiksborg Castle (cat. nos. 59 and 60), Hansen began a large painting of Kronborg Castle (in May 1834). The *Kunstforening* had arranged a competition for the best depiction of "an internal or external view of one of Denmark's more remarkable buildings, or public places". Inspired by the dawning Romantic nationalism, Constantin Hansen picked one of Denmark's historical monuments, Kronborg Castle at Elsinore. He worked very thoroughly, spending most of the summer at it. He did several drawn and painted sketches, in addition to this study of the entire castle – also studies of the end walls of the castle and of the spires on top of the towers (cat. no. 27). In a letter to Jørgen Roed in the beginning of June 1834, he wrote about his chosen angle of view: "I can assure you it will be an enormous task to complete a picture of Kronborg, and yet I believe it will be educative . . . I have viewed it from all sides, and believe that the one I have chosen is, all told, the most interesting."

But he was later to doubt whether he had picked the correct angle, as is evident from a letter to Roed from the middle of June: "The two wings of the building that I see are not so beautiful as the two others, and this has once more put me at a loss." At this stage, however, he had already started priming the huge canvas, and it appears that he, in fact, stuck to his original choice.

Bad weather caused Hansen to leave Elsinore as early as 23 June, and he finished the big picture in his Copenhagen home. He completed it on 8 October, sending it to the *Kunstforening* ten days later, just in time to take part in the competition – which he won.

The freshness and immediacy that mark this sketch were not transferred to the final painting, in which all the forms have been made more precise, and the castle appears more stately.

Hansen's picture of Kronborg differs considerably from Eckersberg's painting of the same subject (cat. no. 17). Here, the castle itself is the main thing, and it is shown in such a way as to convey an impression of the entire structure. It is more *representative* of the castle. The monumentalism of the 1830s is beginning to mark the conception of subject and to separate Eckersberg from his students.

The black border that can be made out along the edge of the frame shows that this study was initially hung unframed. The painting belonged to the eminent museologist Christian Jürgensen Thomsen. From 1839 until his death in 1865 he was in charge of the Royal Collection of Art (now the Statens Museum for Kunst) together with N. L. Høyen, the art historian.

REFERENCE: Not listed in Hannover, 1901

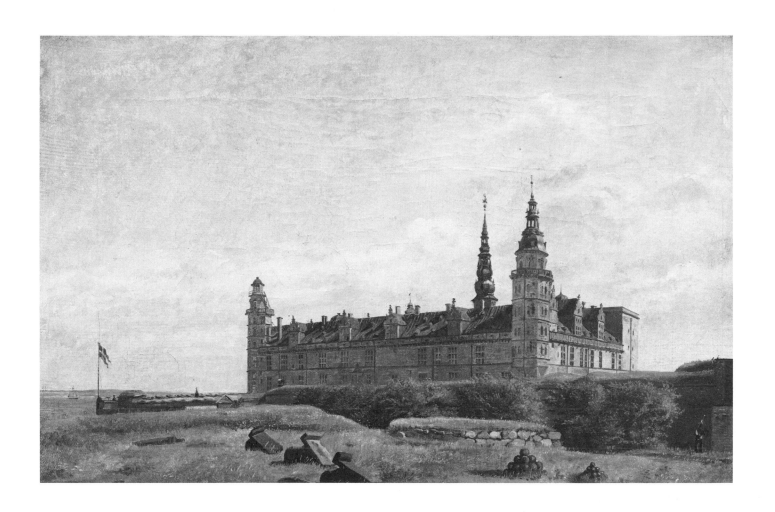

27 The Great Spire of Kronborg Castle (1834)

Canvas, 27 × 17 cm
S.M.f.K., no. 4110

While working on the painting of Kronborg Castle (cat. no. 26), Hansen did a number of detailed studies. "I have drawn the details of the gables," he wrote in mid-June to his friend Jørgen Roed. The drawing is preserved among a number of drawings of the castle in his sketch-book (S.M.f.K.). A few days later, on 19 June, he added: "A couple of smaller studies of the towers are still needed." Four days later he returned to Copenhagen, this small study apparently being his only one of the great spire.

While the sketch of the entire castle shows the same light as the finished painting (i.e. afternoon sunshine and scattered clouds), the study of the tower was done on an overcast day. One senses the bad weather that the painter constantly complained about to Roed.

Both preliminary works show that Hansen learned from Eckersberg's thorough studies of light effects. But the study of the entire castle, in particular, shows that he was better able than his teacher to capture the atmosphere of his subject.

The study of the tower was apparently given by Hansen to Jørgen Roed. In any case it was sold at the auction of the estate of Roed's widow in 1895.

REFERENCE: Hannover, 1901, no. 86

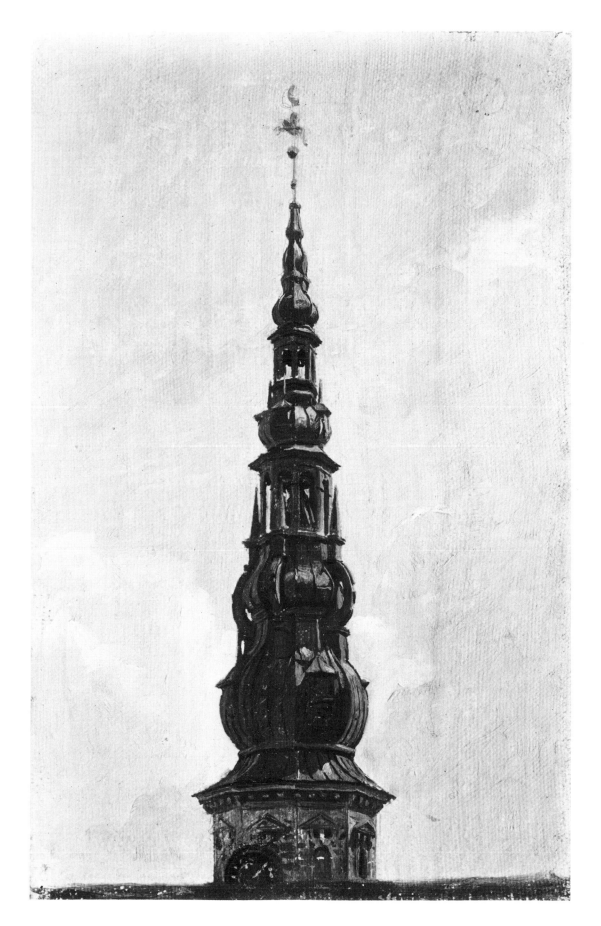

28 Portrait of Hanne Wanscher, née Wegener, 1835

Canvas, 33 × 26 cm. Inscribed, bottom left: *Const.H.1835*
S.M.f.K., no. 3200

From the time of his very earliest portraits made during the second half of the 1820s, Constantin Hansen displayed a pronounced sense of form. His sitters are described with a greater sense of plasticity than are C. A. Jensen's. Whereas to begin with, his models were often shown in a variety of poses, the mid-30s saw a tightening of composition, as in this portrait of Hanne Wanscher. Due to the careful symmetry, the picture possesses a certain classical air. Hansen used the shawl to cover the complicated dress, thus simplifying the forms. As an almost necessary counter-effect to this stylisation, the painter gives us the young woman with her head slightly tilted, so that the figure does not appear so rigid.

In addition, Hansen displays a refined play of colours, found neither in Eckersberg nor Jensen.

Hanne Wanscher (1814–79) was the daughter of the principal of a teacher-training college, and was married to Wilhelm Wanscher (1802–82), a merchant who took a great interest in art.

REFERENCE: Hannover, 1901, no. 90

29 A Group of Danish Artists in Rome, 1837

Canvas, 62.3 × 74 cm. Inscribed, according to early sources: *Roma 1837 C.H.*
S.M.f.K., no. 3236
Illustrated in colour page 54

Two years after leaving for Rome, Constantin Hansen was commissioned to do a painting for Copenhagen's *Kunstforening*, and he painted this picture of a number of Danish artists in Rome. Six painters are shown grouped around Gottlieb Bindesbøll, the architect, who reclines on a Turkish rug, talking about a trip that he and the painter Martinus Rørbye had just made to Greece and Turkey.

N.L. Høyen, the art historian, who had close links to the painters, offered this description of the painting when it was exhibited in Copenhagen in 1838:

"It is no coincidence that the semi-recumbent figure [Bindesbøll] is wearing a high-crowned red cap and rests on a travelling rug, richly decorated in the Oriental manner; these are evidently beloved souvenirs of a journey to Greece. They, together with the warmth in his speech, give us the impression that the words spoken here among silent friends, causing the speaker's coffee to turn cold, are concerned with the wondrous motherland of all art While those listeners who show the greatest interest have placed themselves immediately before the speaker, comfortably listening with their eyes upon him, calmly and slowly tending to pipe or cigar [the painters Albert Küchler and Ditlev Blunck stand to the right on the balcony, and Jørgen Sonne sits on the table], another [Wilhelm Marstrand], standing further out on the balcony, gazes at more distant objects, and a third [Hansen himself], sitting behind the speaker, seems to be less attentive to him than to the audience. The speaker's neighbour [Martinus Rørbye] is toying with his coffee cup in order to have something to do, in a manner that people often use when they have to listen to something that they are well acquainted with."

The painting has given rise to much debate. At the time it was suggested that the painters' grave expressions were due to a cholera epidemic in Rome. A number of art historians have since offered their interpretations of the deeper meaning of the picture. It has been pointed out that all the artists present were considered to be promising talents. Bindesbøll, the architect, was to design the Thorvaldsen Museum (a drawing of the ground-plan is seen on the table to the right). Rørbye, the painter, was probably the most highly esteemed of Eckersberg's students, and the remaining five painters had just had the honour of being commissioned to do paintings for the *Kunstforening*. The painting was thus intended to show a number of young artists of great promise.

Recently, it has been suggested that the painting can be seen as a paraphrase of Raphael's *School of Athens*. Like the Italian Renaissance master, the Danish painter has grouped his persons around a back-lit opening in the centre of the picture. In both cases the persons represent a cultural élite. In both pictures central, contemporary ideas are debated. But while the portals in Raphael's picture lead to higher cognition, Hansen's doors open out to contemporary reality, and ancient philosophers have been replaced by level-headed Danish artists.

Group pictures of artists were at this time especially cultivated in Rome's colony of German artists, whom the Danes frequently met. But among these pictures there is no other that appears to translate Raphael's painting into modern pictorial language. Compared to contemporary depictions of artists, it is unusual, except in a Danish context, in lacking romantic passion and rebellion. Hansen shows us Danish artists of the time as practical, matter-of-fact men, more concerned with their art than with the world surrounding them.

Hansen did preliminary studies of each of those present (most now belong to the S.M.f.K.). He painted himself, however, on the basis of a study by Albert Küchler. The painting met with a somewhat reserved response when it was exhibited at Charlottenborg in 1838, but today it is seen as one of the major works of the Golden Age.

REFERENCES: Hannover, 1901, no. 122
Steen Fridlund Plewing: "Constantin Hansens billede: Danske Kunstere i Rom", in *Kunstmuseets Årsskrift*, LXI, 1974, pp. 50–7
(summary in English: Constantin Hansen's painting "Danish Artists in Rome", pp. 128f.)
Jørgen Birkedal Hartmann: "Roma vista da Copenhaghen nell'Ottocento", in *Urbe*, Rome, 1978, 1–2, pp. 30–44, particularly p. 37

30 A Recitation of "Orlando Furioso" at the Molo, Naples, 1839

Canvas, 93.5 × 118 cm. Inscribed, bottom right: *Const.H. 1839 Roma*
S.M.f.K., no. 393

During a stay in Naples in 1838, Constantin Hansen started on a painting showing a man reading from Ariosto's *Orlando Furioso* at the Molo, surrounded by listeners in Naples. It was a typical, everyday subject, and seen by many others in Naples at the time.

Hansen worked very thoroughly. Apart from a painted compositional sketch (Copenhagen, Hirschsprung Collection), he did several painted studies of individual figures, and his sketchbook is full of studies.

In a letter of 11 August 1838, he wrote the following about the studies: "I have started work on a picture with many figures You should come one morning and watch me go hunting for models on the beach; I see one that I can use, and then the bargaining begins . . . finally an agreement is reached. The fellow is seated and a whole crowd of onlookers turns up; they are all very poor On many occasions it is necessary to make an attempt and then pay without having benefited from it."

The painting itself was done in Rome during the spring and summer of 1839. It is far more detailed than the compositional sketch, and less vivid. On the other hand, it shows a greater concentration on the individual figures. The painting is typical of the large thoroughly worked compositions of the Golden Age.

Hansen may have got the idea for the picture from contemporary accounts of journeys made by his acquaintance Hans Christian Andersen, who in 1834 had witnessed a similar scene: "Went down to the bridge, where a man in a poor coat sat reading aloud from *Orlando Furioso*, with sailors and ragamuffins lying and sitting about and listening." (Diary for 26 February 1834.) In Andersen's novel of 1835, *The Improvisor*, the narrator witnesses a similar scene, seeing "at the end of the place where the lighthouse stands, Vesuvius towering into the air".

But Hansen also had a visual source of inspiration, namely the German painter Friedrich Mosbrugger's *Improvisor at the Molo in Naples* of 1830 (Karlsruhe, Kunsthalle). The Dane could have known the picture from a lithograph made in 1832. The setting is the same — the beach in the Bay of Naples with Vesuvius in the background — and the grouping is closely related. Interestingly, in his sketch Hansen replaced a hexagonal lighthouse with a round tower which is identical to Mosbrugger's lighthouse.

The painting was a great success when it was shown in Copenhagen in 1840 [unlike *A Group of Danish Artists in Rome* (cat. no. 29)]. It was acquired by the Danish king for the Royal Collection (S.M.f.K.) even before the opening of the exhibition.

Among the audience we find Martinus Rørbye, the painter, wearing a grey hat and in the process of lighting his pipe, and behind the reciter's right hand Gottlieb Bindesbøll, the architect, wearing a blue coat.

REFERENCE: Hannover, 1901, no. 169

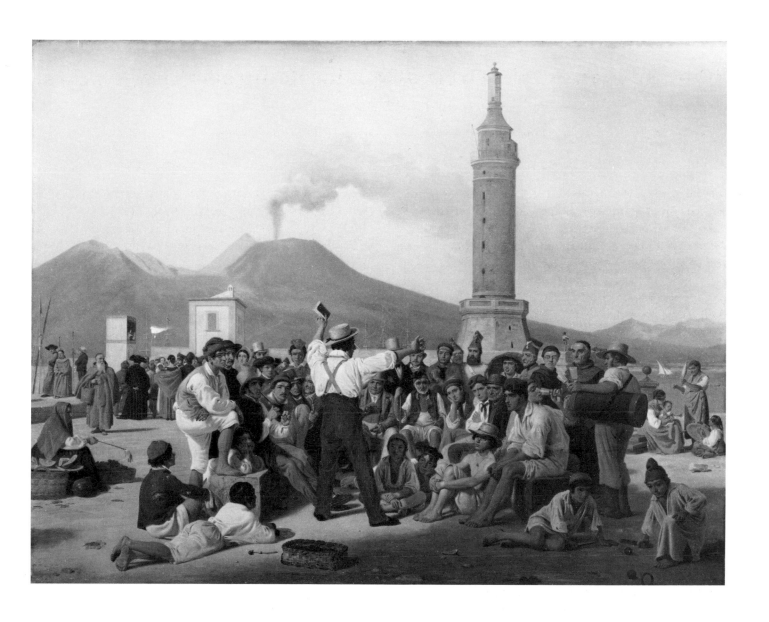

31 The Arch of Titus in Rome, 1839

Paper laid down on canvas, 24 × 29 cm. Inscribed, bottom right: *Const. H. 1839*
S.M.f.K., no. 3679
Illustrated in colour page 55

Constantin Hansen painted the Arch of Titus from an unconventional angle. The arch is not seen in a frontal view, but from the side, resulting in a pronounced fore-shortening of the façade. The picture, therefore, does not give a representative impression of the structure, and was thus not intended as a "tourist" or topographical picture. It was a study made exclusively for the benefit of the artist.

The angle of view clearly shows Eckersberg's influence. This type of foreshortening, setting the face of a wall parallel to the picture plane, is seen in many of his studies of architecture (cat. no. 9). The colouring, on the other hand, differs considerably from Eckersberg's clear, almost schematic choice of colours. Here Hansen displays a far better feeling for the fine, changing nuances of sunlight and shadow. With a picture such as this he comes closer than any other contemporary Danish painter to an Impressionist treatment of colour.

The picture is painted on a sheet of paper which was originally fixed to the lid of the paint-box – a technique used by artists when they painted out of doors.

REFERENCE: Hannover, 1901, no. 172

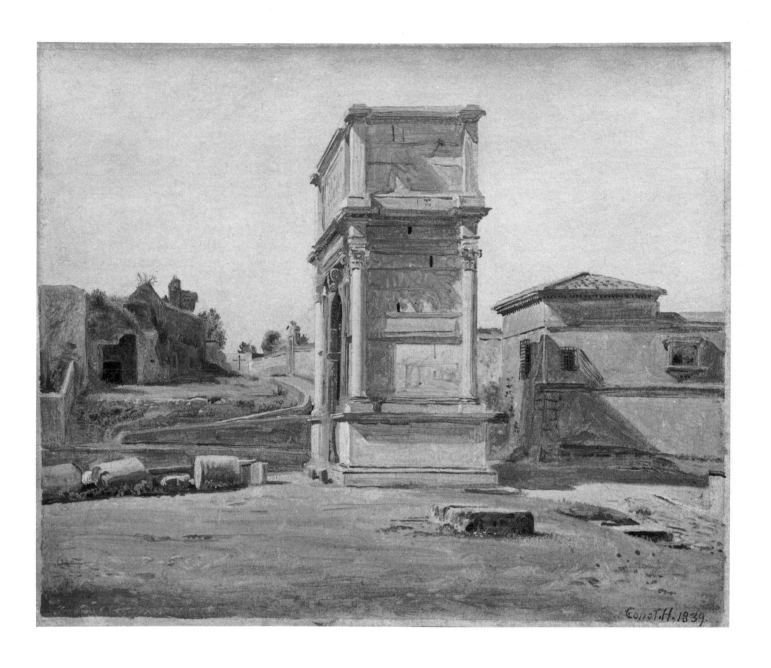

32 In the Gardens of the Villa Albani (1841)

Canvas, 34 × 50 cm
S.M.f.K., no. 3843a
Illustrated in colour page 56

Eckersberg's students frequently painted the same subjects that their teacher had painted about twenty years earlier. In 1829 Ditlev Blunck, the painter, wrote to Eckersberg:

"How often, during all my excursions in vast Rome, do I find myself in my mind's eye in your pleasant, little room [at Charlottenborg], where hang all the small pictures that you painted here in Rome. On many an occasion I have been delighted to go to the very places where you might have sat at work, even more so now that I myself, almost every afternoon without exception, am busy doing such nature studies. It often occurs to me that in Rome everything has been built and planned for the benefit of the painter."

While in Rome, Eckersberg painted a view of the gardens of the Villa Albani, with the nursery and the orangery as the central subject. Constantin Hansen also sought out the famous villa, but selected another part of the gardens – the view from the entrance down one of the avenues. The two pictures are also constructed along essentially different lines. Whereas Eckersberg employs a diagonal wall as the main axis of the picture, Hansen's composition is roughly symmetrical, built up around a centralised perspective. The difference is more or less characteristic of the two painters. It is also typical of Hansen that he has shifted the central point (the distant pillar) slightly to one side, so that the construction becomes less schematic. This alteration would suggest that the painter is interpreting a Renaissance concept of space from the outlook of a nineteenth-century painter – reality never quite corresponds to the ideal.

REFERENCE: Hannover, 1901, no. 222

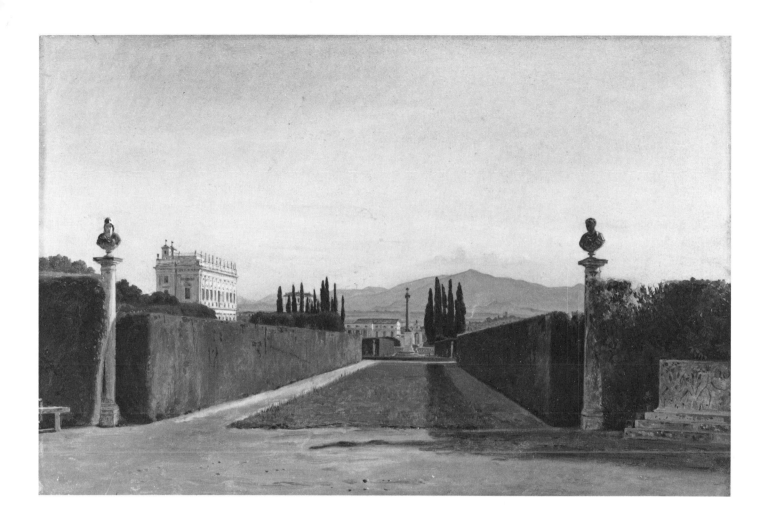

33 Prometheus moulding Man from Clay, study for the Fresco in the University of Copenhagen (1845)

Paper laid down on canvas, 37 × 39.5 cm
S.M.f.K., no. 3665

After his return from Italy in 1844, Constantin Hansen set to work on the fresco for the vestibule of the University. It was an ambitious project, and should be viewed in the context of contemporary attempts to revive the Grand Style and create new monumental, history paintings based on the ideas of the ancient world.

Hansen seems to have been commissioned for this work about as early as 1838, and he had prepared for the task during his stay in Italy. He copied several antique frescoes in Pompeii (his copies now belong to the Royal Academy of Fine Arts in Copenhagen). Around 1840 together with Georg Hilker, the decorative painter, he did several studies for the mural (Royal Academy and the Hirschsprung Collection). They were approved in 1843, and Hansen was recalled to Denmark in order to begin the decoration itself. On his way home he stopped in Munich to study fresco technique at Peter Cornelius's school.

The painting shown here is a small oil sketch for the painting of Athene bringing to life the clay figure made by Prometheus. Each figure was based on studies from the nude (several belong to the S.M.f.K.). It seems, however, that the painter had difficulty in proceeding beyond these studies, and the attempt to revive the ancient world has not really been successful. In view of the theme of the picture, which is no less than the creation of man, the interpretation is surprisingly tame.

Danish painters of the nineteenth century were too thoroughly trained in the study of reality, and lacked the visionary imagination that was a prerequisite for a successful school of mythological painting.

REFERENCES: Hannover, 1901, no. 4 b
Vilhelm Wanscher: "Constantin Hansen (1804–1880) et les peintures du Vestibule de l'Université de Copenhague", in *Artes*, IV, Copenhagen, 1936, pp. 3–51

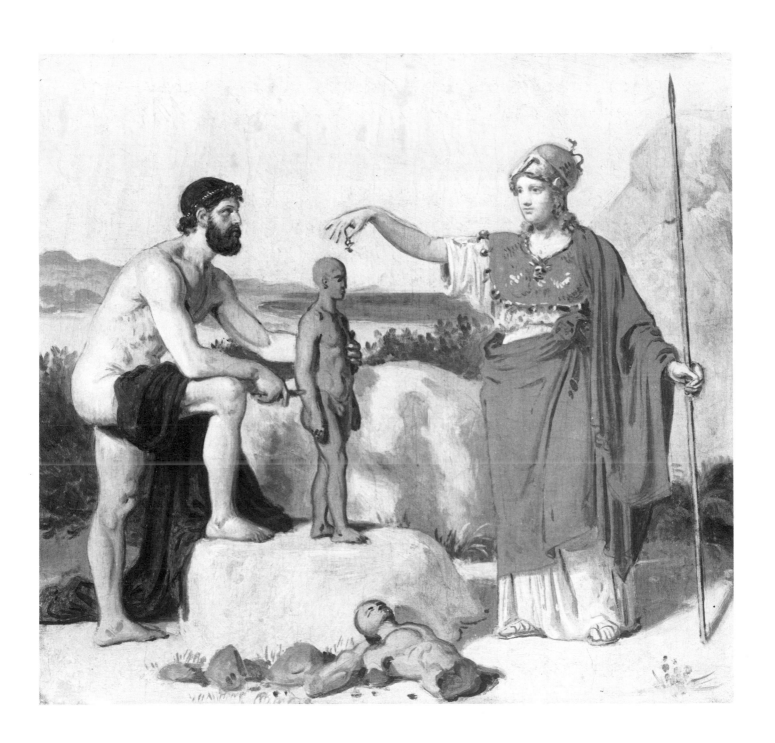

34 Portrait of Elise Købke, 1850

Paper laid down on canvas, 39 × 35.5 cm
S.M.f.K., no. 3388

After his journey to Italy, Constantin Hansen's classical training was best expressed in a number of portraits of young girls. In these not only the poses but also the treatment of form show an obvious simplification and monumentalisation. Although it is difficult to know to what extent the appearance of his sitter brought with it a certain simplification, Hansen exploited her looks to the full in this severe, almost solemn portrait. Hansen paid more attention to plasticity in his later years than in his earlier close observations of the play of colours. He left some notes on art, in which he emphasised "the decorative whole", and in one instance writes:

"The perfect imitation, the complete illusion is not art's purpose. It is decidedly not the artist's objective to copy nature . . . He renders what is essential to the character of the piece, leaves out the insignificant, rounds off or intensifies the expression according to the demands of his work as a whole."

With Eckersberg we do not find a similar "processing" of visible reality; he staged his subjects, but stuck firmly to what he could see. But we find similar attempts among several of Hansen's contemporaries, principally Købke, as is evident from as early as the mid-1830s (see cat. no. 58, *The Artist's Sister*).

The sitter is Elise Købke (1846–79), the daughter of one of Christen Købke's younger brothers.

REFERENCE: Hannover, 1901, no. 263

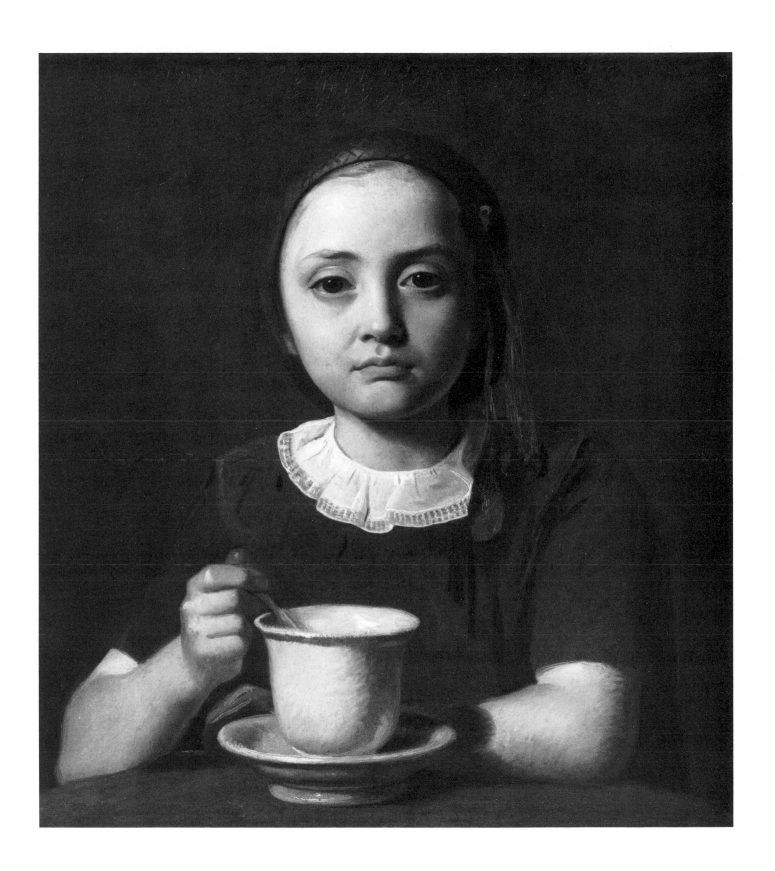

35 Sketch for "First Meeting of the Constitutional Assembly" (1860)

Canvas, 41.3 × 63 cm
S.M.f.K., no. dep. 130. The property of the *Folketing* (Parliament); on permanent loan to the Statens Museum

In the years 1860–4 Constantin Hansen painted the huge, monumental painting of the Constitutional Assembly, which in 1848 brought absolute monarchy to an end and introduced democracy (now in the National History Museum, Frederiksborg).

The artist had become interested in group portraits during a journey to Holland in 1858, where he had been particularly enthusiastic about Van der Helst's civic guard pictures, and the generous offer of support from Alfred Hage, a merchant and politician, made it possible for him to paint the historical portrait.

It was a time-consuming task, since he had to do a great number of portrait studies of the leading politicians of the time. He also did this sketch of the hall at Christiansborg Palace where the assembly held its meetings. It was presumably done as early as the summer of 1860, as indicated in a letter dated 22 May of that year: "If possible I should like during the light early summer to paint a sketch of the Hall in the *Folketing*."

Hansen knew how to take advantage of the summer light, as is quite evident from the painting. The description of the hall is determined by the severe linear system created by the stripes in the carpet and the tables. The light, falling through the windows concealed in the niches, shines on to wall surfaces, tables and floor. Light and colour were of lesser importance in the many portraits he made during this period, but this study shows that he had preserved his fine ability to register the play of light and shadow.

This painting is one of the very last architectural paintings in the Eckersberg school, and as such it marks the end of an epoch.

REFERENCE: Hannover, 1901, no. 404

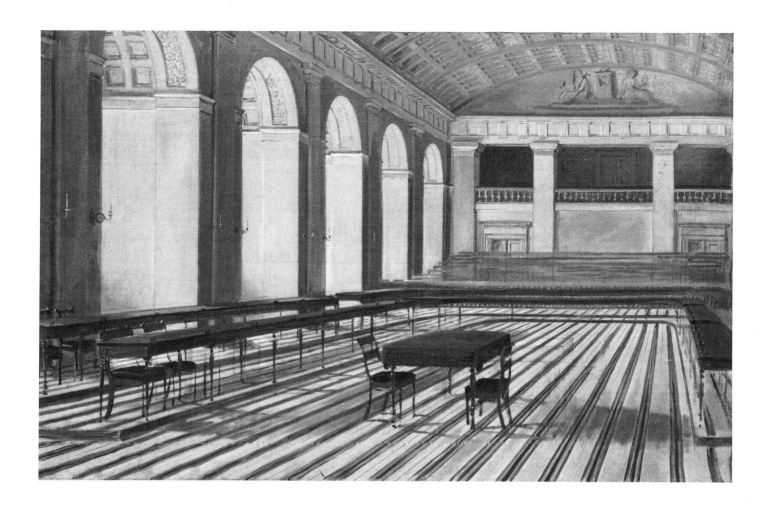

Jørgen Roed, 1859, by H. W. Bissen (1798–1868)

JØRGEN ROED 1808–1888

In his youth, Jørgen Roed attached himself to Eckersberg and became one of the finest architectural painters in his generation of students. Later he took up portraiture and religious subjects. His importance is mainly to be found in his perfect sense of space and light, which is to be seen at its best in his architectural paintings.

Jørgen Roed's talent was acknowledged even when he was at school, and he enrolled at the Academy at the age of fourteen. He also received private tuition from Hans Hansen, a minor portrait artist, and became close friends with his son Constantin. Apart from doing a number of copies at school, he seems to have been mainly preoccupied with portraiture. It was only in 1828, on the death of his teacher, that he became a student of Eckersberg, who in 1830 made a note in his diary that Roed had made some "beautiful impressions from nature". At this stage he nourished his interest in architectural painting, which was to be his main field until the beginning of the 1840s. Around the time that Købke painted his first significant architectural picture of Aarhus Cathedral (cat. no. 48), Roed, together with Constantin Hansen, painted in 1829 the church in the Zealand country town of Ringsted, his own hometown. Both painters chose the same section of the building, the chancel seen from the southern aisle. Roed's painting shows the interior of the church empty (Sorø, Kunstmuseet) while Constantin Hansen's picture has figures in it (S.M.f.K.). He took up architectural painting seriously in 1834, when the *Kunstforening* (the Copenhagen exhibition society) arranged a competition for a painting of a building or public place in Denmark. Encouraged by N. L. Høyen, the art historian, he cultivated the historical monuments of the Middle Ages and the Renaissance. In a letter to the architect Gottlieb Bindesbøll written in October 1834, he gives an account of his work: "On my way back to Ringsted I passed through Roskilde, where I stayed for a few days drawing several beautiful views of the church . . . After a few days in Ringsted, I went on to Frederiksborg, where I spent a day eagerly drawing . . . As you can see from the above notes, I am getting to grips with architecture." For the competition he worked on a subject from the so-called *Karruselgård* by Frederiksborg Castle. But he didn't manage to finish in time, and Constantin Hansen won the competition with his painting of Kronborg Castle (cat. no. 26). The competition was repeated in 1835, however, when Roed won it. The following year Roed was busy with his paintings of the cathedrals in Roskilde (cat. no. 36) and Ribe (cat. nos. 37 and 38). In 1837 he went to Italy, searching out several of Eckersberg's former subjects. He continued on to Naples, and in Paestum and elsewhere did a number of studies of the ancient temples.

After his return to Denmark in 1841, architecture took a lesser place in his work. His treatments of his new subject-matter (portraits and altarpieces) do not generally equal his early architectural paintings. He also tried his hand at genre pictures, being influenced by Høyen's call for paintings of "national" subjects. In 1862 he became an Academy professor, but by that time he had lost touch with newer developments in art.

36 Roskilde Cathedral, 1836

Canvas, 80 × 77 cm. Inscribed on the house bottom left: *I. ROED. 1836.*
S.M.f.K., no. 3099

On his way to and from his parents' home in Ringsted, Zealand, Jørgen Roed passed through the country town of Roskilde, and in 1834 he stopped to study the cathedral there where the tombs of the royal family are housed. To begin with he did a number of drawings of the medieval building, and in 1835–6 several paintings, among them this winter scene. The artist wanted to emphasise the majestic scale of the cathedral, and accordingly included figures and the small houses in the foreground.

During his stay in Rome, Eckersberg had eagerly studied medieval architecture. But Roed's painting differs significantly from his teacher's architectural work in the monumental perception of the subject. Both the large format and the more representative treatment of the building separate Roed from Eckersberg. The changed attitude undoubtedly had something to do with the passion for the Middle Ages which had travelled from Germany. In the years following 1815, several German-orientated Romantic artists had shown paintings of medieval churches at Charlottenborg, among them the Danish-Norwegian painter J. C. Dahl. During his stay in Germany in 1822–3, N. L. Høyen, the art historian, founded his interest in the Middle Ages, and, after being appointed Professor of Art History in 1829 at the Academy in Copenhagen, he directed the attention of young painters to old Danish monuments.

Compared to paintings of medieval churches by orthodox German Romantics like C. G. Carus and K. F. Schinkel, Roed's painting is moderate in its treatment. Here, the level-headed spirit of Eckersberg is dominant.

General interest in the Middle Ages was further strengthened by the violent revival of nationalism after the first clash in 1830 between Danish and German sympathisers in the Danish duchies of South Jutland.

Being a committee member in the *Kunstforening*, Høyen could exploit such public sentiment when competitions were arranged, and he was the prime mover when in 1833–5 the *Kunstforening* published a work on Roskilde Cathedral, with eight copper plates.

One of the prints shows the cathedral from exactly the same angle as Roed, although the medieval houses shown by Roed in front of the church are not included. The print also shows the new sepulchral chapel in the south (built 1774–1825 by the architect C. F. Harsdorff). Roed concealed it behind the snow-covered trees, probably at the suggestion of Høyen, who opposed the building of new extensions. All told, Roed's total view of the cathedral lives up to Høyen's demands, as he put them in a letter to the chairman of the *Kunstforening* (about 1830–1): "As an architectural work of art the general view is the best it has to offer; details reveal far too clearly that the builder could not master his material, and that he also had no understanding of the forms he used . . . As an historical monument too, the view will suffice . . . This building is one of the many links in that chain that unites present day culture with ancient times."

When the painting was shown at Charlottenborg in 1836, one critic claimed to find certain errors in the shadows, but added, "These errors are merely comparable to rainspots on a shiny windowpane. The cold colouring of the deep shadows against the sunlit snow, the sunlight on the cathedral windows, the relationship between the light and shaded parts of the building, in short, the delineation and colouring are so splendid that one hardly has time to wish that the rendering of the shadows in perspective had been better. This work is decidedly poetic."

The painting is one of the very few winter pictures of the Danish Golden Age.

37 The Interior of Ribe Cathedral (1836)

Canvas, 35.5 × 33 cm. Inscribed on the reverse: *18 JR (in monogram) 3(?)*
S.M.f.K., no. 1331

In March 1836, the *Kunstforening* in Copenhagen set a prize subject entitled: "A representation of the exterior or the interior of the Cathedral in Ribe, being one of the architecturally most splendid medieval buildings in Denmark." The man who had formulated these words was N. L. Høyen, and the intention was not merely to get an architectural painter to depict the cathedral in Ribe as it looked. Between 1829 and 1833, Høyen had travelled widely in the country in order to study older, Danish architecture, and during a three-week stay in the country town of Ribe (Southern Jutland) in 1830 he established that the cathedral was in a serious state of disrepair. It was thus Høyen's plan that the cathedral be shown as it ought to look, and he doubtless explained this to Jørgen Roed, the only competitor, before the latter went to Ribe in 1836. On his arrival there he wrote (on 21 June 1836) about his imminent work to his fiancée Emilie Kruse: "... I simply must do a sketch of the exterior, but I believe that I shall do the interior while here, it will cost me a lot of work to remove much that cannot be used in the painting, but I trust you agree it will work out?"

Here Roed showed himself in agreement with Høyen's principle of restoration – namely, that historical monuments should be freed of later additions and brought back to their original condition. This is evident from an account the painter sent to the *Kunstforening*'s periodical *Dansk Kunstblad* in September 1836: "In my painting, the church is seen from the southwestern end of the middle passageway [the nave] looking towards the altar, thus giving a view into the two side passageways [aisles] to the left. I have removed the organ and the galleries, also the mortar from the pillars and the granite copings, in order to show the granite. In general, I have attempted to give it an appearance that, in my opinion, with a little effort it could and should have."

The removal of the organ played an especially important part, as it obscured the apse windows: "the organ is placed directly above the nave, cutting it off so as to completely hinder a view of the choir." In other words it was quite a dark place as we can also see from Roed's description: "There is only a little light; inasmuch as the light falls only sparsely through the side windows that have been half walled up." This impression is corroborated by "a young scholar" (Høyen?), writing in the same issue of *Dansk Kunstblad*: "I was particularly struck by the light, as I stepped up into the choir from the somewhat dark church, and felt particularly enlivened by the light streaming down." Roed chose to change the light effect radically as is evident even in this painted sketch which he did while still in Ribe. There are no sharp contrasts. The soft, evenly dispersed daylight gives the interior a feeling of unity which it did not have at the time. What appears to be a reproduction of visual impressions, then, is to a great extent a construction. The lighting of the interior relates more to a seventeenth-century Dutch church painting than to reality. Yet the sketch shows the painter's ability to register the varying nuances in the building's brickwork and floor. The artist has selected the angle of view most representative of the interior of the church, the nave seen towards the choir. This is the traditional angle of view in church interiors, but is extremely rare in Danish architectural views during the Golden Age. Eckersberg tended to select less traditional angles, for example the choir seen from the transept – as did his students (among them Købke, Constantin Hansen and Roed himself) when in 1829 they painted interiors of the cathedral in Aarhus (see cat. no. 48) and the church in Ringsted respectively.

In the autumn of 1836 Jørgen Roed painted the subject in a large format (Copenhagen, Hirschsprung Collection), winning the offered prize. When the painting was put on show at Charlottenborg in April 1837, a critic praised the changes Roed had made in the church interior, but commented on the somewhat unnatural lighting: "The lines of perspective are fine, and the architectural ornaments splendidly perceived and rendered. But the picture seems to be lacking in force, mainly in the shaded parts of the vaults, although we do believe that the light in the church approaches what the artist has shown us. But the tone of the granite pillars must necessarily be weaker in the choir than in the foreground, which is not the case here."

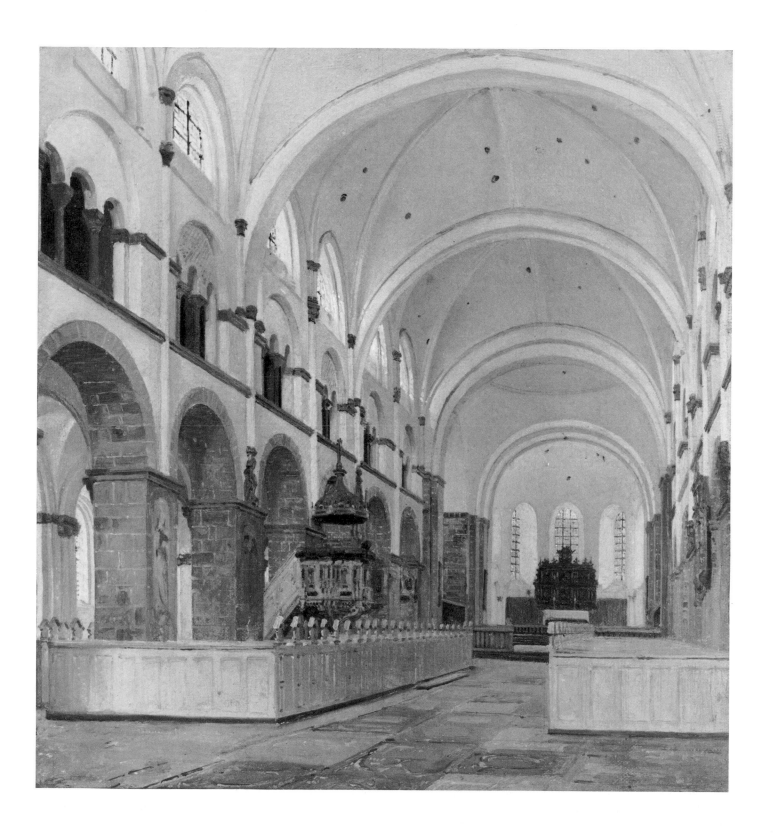

38 Ribe Cathedral (1836)

Paper laid down on canvas, 30 × 38 cm
S.M.f.K., no. 3798

While Jørgen Roed was working on his painting of the interior of Ribe Cathedral (cat. no. 37) he also did a study of the exterior of that church. From the outset he knew that it was the painting of the interior that he was going to submit for the *Kunstforening*'s competition. He wrote about the exterior of the building: "The church has been whitewashed a number of times, but most of this has been worn off by the western winds and rain, giving the walls a strong play of colours. I have done a sketch of the exterior, but the interior is what I have done for the *Kunstforening*, as it, more than the exterior, has resisted wear." Here, Roed shows the church as it really looked, but he has been careful to select the angle of view that presents the Romanesque cathedral most splendidly. The building could be seen from a distance only from the north and east since the remains of a former convent obscured the south side, and the western façade was in severe disrepair. The building looked best from the north-east, with its Romanesque apse and transept and the spireless Gothic tower looming against the sky.

The cathedral has a markedly Italian character in Roed's painting. This could have something to do with Roed's knowledge of one of Eckersberg's more tourist-like Roman views, that of *Sant'Agnese fuori le Mura* (1815, S.M.f.K.), where the church building and the towering steeple are also seen silhouetted against the sky.

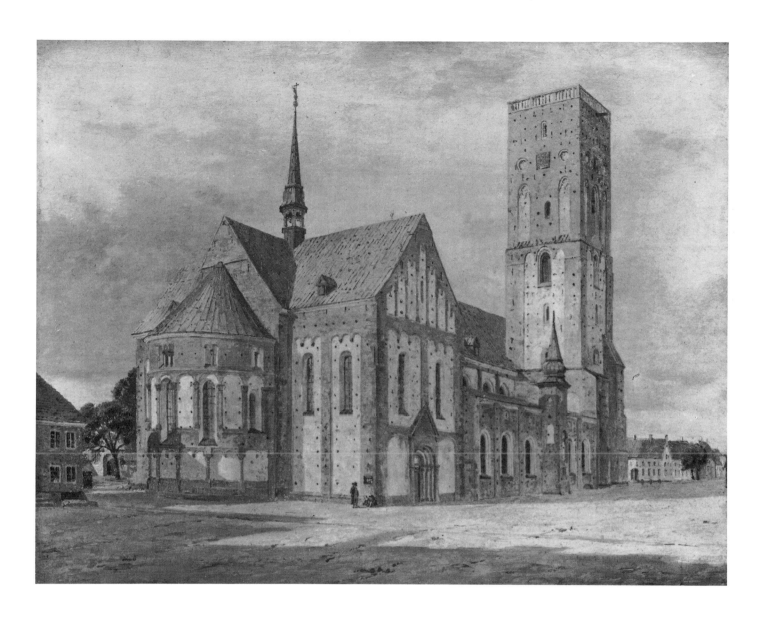

39 The so-called Temple of Poseidon at Paestum, 1838

Paper laid down on canvas, 26 × 24 cm. Originally inscribed on the reverse: *J.R. 1838*
S.M.f.K., no. 1332
Illustrated in colour page 57

While living in Italy Roed went with Constantin Hansen to Paestum where they both did several paintings of the ancient temples. The previous year, in Rome, Roed had painted a couple of paintings of San Lorenzo fuori le Mura that almost repeated Eckersberg's compositions. In this study of the so-called Temple of Poseidon (now known as the Temple of Hera), his teacher's influence also shows clearly. He has come close up to the ruins, avoiding a clear, general view, and diagonals dominate the composition. The picture is sketch-like in its handling, but the artist has, nevertheless, meticulously rendered the dilapidated columns and ashlars, as well as the vegetation that has spread through the ruins. The pronounced effect of light and shade and the circling of the black birds contribute to the picture's impressionistic character.

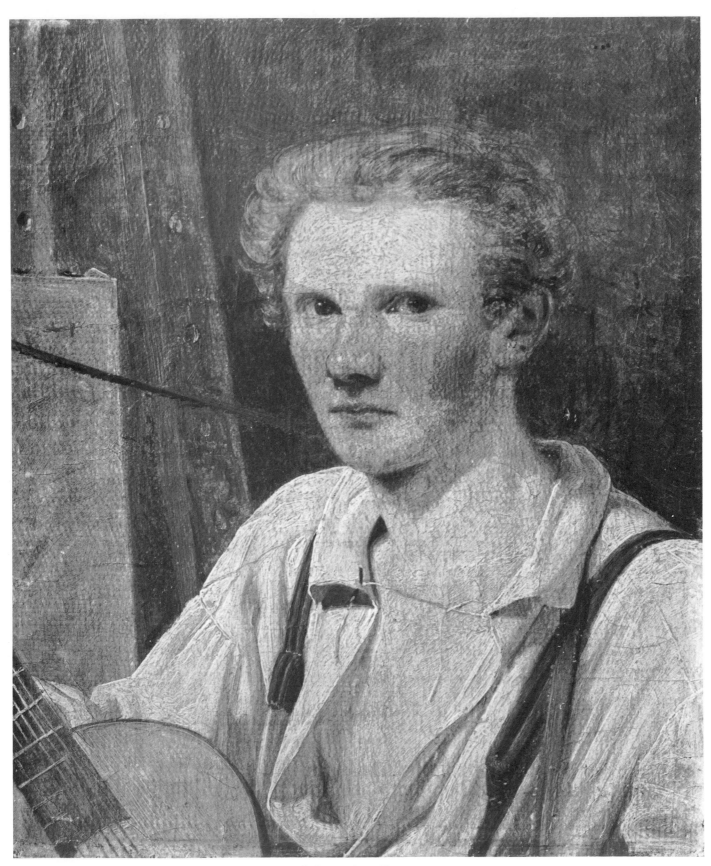

Wilhelm Bendz: *Self Portrait*

WILHELM BENDZ 1804–1832

Wilhelm Bendz introduced the middle-class conversation piece into Danish art. He did several, some showing artists in their studios, others of family groups or circles of friends in their Copenhagen homes. He was a student of Eckersberg, but his preference for complex light effects and for complicated compositions went beyond the boundaries of his teacher's art. Furthermore, several of his paintings conceal a symbolism which was atypical of the Golden Age. As a colourist he came to influence painters such as Købke, Constantin Hansen and Marstrand.

Wilhelm Bendz entered the Academy in 1820 and was thus one of the first to be influenced by the newly appointed Academy professor, Eckersberg. As early as 1822 he received personal tuition from Eckersberg, although he did not often visit his teacher's studio. On 5 May 1827, Eckersberg made the following entry in his diary: "After four years absence, Bendz was here again." In the interim he had attended classes at the Academy. It seems that he was also influenced by contemporary German painting, although precisely how this came about cannot be determined, since there is no evidence that he went abroad during this period. Possibly German students at the Copenhagen Academy acted as intermediaries – or perhaps the painter Ditlev Blunck (see cat. no. 40), who was in Munich from 1818 to 1820, was the go-between. The years after 1827, however, saw a close relationship between Eckersberg and Bendz.

In 1826–7 Bendz exhibited a number of pictures of artists at work, which attracted considerable attention. In 1827–8 there was the brilliant *Smoking Club* (Copenhagen, Ny Carlsberg Glyptotek), in which he experimented with dramatic chiaroscuro effects. At the time it was criticised for its imperfect anatomy, but today it is seen as one of his most successful paintings. In this picture there are several striking parallels to *The Chess Game* of 1818–19 (Berlin, Neue Nationalgalerie) by the German Johann Erdmann Hummel.

In 1831 Bendz embarked on his Grand Tour travelling to Munich via Hamburg, Berlin and Dresden (where he visited J. C. Dahl). He stayed there for one year, completing his great painting of artists gathered in *Finck's Coffee-House in Munich* (later acquired by Bertel Thorvaldsen). It would appear that he planned to settle in Munich after his stay in Italy. In the autumn of 1832 he travelled south, but got only as far as Vicenza where he died, twenty-eight years old.

Wilhelm Bendz strongly influenced several artists, including contemporaries and some from a slightly younger generation. He became something of a legend within a narrow circle, but was soon forgotten by the public. In a lecture of 1866 the art historian N. L. Høyen celebrated the painter who died so young: "Wilhelm Bendz was one of the first among Eckersberg's students to receive with love impressions from the life that surrounded him. He could not seek it widely; he sought it in the studios of his friends, and in the life class where they stood drawing. But he rendered the impressions he received so strikingly, with such fullness, and such power considering his youth, and with such decisive conviction that he was bound to have a great impact on his fellow students."

40 A Young Artist examining a Sketch in a Mirror, 1826

Canvas, 98 × 85 cm. Inscribed, bottom left, under the mirror: *VF BENDZ 18 28/3 26*
S.M.f.K., no. 280

A young artist has briefly taken his painting off the easel, and is examining it in the mirror in order to ascertain whether the composition balances. The picture gives a glimpse of conditions of work for painters at that time, but should not merely be seen as a genre piece or as the portrait of a particular painter. It is also an allegory on the nature of art. A zigzag movement through the dense pictorial space takes the eye from the paint-box and brushes to the easel and on to the artist. The mirror image of the painting is symbolically suspended above the skull (the old symbol of *vanitas*) – the immortal part of man elevated above the mortal. In other words, man, by means of art, may reach immortality. The bird in the cage is also symbolic of the imprisoned soul. Simultaneously, Bendz plays on art's function as a mirror of reality – we do not see the actual picture in the hands of the artist, only the reverse side of the canvas, and have to make do with the mirror image.

This kind of symbolism was not typical of the Golden Age. It leans more towards German art. Nor was the symbolism, when the picture was exhibited in 1826, understood by the portrait artist Hans Hansen in a review of the exhibition: "It . . . is truly a splendid production, mainly in the brushwork. The effect may have been more pleasurable, and the painting more beautiful, had the artist not attempted to show us so many things that, seen one by one, are very beautifully painted, but tend to distract from the whole. Young and less experienced artists are too fearful of emptiness and poverty, and easily give in to the opposite error, especially as they do not always know how to put together the objects they wish to render in an artistic manner that corresponds to their intentions." But the painting was bought for the Royal Collection (now S.M.f.K.) as early as 1826.

In the painting the artist Ditlev Blunck (1798–1854) is seen portraying his colleague Jørgen Sonne. The sketch in his hands is a study for a larger work of 1823 (now in the S.M.f.K.).

REFERENCE: Mogens Nykjaer: "I kunstnerens vaerksted" (with a summary in German: *In der Werkstatt des Künstlers. Über Wilhelm Bendz*), in *Kunstmuseets Årsskrift*, LXIV–LXVII, 1981, pp. 37–47

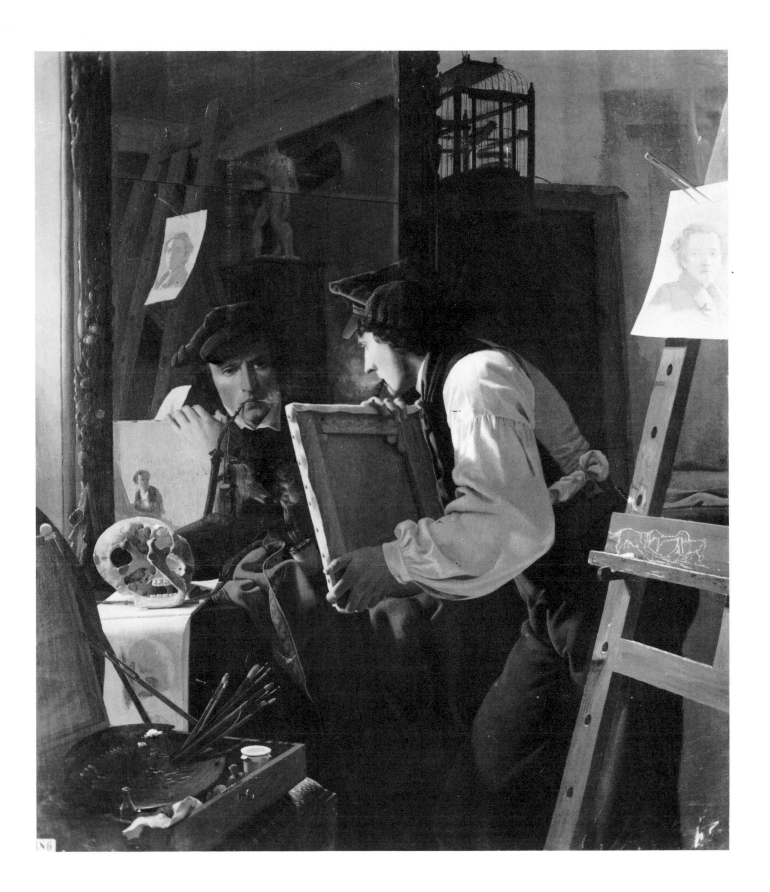

41 The Actor Christoffer Hvid

Canvas, 38.5 × 31 cm
S.M.f.K., no. 3262

In addition to his ambitious portraits of artists and middle-class family pictures, Wilhelm Bendz also painted several small, simple portraits in which there can be traced a close attachment to C. A. Jensen as well as to Eckersberg. The meticulous technique of this painting is close to Eckersberg's, but the perception of the model is related to Jensen's portraits.

The portrayed person was the actor Christoffer Hvid (1803–72). For a short while in 1829 he was engaged to Johanne Louise Heiberg, *née* Pätges, who has been described as the greatest Danish actress ever.

The creation of the picture is not documented, and its attribution to Bendz is based on information from the actor's daughter, who in 1903 bequeathed the painting to the museum, and said that the painter was "a friend from father's youth". She further wrote, "It would delight my old mother if she could add to the number of pictures by Bendz in the Gallery."

From Eckersberg's diary we know with certainty that Bendz' friend, the lithographer Peter Gemzøe (1811–79), painted in 1833 a portrait of Hvid. Gemzøe was a student of Eckersberg and also strongly influenced by Købke and Bendz. It has recently been suggested that there has been a confusion of the names of the two artist friends. However, only little is known about Peter Gemzøe's very limited activity as a painter, and it is thus difficult to settle the question.

An anonymous portrait in a private collection, however, is now (1984) identified as Gemzøe's portrait of the actor. This supports the attribution to Bendz of this painting. But whoever painted it, it is a typical example of a portrait from within the circle of students closest to Eckersberg.

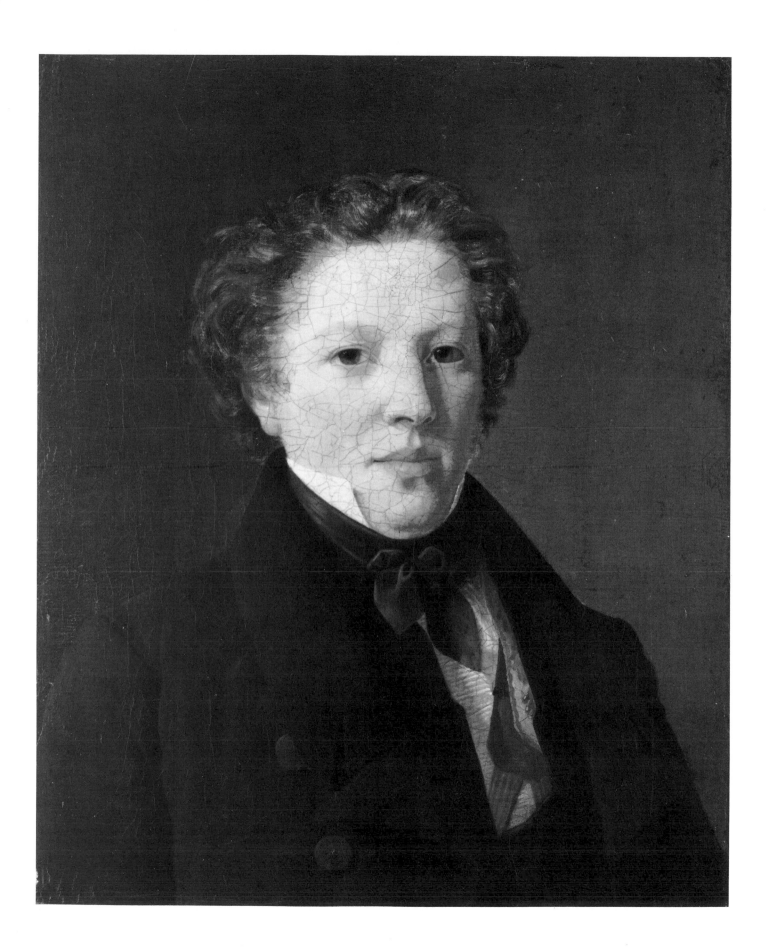

42 A Gateway to a Coach-House, Partenkirchen, 1831

Paper laid down on canvas, 33 × 26.5 cm. Inscribed, lower left: *Partenkirch WB. (in monogram) 18 28/9 31*
S.M.f.K., no. 4081

Immediately before Wilhelm Bendz embarked on his journey abroad in December 1830, Eckersberg saw to it that he was well prepared. On 5 November, ''Bendz received some instruction in perspective'', as Eckersberg noted in his diary. This was repeated a couple of times in the following weeks. It was presumably also at this time that Bendz copied one of his teacher's Roman views (of the Church of Sant' Agnese fuori le Mura, now in Ribe Kunstmuseum). That Bendz learned from Eckersberg's instruction is evident from several of his late works and not least from this painting of a coach-house in Partenkirchen (Bavaria), painted shortly after his arrival in Munich in mid-September 1831. It is one of the very few pictures by Bendz where architecture is the central theme. There is a classical tautness in the composition of the picture, which was not in evidence in his early work. The painting also shows that he mastered perspective – in July 1830, Eckersberg had had to assist him with the perspectival construction in a painting. The fine rendering of natural light spreading through the distant gate, too, could be attributed to Eckersberg's influence. The sparse description of the coach-house reminds one of Eckersberg's exhortation to ''draw from nature, no matter what it is''.

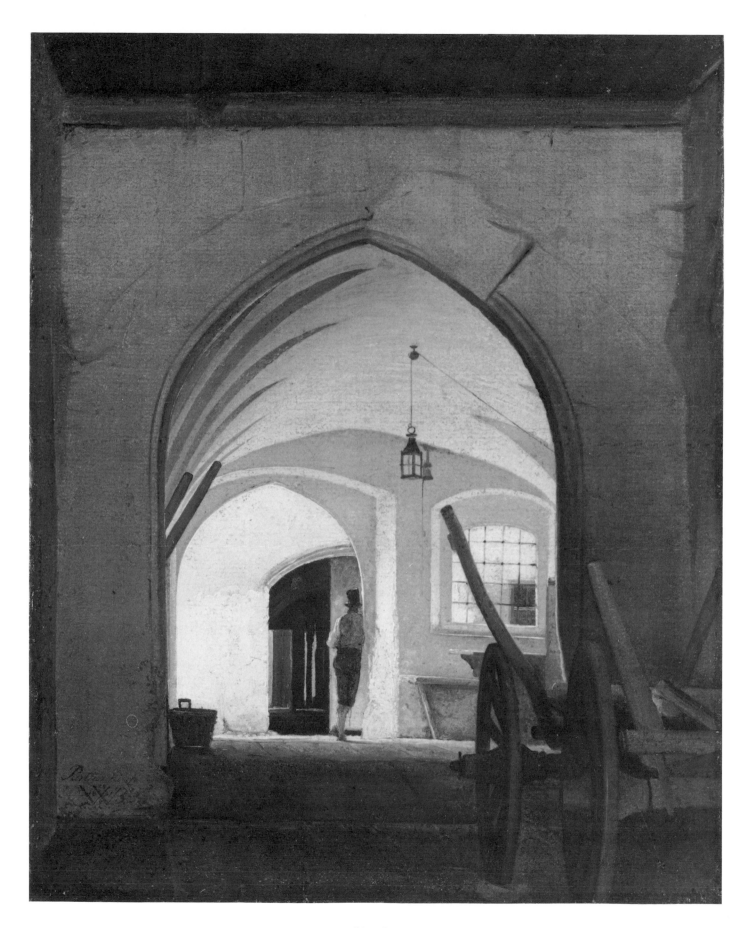

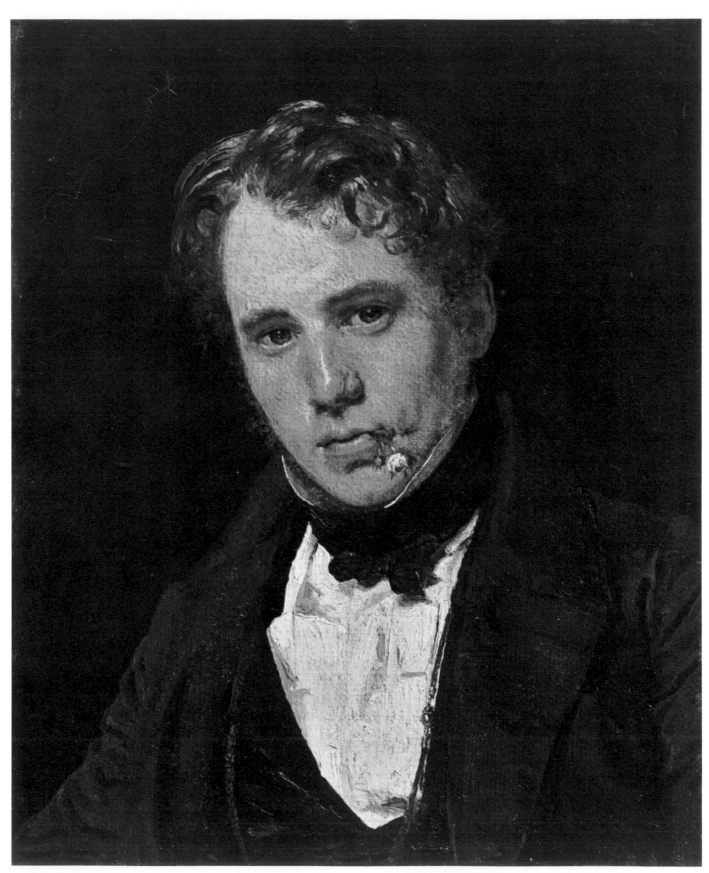

Wilhelm Marstrand, 1836, by Christen Købke (1810–48)

WILHELM MARSTRAND 1810–1873

Narrative and illustration as such meant more to Wilhelm Marstrand than to any other of Eckersberg's students. But although genre painting and subjects taken from literature were very important to him, he was also a highly productive portraitist. He took no interest in architectural painting. He was extremely prolific as is evident from his often very sketch-like paintings. Although he was Eckersberg's favourite student, he imitated neither his teacher's subjects nor his style.

Marstrand enrolled in the Academy in 1825. His father was a friend of Eckersberg and the young Academy student studied privately with the Academy professor as early as 1826, three years before graduating to life class. He remained at the Academy until 1833. At that time he was mainly preoccupied with pictures of crowds in Copenhagen, but also did a number of portraits, some on commission, in addition to small pictures of artist friends.

Even before beginning his actual training as an artist he had drawn copies from Bartolomeo Pinelli's etchings of Italian street scenes. In his conversation pieces, he adopted the latter's partly humorous, partly idealising attitude, often infusing them with his own ironical objectivity. The character of his Italian subjects was thus determined by the time he arrived in Rome in 1836. There he became a large-scale supplier of touching and amusing pictures of Italian street scenes. The best-known painting from his Italian period is *The October Festival* (1839), which was bought by the sculptor Bertel Thorvaldsen (now in the Thorvaldsen Museum, Copenhagen). In his picture *A Group of Danish Artists in Rome* (cat. no. 29) Constantin Hansen shows Marstrand characteristically turning his back on the other members of the group, more interested in observing life in the streets of Rome.

In 1841 he was back in Copenhagen, where illustrative pictures became predominant in his production. He specialised in illustrating plays by the Danish author and playwright Ludvig Holberg. From 1845 to 1848 he was once more in Italy. In 1848, on the death of Rørbye, he was appointed professor at the Academy in Copenhagen. In his later years he also took up history painting, his most important contribution in this field being his monumental painting (1863–6) of the Danish king, Christian IV, on his ship *Trefoldigheden* (Roskilde Cathedral).

Neither in colour nor in plastic expression was Marstrand the equal of his artist friends Christen Købke and Constantin Hansen. His attitude towards foreign art is seen from a letter he wrote in "Rome at Shrovetide, 1846: My journey here was partly interesting, Amsterdam, and Holland in general, the best. I have had the useful pleasure of seeing the great full-length pictures by Van der Helst, Bol, Rembrandt, Hals, and several marvellous pictures by Jan Steen. As far as painting is concerned, Amsterdam is the most interesting city I have seen outside of Italy. In Paris it was the African pictures by Vernet, and Delaroche's great picture in the Academy that gave me the most pleasure. It is painted on the wall in oils, giving a splendid effect."

One may wonder, knowing Marstrand's brilliant, sketch-like painting technique, that he apparently had no knowledge of Honoré Daumier's art. In 1865–9, for example, Marstrand did twenty lithographs for an edition of Cervantes' *Don Quixote*.

Thanks to his sure narrative technique, Marstrand won wide popularity, greater than that of any contemporary Danish painter. Around the turn of the century the art critic Karl Madsen described him as "the greatest genius in Danish painting", and as late as 1920 the art historian Oppermann said that he was "after Thorvaldsen, Denmark's most richly endowed artist". Since then, his reputation has dropped considerably.

REFERENCES: Karl Madsen: *Wilhelm Marstrand*. Copenhagen, 1905
Th. Oppermann: *Wilhelm Marstrand*. Copenhagen, 1920

43 The Waagepetersen Family (1836)

Canvas, 58.5 × 68 cm
S.M.f.K., no. 3329
Illustrated in colour page 58

The scene is the Copenhagen home of Christian Waagepetersen, a wine merchant, and the family is seen gathered in the living room. The children are busy playing at the coffee table, while mother turns her attention away from her knitting as the maid enters with the youngest child on her arm. In short, a quite ordinary everyday scene in a comfortable middle-class home. Only one person is missing in the picture, the master of the house, who is presumably working. His absence is a reminder that the basis for the new wealth of the middle class in the 1830s was industry and diligence.

Compared to Eckersberg's group portraits of about 1820, Marstrand's painting bears witness to the remarkable development in Danish society during the intervening fifteen years. Whereas Eckersberg's double portrait of the oldest daughters of Nathanson (cat. no. 13) has an official and representative character, Marstrand's family group is relaxed and natural. Bourgeois norms were now a matter of course and did not need demonstrative display. Now the painter could concentrate on showing the everyday life of the middle class. The only unnatural element is the maid. Dressed in her Sunday best, she looks as if she has been removed from her proper surroundings.

For better or worse, the picture shows the enclosed life of the middle class in their Copenhagen homes. The treatment of subject shows the influence of family pictures by Wilhelm Bendz, although here the figures are grouped more freely and vividly. Marstrand demonstrates his superior ability to see and tell a story of everyday life. When it was exhibited at Charlottenborg in 1837, he received considerable acclaim: "One glance at this picture allows us to delight in the good humour and the genius with which the artist has given us a true, natural picture of the merry, free life of a happy family. Just look at these four happy children, so naturally grouped around the table! . . . In truth, this pretty little picture is so attractive in its composition and execution that it is hard to tear oneself away from it. The colouring is strong and natural, and the light effect very beautiful." (From the *Kunstforening*'s periodical, *Dansk Kunstblad*.)

The two paintings hanging on the wall as companion pieces are Eckersberg's portraits of Schmidt, a merchant in the East Indies, and his wife, who were the wine merchant's parents-in-law.

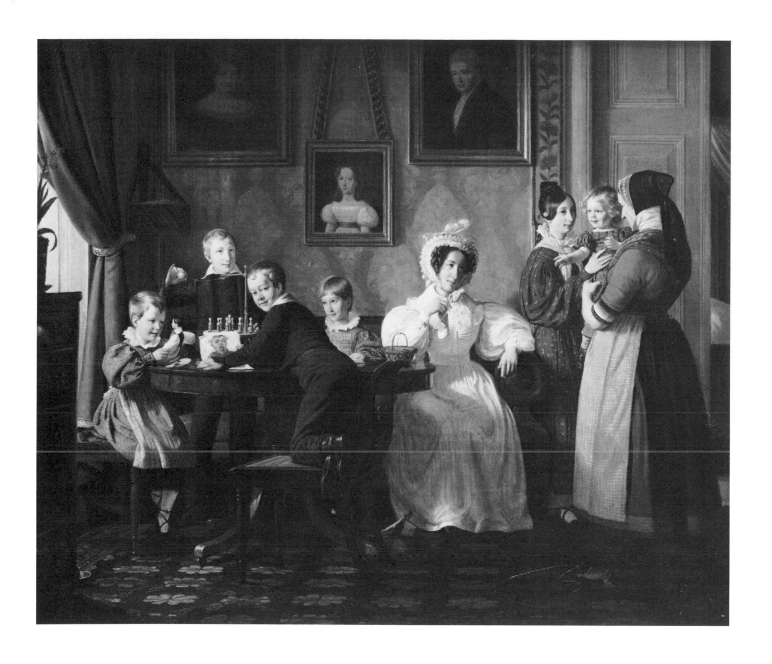

44 Portrait of Frederikke Raffenberg, née Hagerup (1846)

Canvas, 44.5 × 35 cm
S.M.f.K., no. 1649

During his second period in Rome, Marstrand did this portrait of Mrs. Frederikke Raffenberg (1806–69), wife of the prominent customs official Michael Raffenberg who had been a close friend of Wilhelm Bendz, and who held a seat in the governing body of the *Kunstforening*.

The forty-year-old woman is seen full face, sitting on a sofa. In order to indicate that it was painted in Rome, a vine has been added, as well as a view of St. Peter's. The picture shows far greater emphasis on plasticity than Marstrand normally displayed, especially in the face. Other features, too, are untypical of the painter – not only the relatively sober colouring and tight composition, but also the erect pose and grave expression of the woman. All of this indicates that Marstrand was working under the influence of the French painter Gustave Ricard, who was in Rome in the years 1845–7. In a letter to Constantin Hansen, written in July 1847, Marstrand commended a couple of German painters who ''deserve respect for their colour and treatment – but most of all a young Frenchman who has now left, Ricard – he has painted a number of heads and portraits, masterfully coloured and modelled.''

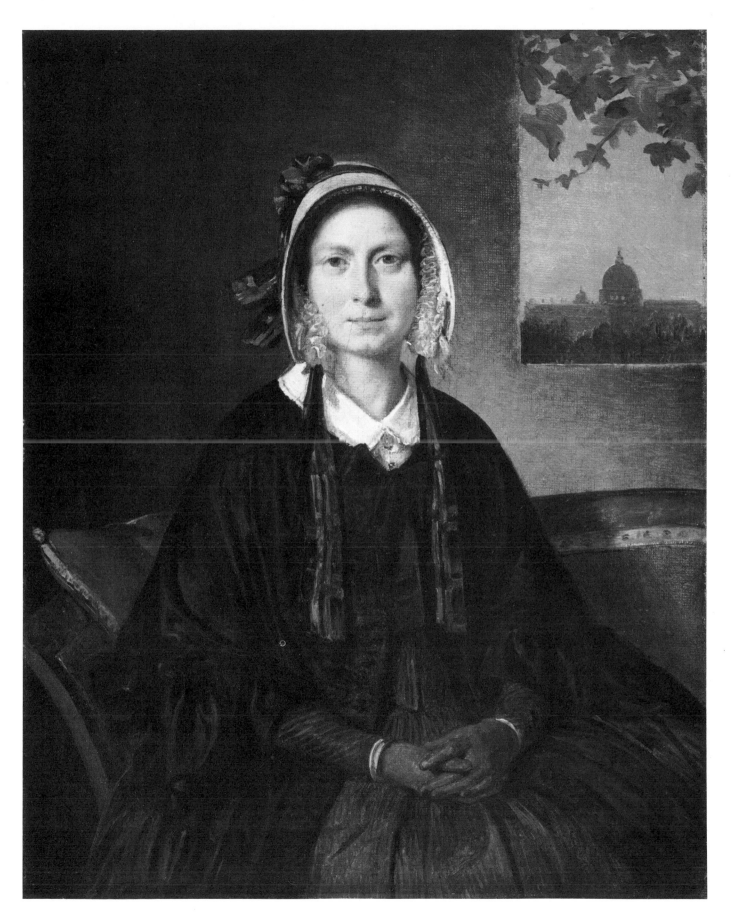

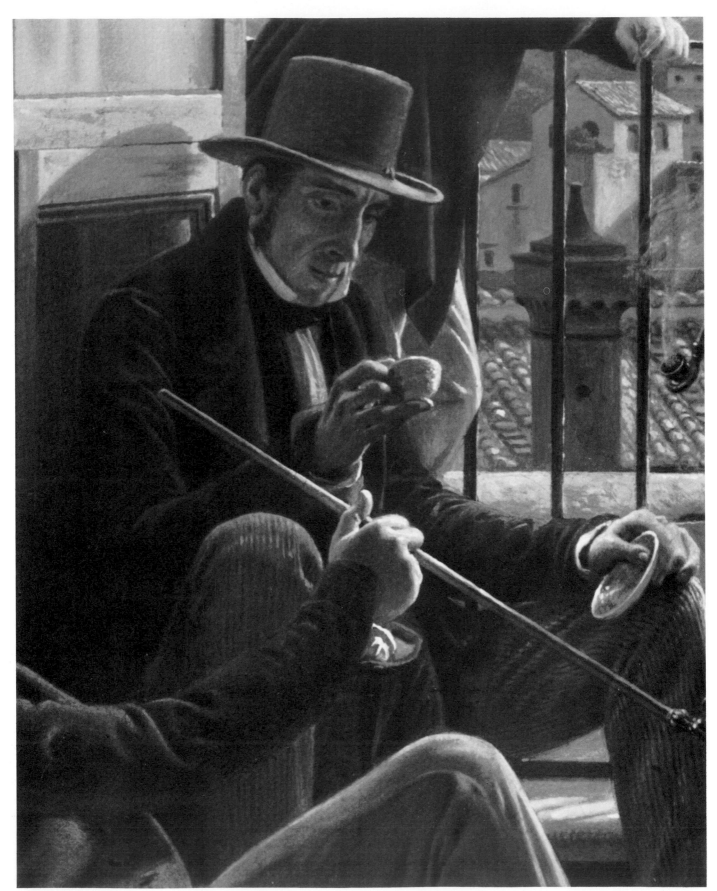

Martinus Rørbye, 1837, by Constantin Hansen (1804–80)

MARTINUS RØRBYE 1803–1848

The art of Martinus Rørbye is marked by his constant wanderlust, his journeys taking him further afield than any other Danish painter of the Golden Age. Essentially a painter of genre pieces and architecture, Rørbye developed his teacher Eckersberg's sober and realistic attitude to these subjects. His pictures contain a good deal of reportage, but at the same time he displays a uniquely sympathetic view of the people he painted.

Rørbye entered the Academy in 1820 as a student of the minor painter C. A. Lorentzen, and from 1825 he also received private tuition from Eckersberg with whom he soon developed a very close relationship. He appears to have completed his Academy training around 1830, when he embarked on his first journey abroad, to Norway. Two years later he went to Norway again, and in 1834 he set out on his grand educational journey. Via Paris he went to Rome, and the following year went on – together with Gottlieb Bindesbøll, the architect – to Athens and Turkey, places that until then had never been visited by Danish visual artists. Towards the end of 1836 they were back in Rome, and the following autumn Rørbye travelled home via Munich. From 1839 to 1841 he was once more in Italy, and in 1846 he went to Stockholm. He went to Jutland on several occasions, which was, to citizens of Copenhagen, an almost unknown part of Denmark. He was the very first painter to visit (in 1833 and 1847) the Skaw, Jutland's northernmost point.

Rørbye's works from Greece and Turkey commanded a great deal of attention when he returned to Copenhagen in 1837. The *Dansk Kunstblad* critic was very enthusiastic when Rørbye exhibited his works at the *Kunstforening* in February 1838: "Truly, the quantity and beauty of what his brush has elicited from nature are so great that one scarcely knows where to begin and where to end in order not to omit something splendid."

In 1844 Rørbye was made a professor of the Academy, the first of Eckersberg's students to achieve this honour.

It was probably on Eckersberg's advice that Rørbye went to Paris on his first journey abroad. His attitude toward French art clearly reflects the training he received from Eckersberg. In a letter to his teacher dated 20 August, he wrote about Géricault's *The Raft of the Medusa*: ". . . it is a painting that has pleased me much, not only for its composition but also for the bold manner in which it is painted; his colouring is not exactly pleasant, but once familiar with it, one grows fonder of this painting. The subject, hideous as it is, is far from being rendered in the outrageous manner seen in the pictures of Le Gros [J. A. Gros] and other present day painters of gruesome scenes. Géricault awakens a feeling of pity, the others pure abhorrence. Géricault has known the human body and attempted to show it in harmony with nature It is when Delacroix paints *The Massacre at Scios* that one turns away with distaste. This painting is epoch-making, and has unfortunately found many imitators who compete with him in the distortion of nature and the display of its darkest side. He is currently one of the first of the so-called 'Romantics', striving to bring French art back to the level from which David and others sought to elevate it."

Rørbye's favourite painter in Paris was definitely Horace Vernet: ". . . he is beyond question the first, a man with his talents is rare; you know his versatility and I cannot decide in which genre he is greatest." Vernet's exotic, Oriental subjects were particularly important to the Danish painter. On the other hand he was very reserved towards Ingres: "Vernet is now about to retire from his post as Director of the Academy in Rome, Ingres is mentioned as his successor, I very much doubt that he is, at this moment, the right man to hold art to its correct course."

A few contemporary critics, and more in later times, have found Rørbye's art dry and pedantic. In some instances this criticism is justified. But his limitations as a painter must be said to be balanced by the sympathy and respect that always mark his description of people – in sharp contrast to the irony and idealisation typical of many contemporary genre painters.

REFERENCE: Dyveke Helsted, Eva Henschen, Bjarne Jørnaes and Torben Melander: *Martinus Rørbye*. Exhibition catalogue. Thorvaldsens Museum, Copenhagen, 1981

45 The Prison of Copenhagen, 1831

Canvas, 47.5 × 63 cm. Inscribed, upper right edge: *M. Rørbÿe 1831*
S.M.f.K., no. 206

Rørbye placed this scene of everyday life in modern Copenhagen. While Eckersberg and his students preferred historic architecture as a subject for painting, Rørbye chose to paint the modern prison, next to the combined Town Hall and Courthouse, built (1805–15) by the nation's leading architect, Christian Frederik Hansen (1756–1845). In front of the severe, almost gloomy prison a number of scenes are set. In the centre, a young dandy gazes interestedly after a woman with two children. Behind him walks a gowned official, accompanied by his manservant who carries his master's briefcase. To the right by the corner of the arch a young man vainly asks an old moneylender for a loan, while a policeman tugs at his cloak and points towards the gate leading to debtors' prison. His fate is hinted at by the prisoner who can just be seen behind the bars in the window. On the left side of the picture a poor, pregnant woman is begging beneath the arch, while the boy shoemaker witnesses a transaction between a female pedlar and a young servant girl. In the foreground is seen a sombre, gowned man carrying a lit lamp although it is broad daylight. Behind him a chimneysweep has just emerged from the prison building.

On the surface this would appear to be no more than a rendering of everyday events, but at the time of its creation it was also interpreted as an allegory of crime and punishment. In the *Kopenhagener Kunstblatt* of April 1832, a thorough review of the painting emphasised the symbolism attached to several of the figures. The chimneysweep "seems to allude to the conditions a person is placed in, once he has been locked up behind these walls", the beggar woman "seems to indicate the beginning of the road of depravity" and the man with the lamp is called "the old misanthropist" who is "dissatisfied with all that goes on about him". The black cat, too, presumably portends catastrophe. The gloomy nature of the building corresponds to this symbolism, reflecting the contemporary view of punishment as a deterrent. Like Bendz' painting of *A Young Artist examining a Sketch in a Mirror* (cat. no. 40), Rørbye's painting is linked to an older, more symbolic era in Danish art. The two artists share common ground in that they both, during their student years at the Academy, were influenced by the old professor C. A. Lorentzen whose views on art belonged entirely to the eighteenth century. The forceful rendition of the Roman-inspired architecture and the consistent treatment of light belong to the Eckersberg school, however, and thus to Rørbye's own time.

The painting was bought by the Royal Collection (now the S.M.f.K.) when it was exhibited at Charlottenborg in 1832.

The buildings in the painting exist in unchanged form to this day.

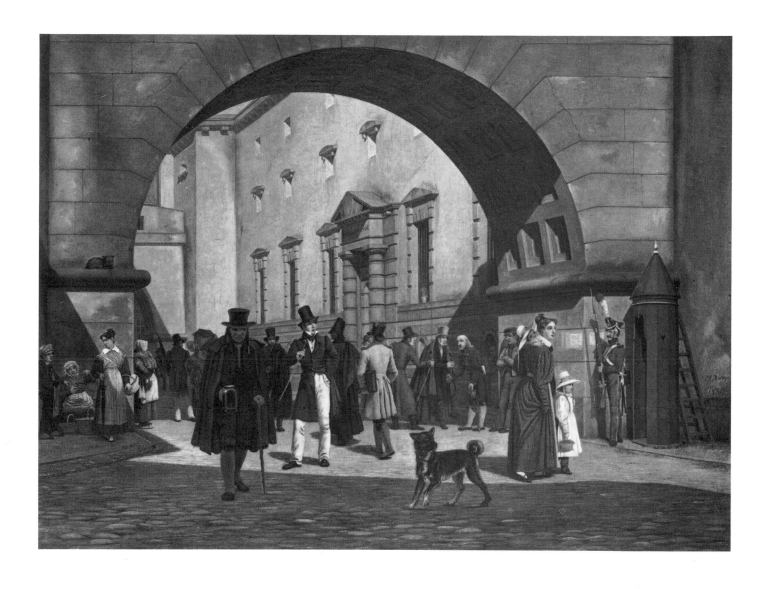

46 Greeks working in the Ruins of the Acropolis (1835)

Paper laid down on canvas, 28.5 × 41.5 cm
S.M.f.K., no. 4299
Illustrated in colour page 59

When Rørbye and the architect Gottlieb Bindesbøll arrived in Athens towards the end of October 1835, the authorities were in the midst of clearing up after centuries of Turkish occupation. Greece had been independent for only six years. The two Danes were naturally interested in seeing the Acropolis in Athens, and here were Greek workmen busy ridding the ancient temples of Turkish defence installations. Rørbye was fascinated by the sight of the excavation work, and on 21 November he wrote in his diary: "In the afternoon I began drawing in front of the Propylaea where excavation is going on; something might come of it if I am fortunate." A few days later he wrote about his drawing to Eckersberg (the drawing now belongs to the Statens Museum): "In recent days I have been occupied with a small drawing, showing on the right the excavation work in front of the Propylaea; directly before me is the great pedestal upon which there once stood something now unknown. It truly takes up a lot of space in the drawing but has no little effect since immediately behind it there is a view of the valley and the mountains. The figures unfortunately had to be small, set against these architectural giants."

Immediately afterwards he set to work painting the subject, making this entry in his diary on 5 December: "Finished painting my study with excavations in front of the Propylaeum." At roughly the same time Bindesbøll described the excavation work: "The battery in front of the Propylaeum is almost entirely down, but the ancient path to the entrance not yet found; but the small Temple of Fortuna [Nike] is uncovered. It is in ruins, but most of the fragments exist, and these days witness the erection of the columns. Rørbye has painted an interesting sketch of the excavations by the Propylaeum, with a splendid view of Piraeus in the background."

In his letter to Eckersberg, Rørbye mentioned that the figures "unfortunately" were small, but it seems that in the painting he consciously exploited their modest size to emphasise the vastness of the blocks of stone.

After his return to Copenhagen in November 1837, Rørbye showed his works from the journey and the new, unknown subjects aroused popular interest. Even before they were exhibited the critic of *Dansk Kunstblad* wrote on 16 December: "We must thank the lucky star that led the artist to places that may never before have been visited by any Danish painter, for the paintings, sketches and studies that he has brought back show how richly the brush may profit from Hellas and the Orient. In this we think not merely of the charming natural beauty characterising these lands, but particularly of the inexhaustible wealth of genre pieces that the unique local street life has to offer."

When it was shown in the *Kunstforening* in February 1838, the critic wrote about this picture: "It is as lively as an anthill, if we may be permitted to use this simile."

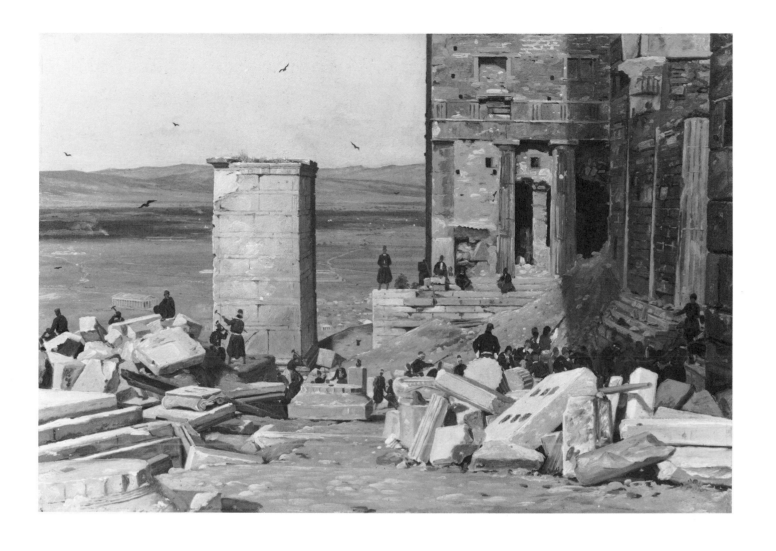

47 A View from the Temple of Athene on the Acropolis, 1844

Board, 25.5 × 33 cm. Inscribed, bottom centre: *M.RÖRBŸE 1844*
S.M.f.K., no. 3769

After returning from his voyage through Italy, Greece and Turkey, Rørbye worked over many of his sketches and studies. During the following years a number of them were recreated as large paintings with meticulously worked-out compositions. He also repeated a number of the small paintings. This painting is such a repetition, dated 1844.

It gives a view through the columns of the Parthenon across the plain south-west of Athens, to Piraeus and the Gulf of Saronikos, with the mountains of the Peloponnese in the distance. In the middle distance to the right we see the so-called Frankish Tower, built above the south wing of the Propylaeum during the Frankish reign of Athens after the Fourth Crusade in 1204.

When in 1838 Rørbye exhibited the original version of the subject at Charlottenborg, N. L. Høyen, the art historian, wrote: "What particularly captivates in several of his studies is the feeling of southern warmth that meets the eye. There is a particular brilliance to the sunlight falling between two of the columns of the Parthenon, against which the figures in beautiful dress and the huge columns with their shadows are so deeply and powerfully in opposition."

Rørbye's many repetitions of his foreign subjects bear witness to the extent of popular interest in them.

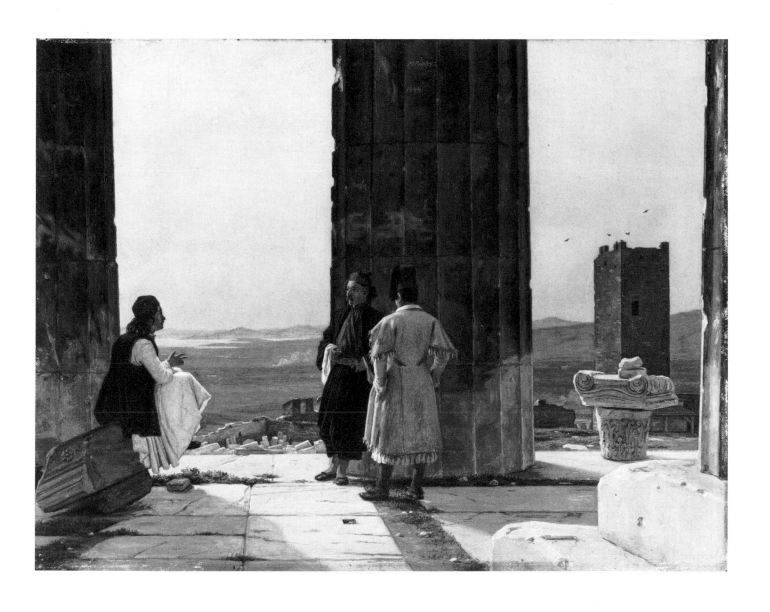

Christen Købke, 1839, by Willem Marstrand (1810–73)

CHRISTEN KØBKE 1810–1848

Today Christen Købke is considered the most outstanding Danish painter of the Golden Age. He is unsurpassed in his brushwork, his vision and in his gift for composition. He was also a very talented colourist. He had a good deal of Eckersberg's severity, but was guided more by intuition than by strict principle, and he had a far livelier perception of his subjects. He painted portraits, landscapes and architecture.

His early works, from about 1830, show great individuality in their interpretation of the subject, but, by the mid-1830s he had been seized by the contemporary urge towards monumentalism and by the increasingly romantic current of ideas. This resulted in a number of tighter compositions and a more defined atmosphere. He nevertheless retained his spontaneity in his small sketches until his early death. He led a modest and regular life, and is diametrically opposed to the type of wild and visionary artist thought to be typical of Romanticism.

Købke was only eleven when he began at the Royal Academy of Fine Arts in 1822, but showed no special talents to begin with. From 1825 his teacher was the minor painter C. A. Lorentzen, after whose death in 1828 he became a student of Eckersberg.

He truly emerged as a painter around 1830. He gave up his studies at the Academy in early 1832, but received personal tuition from Eckersberg for a couple of years after that. Around the time that he left Eckersberg's studio he also began to show signs of straying from his teacher's conception of art. N. L. Høyen, the art historian, and H. E. Freund, the sculptor, were to influence him greatly during this period.

In 1838 Købke went abroad, stopping in Dresden on his way south to visit J. C. Dahl. His stay in Italy, however, offered no decisive influence of his art, save that during this time he studied murals in Pompeii, apparently in order to be able to make a living as a decorative painter.

His big paintings from the last years of his life often show dryness and lack of inspiration. The several attempts to explain this include the negative influence of his trip to Italy, his financial difficulties after the death of his father in 1845, and the death in 1840 of Freund, with whom he had an inspiring friendship. But none of these explanations has been widely accepted.

Købke had a narrow field of subjects. The majority of his paintings were done close to his Copenhagen home, which was in the Citadel up to 1833, and from 1833 to 1845 in a country villa by the lakes just outside town. In the mid-1830s he was preoccupied with Frederiksborg Castle, north of Copenhagen. During his final years he used Italian themes in his big compositions. Almost all his portraits are of family and friends.

Henrik Bramsen wrote the following about Købke's use of colours: "He was a very conscious colourist, in the sense that colours to him were not only a means with which to characterise the depicted objects; they also possessed an intrinsic value with decorative, sense-awakening, evocative, musical qualities" (1964). Købke's paintings did not attract much contemporary attention. While he lived, only two of his pictures were bought by the Royal Collection, and none at all by Thorvaldsen, the talent scout. The *Kunstforening*, on the other hand, bought twelve.

After his death he was almost forgotten, winning true recognition only towards the end of the nineteenth century.

REFERENCES: Emil Hannover: *Maleren Christen Købke*. Copenhagen, 1893
Mario Krohn: *Maleren Christen Købkes Arbejder*. Copenhagen, 1915
Arne Brenna: "Et efterarslandskap av Christen Købke", in *Meddelelser fra Ny Carlsberg Glyptotek*, XXVIII (Copenhagen), 1971, pp. 25–50 (summary in French)
Hans Edvard Nørregård-Nielsen: "The Lyricism of Christen Købke", in *Apollo*, June 1981, pp. 372 f
Anne-Birgitte Fonsmark: "Købke på Capri", in *Meddelelser fra Ny Carlsberg Glyptotek*, XXXIX, Copenhagen, 1983, pp. 76–98 (summary in English)

48 The Interior of Aarhus Cathedral, 1830

Canvas, 48.5 × 34 cm. Inscribed, bottom right: *C. Købke 1830*
S.M.f.K., no. 1345

Købke started work on this painting of the cathedral while staying in Aarhus, Jutland, in 1829. In his diary there is this entry: "Painted in the church on September 15." But he did not finish the picture then, returning to Copenhagen three days later. It was completed the following year.

His subject is the transept of the Gothic cathedral. Fascinated by the massive, whitewashed masonry of the building, and by the diffuse light within, he succeeded in reproducing the varying shades of colour on the different faces of wall, and in giving an impression of the building's space. The limited section of the subject shown and the emphasis on perspectival display reveal the influence of Eckersberg.

Købke may have got the idea for this painting from N. L. Høyen, who at this time was beginning his research on Danish medieval monuments.

In 1829 two of Købke's Academy friends, Constantin Hansen and Jørgen Roed, also painted the interior of a Danish medieval church (Ringsted Church in Zealand), so it was obvious for Købke to visit the cathedral in Aarhus when he visited a friend there in the summer of that year.

A growing interest in the Danish Middle Ages can be clearly seen in the painting. The verger is pointing at one of the tombstones in the floor, while a couple of Købke's painter friends listen to what he has to say. The young man bends towards the stone, interested in giving it a closer look, while the older one listens politely.

REFERENCE: Krohn, 1915, no. 26

49 The Plaster Cast Collection at Charlottenborg, 1830

Canvas, 41.5 × 36 cm. Inscribed, bottom right: *C.K. 29-8(?)-1830*
Hirschsprung Collection no. 307

The Academy's collection of casts from antique sculptures played an important role in the Golden Age. Before the young Academy students reached model school, where they were allowed to draw from the life, they had to spend a year or two drawing from these plaster casts. As a break from this routine exercise, a number of the young painters began painting views of the Antique Hall at Charlottenborg, where their friends studied. We know of several such paintings from the 1820s, by Rørbye among others. By 1828, Købke had reached model school; nevertheless, in 1830 he did this painting of the cast collection. A young man is studying the Ilissos figure from the Parthenon. Above that is one of the metope reliefs from the same temple, and beneath the corbel we see the head of one of the Dioscuri from Rome's Piazza Quirinale.

Købke has accentuated the shapes of the figures by lighting them from the side, and the man in black contributes to the creation of depth. The painting shows Købke's special way of using colour for accentuation. All the colours are within a limited spectrum of shades of white, grey, brown and black, the exception being the yellow rag that acts as the focal point of the painting.

Shortly before Købke executed the painting, the plaster cast collection had been rearranged, and this was celebrated on 16 November 1828, as is known from Eckersberg's diary:

> "We had a pleasant evening, the young friends had been invited to see the new Figure Hall, and see the statues by torchlight – the evening was then spent looking at drawings and so on, and with music, mostly singing and a little dancing."

Among those present were the painters Constantin Hansen, Jørgen Roed, Wilhelm Marstrand, Martinus Rørbye and Købke, in addition to the art historian N. L. Høyen.

REFERENCES: Krohn, 1915, no. 31
The Age of Neo-Classicism. Exhibition catalogue. London, 1972, no. 16

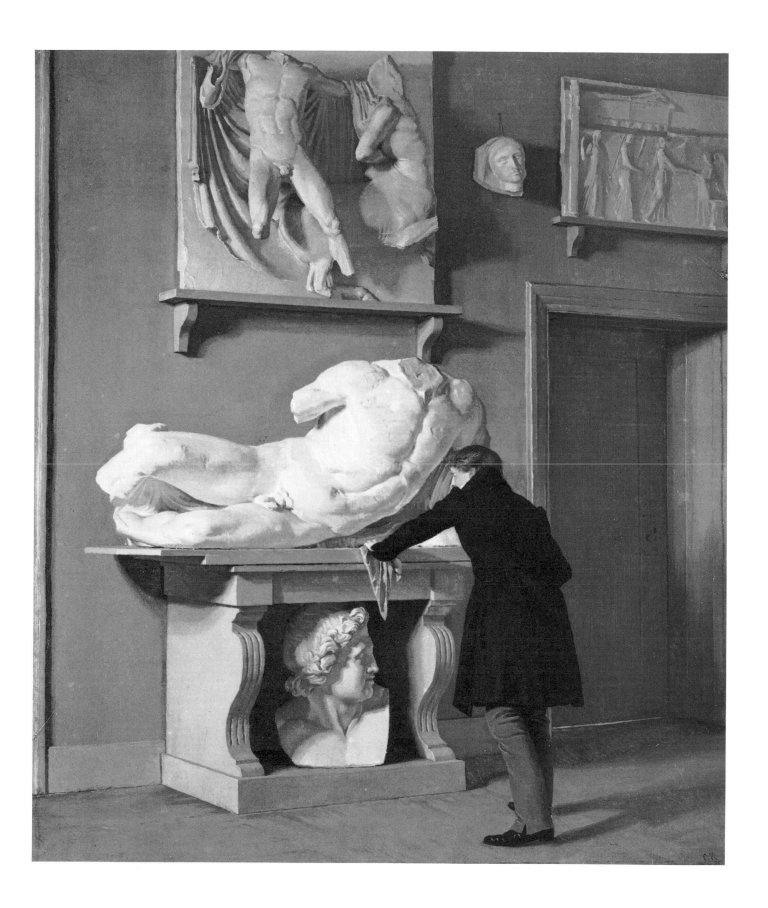

50 A View from a Store-House in the Citadel of Copenhagen, 1831

Canvas, 39 × 30.5 cm. Originally inscribed on the stretcher: *C. Købke 1831*
S.M.f.K., no. 1662
Illustrated in colour page 60

In the years from 1818 to 1833, Købke's father was in charge of the bakery in the Citadel of Copenhagen. Here, the young painter found many of the subjects for his early paintings. This painting shows the view from the bakery store-house through the attic door towards the ramparts surrounding the Citadel. His sister, Cecilie Margrethe, is walking up the wooden bridge, knitting.

The play of light and shadow is vitally important to this picture. The dark attic contrasts to the sunlight on the tree and on the grass in the background. The trunk of the tree is a dark silhouette against the foliage of the crown of the tree. A few sun-flecks touch the girl's dress, the doorstep and the floorboards.

The colour scheme is characteristic of Købke at this time. The green and brown nuances harmonise, and only the dress stands out. The gate plays an important role in the composition, framing the subject. The painting thus instances one of the more popular subjects of early nineteenth-century Danish and German painting – the open window that opens out from the well-known and secure, towards the unknown, the uncertain and the alluring. Something of this effect is created by the open door in Købke's painting. One feels like leaving the cool attic to go out into the warm sunshine. Yet the picture does not truly interpret the call of the open spaces. In general, Købke's art shows a preference for homely subjects.

Contrary to his usual practice during his Citadel period, Købke made preliminary drawings for the painting. A drawing of his knitting sister exists in the Statens Museum.

REFERENCE: Krohn, 1915, no. 34

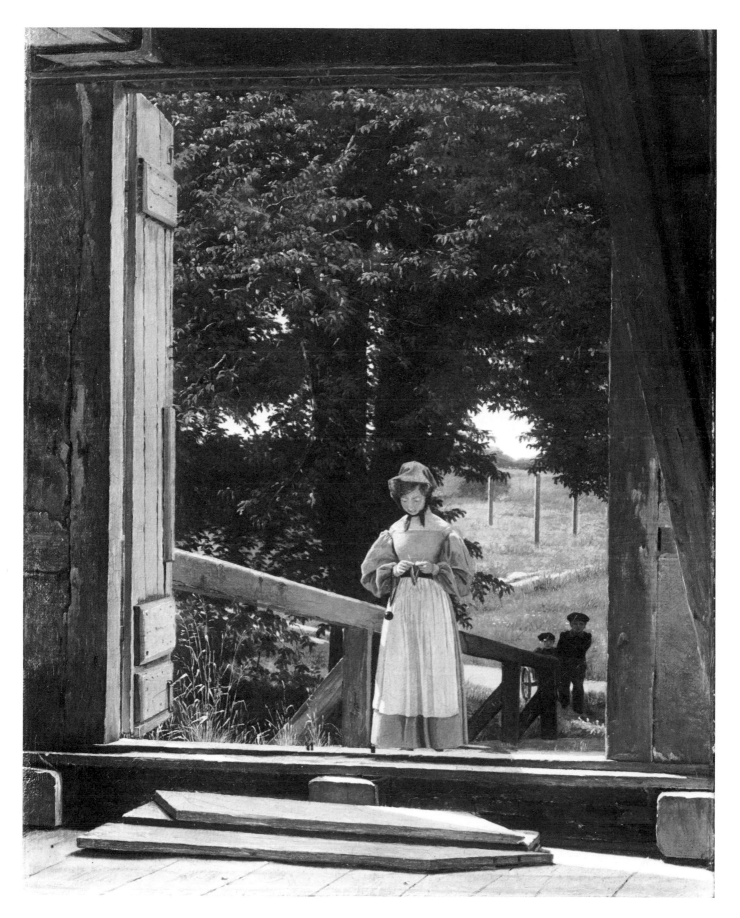

51 Portrait of Ida Thiele, 1832

Canvas, 22.5 × 20 cm. Inscribed, bottom right: *C. Købke 1832*
S.M.f.K., no. 3136
Illustrated in colour page 61

In the early part of 1832, Købke painted this portrait of the one-and-a-half-year-old Ida, the daughter of the art historian Just Mathias Thiele. In an unpublished account of her first year, "Ida's savings box", Thiele describes the making of the picture:

"In February of this year (1832) a young painter named Købke did your portrait, as a present for your grandfather's coming birthday. It was a good likeness in spite of your being very fidgety, and despite the fact that we had to use all sorts of means to make you sit still as long as he painted. The objects surrounding you in this picture were at the time your fondest playthings, a flock-covered yellow wooden cat of which only part of its behind is visible, and a boardgame on which you drew with a piece of chalk. "On March 27, your grandfather's birthday, your portrait was finished. The girls dressed you up as a little country maid and the wrapped portrait was tied to your back. In this costume you were driven off and, with a roguishness that amazed us all, because you thus showed that you understood your rôle, you approached beloved grandfather, curtseyed and then turned, thus presenting him with the portrait that you carried on your back."

Købke depicted the little girl at a moment when her attention was successfully held. The painting shows that the artist was now attempting to work with a range of colours that was not as subdued and limited as in his earlier paintings. By setting the red colour of the dress against the greyish-purple background he actually seemed to flirt with disharmony. Ida Thiele (1830–63) was the little girl in Hans Christian Andersen's fairy tale, *The Flowers of Little Ida* (1837).

REFERENCE: Krohn, 1915, no. 36

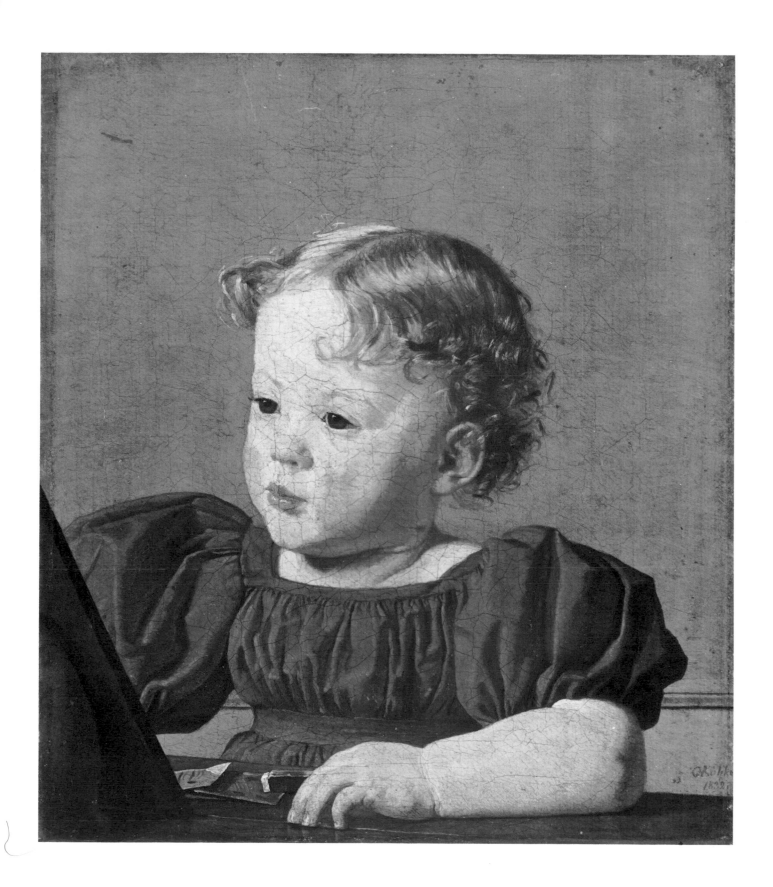

52 Portrait of F. Sødring, 1832

Canvas, 42.2 × 37.9 cm. Inscribed, bottom right: *C Købke 18 26/5 32*
Hirschsprung Collection no. 309

In the early summer of 1832 Købke painted a portrait of his friend, the landscape painter Frederik Sødring, with whom he shared a studio. The portrait is painted in clear forenoon light. Sødring is seen at work, as he briefly looks with an appraising glance at the painting on his easel. He is informally dressed, without jacket or tie, sitting comfortably with a twinkle in his eye and apparently about to pass a casual remark.

The subject, as well as the description itself, shows the influence from Wilhelm Bendz, who, starting in 1826, had painted several pictures of artists at work, for instance *A Young Artist examining a Sketch in a Mirror* (cat. no. 40). The meticulous arrangement of objects around the artist is clearly inspired by Bendz, but whereas the latter appears to have consciously infused his picture with symbolism, Købke has first and foremost painted a portrait of his artist friend. The mirror is placed on the double door to create a purely pictorial effect rather than as a reminder of art's function as a mirror of reality. But we do catch a glimpse of Sødring's easel in the mirror, and his attribute as a landscape painter, the folded camp-stool, is seen in the corner. True to his own artistic disposition, Købke has created a simpler and calmer composition than Bendz did. The little red box leaning against the flowerpot of ivy stands as a clear contrast to the many shades of grey in the picture, thus emphasising the coolness of the other colours.

Købke dated the painting 26 May 1832, and on the reverse of the canvas Sødring wrote: "Presented to me by my friend Købke on my birthday, 31 May 1832."

Frederik Sødring (1809–62) was one of the few painters of the time who almost entirely devoted himself to landscape paintings, with a pronounced Romantic attitude. His pictures were thus in contrast to the more down-to-earth attitude of the Eckersberg school.

REFERENCES: Krohn, 1915, no. 37
Fritz Novotny: *Painting and Sculpture in Europe 1780–1880*, 2nd ed. (paperback). Harmondsworth, 1971, p. 211

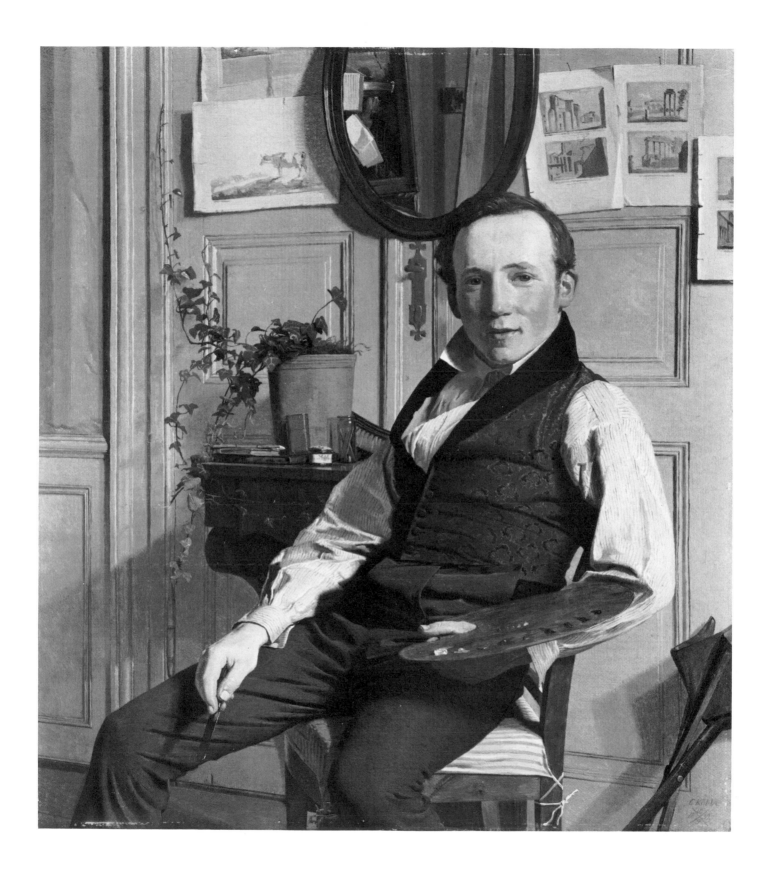

53 The Mother of the Art-Historian N. L. Høyen, Inger Margrethe Høyen, née Schrøder, 1832

Canvas, 30.5 × 25 cm. Inscribed along the right edge: *C Købke 18 26/6 32*
S.M.f.K., no. 1667

Købke met the art historian N. L. Høyen during his Academy years, but the acquaintance was strengthened when both of them spent the summer of 1831 in Hillerød – Købke in order to visit his sick sister, Høyen to arrange the collection of paintings at Frederiksborg Castle.

The following summer the painter did this portrait of the art historian's mother. She was the daughter of a Jutland gardener and had been married to a distiller who had worked his way up to become the owner of the distillery. J. L. Ussing, biographer of Høyen, wrote about the mother in 1872:

> "She was more imaginative than the husband, but no less clever or wise; and happy as she might be with the good life, it always seemed to her that part of their happiness stemmed from their having worked for it. They always had their meals together with the employees, and their house retained a certain plainness. She often spoke of the people she had served, and of the elegance they had displayed, but she herself could not be persuaded to wear a silk dress; such finery she did not consider fit for common citizens. One was always happy to see the fine, buxom burgher's wife with her mild and wise face. A splendid portrait by Købke has preserved her appearance in old age."

Høyen later recalled how his mother had contributed to arousing his interest in art when she brought her then six-year-old son to an art exhibition at Charlottenborg.

Købke's painting shows a woman with a simpler appearance than was normally the case in portraits of the Golden Age. Indeed, she was portrayed only because Købke knew her son. Her firm, sharp look reveals her strong personality, an impression that is enhanced by the way her face is clearly lit against the dark background.

Købke tried to emphasise the individuality of his sitters, in this case by describing details like wrinkles and lines at the corners of the mouth. The feeling of immediacy in the portrait is common to Købke and C. A. Jensen.

REFERENCE: Krohn, 1915, no. 41

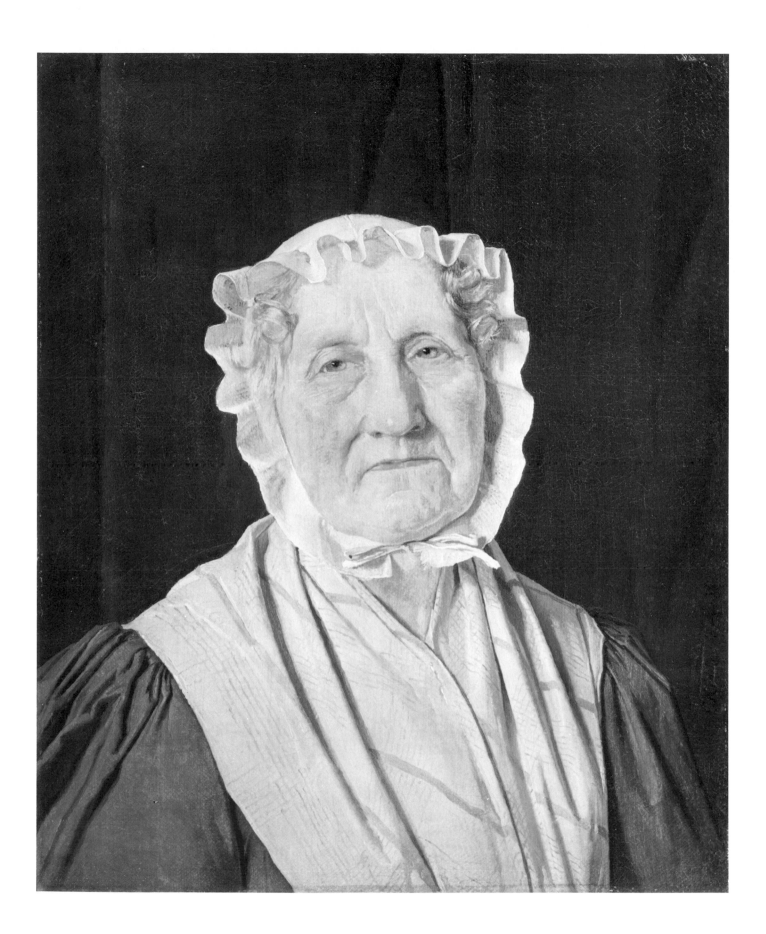

54 The Citadel of Copenhagen seen from a nearby Window (*c* 1833)

Paper laid down on canvas, 15 × 27.5 cm
S.M.f.K., no. 3156

In 1832, Købke, together with the landscape painter Frederik Sødring, rented a studio close to his Citadel home. This was where he painted the portrait of his friend (cat. no. 52), and possibly several studies from models. But he also used this opportunity to see his home from a new angle, painting this small picture of the Citadel Mill, the upper part of the Citadel Church and the red roofs of the military buildings. In the foreground a chimney and the edge of a rooftop give depth to the picture. The interplay of sunshine and shadows above the roofs and the trees is finely observed.

The sky is at least as important to the painting as the view of the Citadel. Eckersberg was preoccupied with the study of the changing formations and colours of clouds, but acquaintance with the Danish-Norwegian painter J. C. Dahl might have stimulated Købke even further. Interest in the study of clouds can be traced back from Dahl to the German art theorist and painter C. G. Carus who, influenced by the numerous studies of clouds by Goethe and John Constable, wrote about this in his *Nine Letters on Landscape Painting*. During his Citadel period Købke chiefly painted small unambitious studies of different parts of the military bastion. Influenced by Eckersberg he selected sections of the domestic surroundings almost at random. Eckersberg encouraged his students to paint subjects that presented themselves immediately. They were to "paint from nature, no matter what it might be, farmhouses, churches, castles, trees, plants or animals, in short whatever is there", as he put it in a letter to his son Erling Eckersberg, the engraver. It is characteristic of Købke's paintings during the Citadel period that they are modest in size and appear to have been painted directly in front of the motif. Almost no drawings for these paintings exist, which leads to the conclusion that Købke painted the subjects as he saw them, without working on the composition beforehand, and without adding details to what he saw.

REFERENCE: Krohn, 1915, no. 72

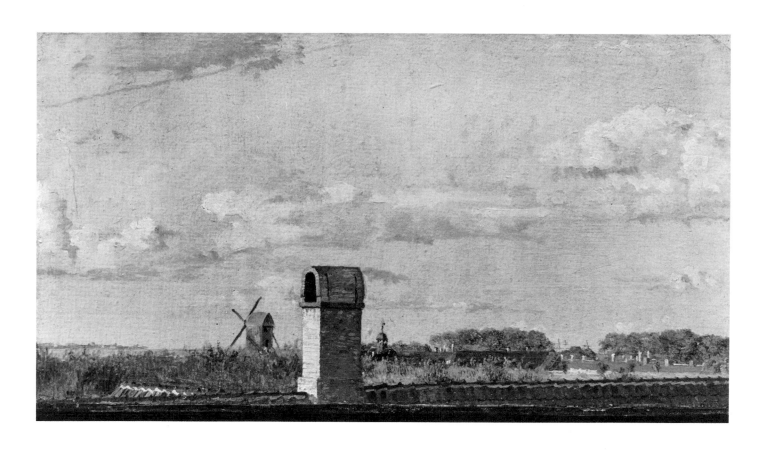

55 The North Gate of the Citadel, 1834

Canvas, 79 × 93 cm
Ny Carlsberg Glyptotek, I.N. 909. Inscribed along lower left border: *C. Købke 1838*
Illustrated in colour page 64

In January 1834, Købke was commissioned to do a large painting for the *Kunstforening* in Copenhagen. Prior to that he had sold three smaller pictures to them, but this constituted a far greater honour in that it was his first commission. Købke took this as a challenge, putting all his energy into the work. The result was a painting which marked a turning point in his development as an artist. The subject is the north gate of the Citadel, where he had lived with his parents until the end of 1833. In a way the subject is as "casual" and "insignificant" as in his earlier works. But this is no sketch-like painting of modest size, but a large, detailed composition, and it exhibits a completely new, imposing and monumental conception of the subject. It was also new for him to do an oil study (now in a Danish private collection) before starting work on the large painting. A comparison of the two pictures shows how Købke made small, almost unnoticeable changes, mainly tightening up the subject. But the changes are essential to the total impression. The painting marks the start of Købke's "monumental phase".

According to the rules laid down by the *Kunstforening*, a commissioned work was to be started no later than 1 July, and completed before the end of October; otherwise the artist risked the commission being given to someone else. Købke observed the time limits, and on 27 October 1834 he was able to inform his sister Conradine that the picture was complete. In one of the few preserved letters in which he reflects on his art, he wrote: "Believe me, my dear sister, this has been a struggle for me; for no less than three months I have fought with it every day; and on occasion it has been a hard fight, but then again I have been blessed with lighter moments . . . I can assure you I have really been working up to the very end. I've woken up every morning and yearned for the light to come so that I might get to work, then painted all day long until evening, when I was tired but grumpy at having to tear myself away. . . . My painting, it is felt, pleases – it should do, considering the above-mentioned feelings that have gone into it. I take it as a great blessing granted me by God that it arouses general interest and attention, both from those whose opinion I respect the most and also from those uninitiated in art . . . And upon this I confidently found my future hours, as one has never seen God refuse sustenance to whoever has the will and the ability to work. . . . I must make one further comment, that in addition to all the joy and encouragement I have had from my work, I am also one hundred *species* better off."

REFERENCES: Krohn, 1915, no. 79
Hans Edvard Nørregård-Nielsen: "The Lyricism of Christen Købke", in *Apollo*, June 1981, pp. 372–3

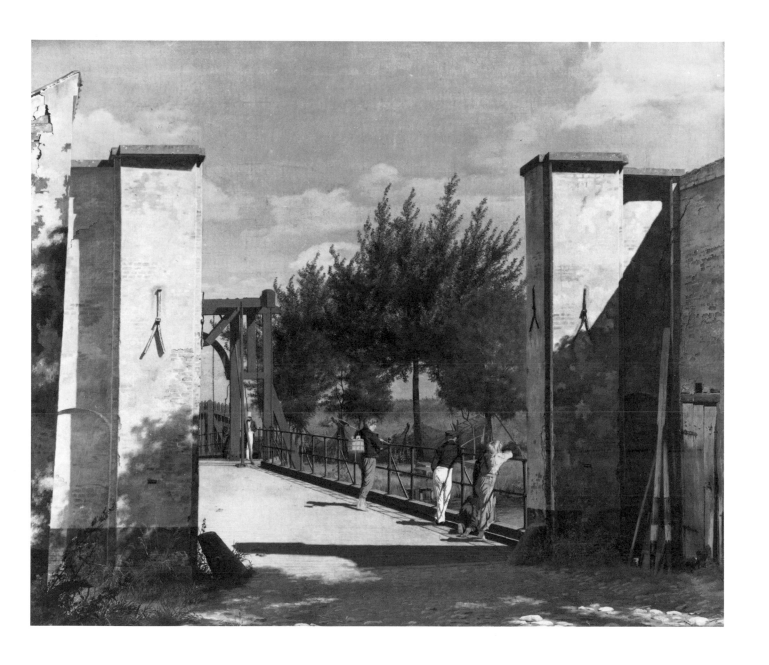

56 Portrait of Johanne Plöyen, née Bachmann, 1834

Canvas, 25 × 19.5 cm. Inscribed on the stretcher: *Købke 18 14/11 34*
S.M.f.K., no. 1670

The art historian N. L. Høyen was instrumental in getting Købke a commission for a portrait of this elderly lady, Mrs. Plöyen, whom Høyen had known since childhood. Thus in this case like others, it was a commission which came from within the circle of family and friends.

The husband of the woman portrayed had been a prominent diplomat until 1825, and belonged to the better classes.

Købke has successfully conveyed an impression of the old lady's character through her facial expression and her very expressive, clenched hands. Attempts to define the sitter's character are not found in Eckersberg's art. Here, the influence of C. A. Jensen is at its strongest, as was emphasised by the then director of the S.M.f.K., Leo Swane, in his description of the painting:

"From Jensen comes the sparkling reproduction of the clothing in light and shade, and a comparably vivid interpretation of the sitter, an urge to enhance the mental aspect, to accentuate it in a way that we do not meet in Eckersberg's portrait art. Eckersberg is essentially calm; his sitters are not about to speak and have no twinkle in their eyes. Købke's portrait is a splendid example of his art during this period. It is as full of life and charm as a Jensen, but there is evident a better training, and a better sense of both form and colour."

REFERENCE: Krohn, 1915, no. 80

57 Portrait of a Naval Officer, D. Christen Schifter Feilberg (c 1834)

Canvas, 52.5 × 37.5 cm. Inscribed, bottom right: *C. Købke 18 8/12 3(?)*
S.M.f.K., no. 4531

Around 1834 Købke painted this portrait of the young naval officer. He is shown in uniform, in an erect and agile pose befitting his profession. Yet Købke wanted to avoid giving the portrait an official character, and the young man gives us a quick glance as though he were taken by surprise as he pulled on his gloves. In spite of this mark of instantaneousness Købke has successfully conveyed an impression of the young man's character.

The model was a member of the Feilberg family who, like Købke, lived near the bleaching grounds (*Blegdammen*) just outside Copenhagen. The two families were closely connected, a brother as well as a sister of Christen Købke having married into the Feilberg family.

REFERENCE: Krohn, 1915, no. 85

58 Portrait of Cecilie Margrethe Petersen, née Købke, the Artist's Sister, 1835

Canvas, 94 × 74 cm. Inscribed, bottom left: *C Købke 18 15/4 35*
S.M.f.K., no. 3160

Towards the middle of the 1830s Købke's art took on an entirely new feeling of grandeur. In his portrait art the "monumental phase" was introduced with this portrait of his sister Grethe. His earlier more humble and intimate descriptions of members of his family are now replaced by grander depictions, with the subjects posing for the viewer in a more exaggerated way. The forms became stylised and were subjected to strict linear definition; and he adopted a strong and simplified colouring. In spite of the new, grander conception Købke made no attempt to embellish the sitter but has shown her as she looked. He had many problems with the painting, and its execution took a long time. From the start, the portrait was planned in a large format, as mentioned in a letter to his sister Conradine:

> "On Thursday I shall begin painting Grethe, and it will be a hard nut to crack, but I have made up my mind not to despair. The result must be as it will, but I am determined to finish it, if only she will be patient, it is such a help to my work."

On 15 April 1835, Købke signed the portrait and summed up his work in another letter to Conradine:

> "I have now completed Grethe. It is so odd when I have finished something, I hardly know whether to laugh or cry. When I think of the bitter hours I have spent at work, and all the troubles I have had, and the multitude of sins therein through no will of mine; and then comes the sad part, and just as I feel I have conquered it I feel so light at heart and filled with new strength to begin all over. It is the old refrain to the song – as Goethe so appropriately puts it in a simile where he compares mankind's doings with the grasshoppers' chirping their song in the grass and interrupting it with a giant leap from which they fall headlong in the grass again and begin their chirping and leaping once more. But the simile does not hold that far inasmuch as the grasshoppers repeat the same length of leaps. Mankind, on the other hand, goes further and further all the time."

None of Købke's letters reveals him to be a man of wide reading, and nor does this. He could have referred to Goethe without having read *Faust*, and it is even debatable whether Købke really understood the German poet's simile.

REFERENCE: Krohn, 1915, no. 95

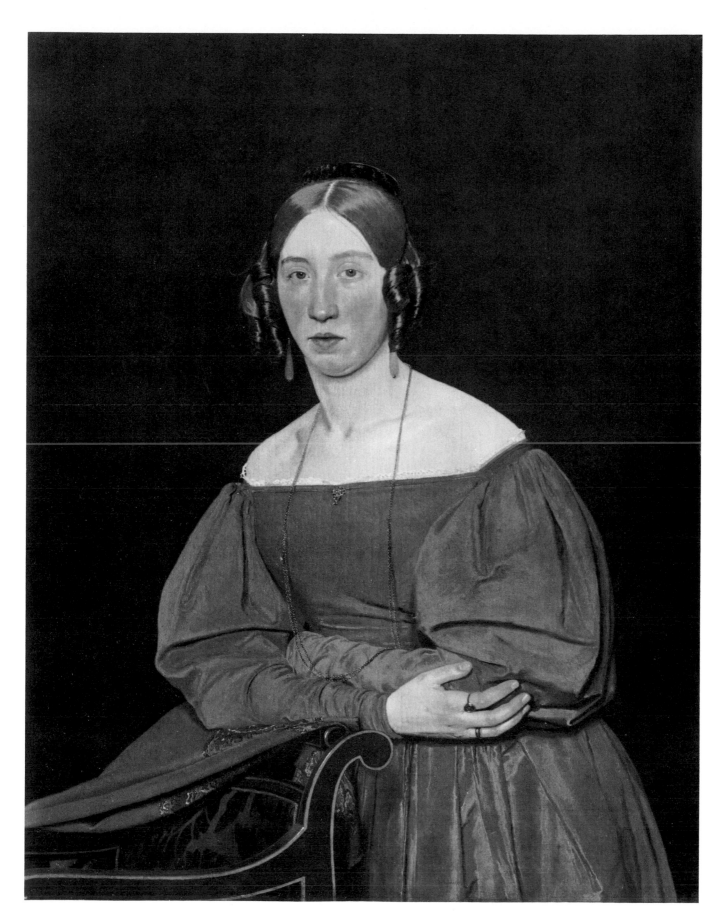

59 Frederiksborg Castle seen from the North-West. Study (1835)

Paper on canvas, 24 × 27 cm
S.M.f.K., no. 1493
Illustrated in colour page 62

In the mid-1830s Købke did several paintings of Frederiksborg Castle north of Copenhagen, among them this study of the castle seen from the North-West, made in preparation for a monumental composition (cat. no. 60). Købke began visiting the castle in 1831, roughly at the same time as N. L. Høyen. Høyen had begun taking an interest in medieval and renaissance architecture in Denmark as early as the late 1820s – in other words before the powerful renewal of Danish nationalism, occasioned by the uprising within Denmark's two German duchies, Schleswig and Holstein, in 1830. A strongly increased interest in national history resulted, and Høyen, a herald in this context, wrote a paper in 1831 about the seventeenth-century Frederiksborg castle, which he called "The finest castle in northern Europe". The art historian undoubtedly used some of his legendary eloquence in opening the young painter's eyes to this historic national monument.

On 4 September 1831, Købke wrote in his diary: "Spent the evening at Professor Høyen's. God! Let me always think alike and give me the power to carry it out."

As early as 1832, Købke did a drawing of the castle seen from the North-West with the Audience Chamber in the foreground (S.M.f.K.). But only in 1835 does he appear to have begun working up the subject, and then only in order to make use of the time while the priming for the large painting of the entire castle seen from the North-East was drying (Copenhagen, Hirschsprung Collection).

First he did a detailed compositional drawing (private collection), which he finally ruled in squares with a view to transferring the subject to a painting. He then painted *this* sketch in oils, showing only a section of the composition of the drawing. The squares, which can just be made out through the thin colouring of the sky, correspond exactly to the squares in the drawing, and the cutting off of the subject to the left follows one of the squaring lines.

The size of this small study in oils might well have been determined by the lid of his paint-box, where the paper presumably was fixed while he worked. A letter to the painter Jørgen Roed tells us that the study was finished on 25 August 1835. Købke has here built up the forms solely by means of colours, and the picture shows a wealth of nuances as a result of the changing sunlight, shadows and reflected light. The adroit brushwork and the play of colours create a life that counteracts the otherwise static character of the subject. The glitter of light in the water and the briskly painted reeds and trees are particularly important in conveying the impression of a single moment. In many ways Købke here anticipates Impressionism.

The painting was acquired in 1894 from the estate of the widow of Roed to whom it seems to have been given by Købke.

REFERENCE: Krohn, 1915, no. 99

60 Frederiksborg Castle seen from the North-West, 1836

Canvas, 58 × 64 cm. Originally inscribed on the reverse: *C. Købke 2/1836*
S.M.f.K., no. 3148
Illustrated in colour page 63

The work on this painting of Frederiksborg Castle was carefully planned by Købke. In August 1835 he did the sketch in oils (cat. no. 59), and at roughly the same time made a number of drawings of details. He used this material in Copenhagen to do the final painting around the turn of the year. It was completed in February 1836.

It differs from the studies in a number of ways. In breadth the section of the subject corresponds to the compositional drawing, but it has been increased in height giving the painting (like the oil study) an unusual, almost square format. Thus the octagonal tower is seen to its full height. Furthermore, Købke has tightened the forms and given a greater emphasis to the architectural structure and details of the building. The castle now appears far more monumental. This is also due to a few important changes.

The two tallest trees at the end of the Audience Chamber have been removed together with an eighteenth-century stair turret (which had displeased Høyen). The end wall thus stands as an undisturbed surface, giving gravity to the building. He has also severed the tongue of land so that the trees in front of the bridge stand on a small islet and a couple of the arches of the bridge are visible. The walls of the building can thus be seen to rise directly from the water – one of the special features of the castle. The opening of the composition to the left allows the spectator to see round both sides of the main trees. This dual view is one of the marks of classical landscape painting, and we can probably trace Købke's source of inspiration.

While he was still at Frederiksborg in September 1835, Høyen arrived there directly from a stay in London of which he spoke enthusiastically. In a letter to Roed, dated 19 September 1835, Købke wrote: "Some Claude le Reine [sic] that he has seen, are fit to finish off all other landscape painters." In Copenhagen's Royal Collection of Art, Købke was able to see a painting attributed to Claude, with a similar dual view (it is now attributed to an unknown Dutch painter), and also to study prints after paintings by Claude.

Compared to the oil sketch, in the final painting the lighting and time of day have also been changed. The calm late afternoon atmosphere gives the painting a decidedly Romantic feeling. This is new to Købke's art, and the influence may stem from either J. C. Dahl, who lived in Dresden (but who exhibited every year in Copenhagen), or from Høyen, who in 1822–3 met the German Romantic Caspar David Friedrich and C. G. Carus in Dresden.

The Romantic atmosphere is not so pronounced, however, as in Købke's large painting of 1835 showing the castle as seen from the North-East (Copenhagen, Hirschsprung Collection). This was also noted by a critic when the two paintings were exhibited in 1836. He pointed out a number of "errors" in the perspective of this painting and went on: "But the colouring is immaculate and beautiful. We loudly regret that there is no poetry in this painting; that would have made it easier to overlook the inexactitudes that are now conspicuous."

REFERENCE: Krohn, 1915, no. 100

61 A View of a Street in Copenhagen, Morning Light (1836)

Canvas, 106.5 × 161.5 cm
S.M.f.K., no. 844
Illustrated in colour page 65

It was only a couple of years after his family had moved to Blegdammen outside the old Copenhagen boundaries that Købke seriously began to paint his new surroundings. The first large painting that he did was this picture, which shows one of the approach roads to Copenhagen with several of the rural mansions of the suburb of Østerbro. (Today, the area is in the centre of town.)

In this tightly constructed composition the painter shows events typical of an early morning. Fishwives rest on the embankment on their walk to town; peasants in their Sunday best are coming to town by horsecart; cows plod on their own familiar way to the common; other citizens promenade in the shade alongside the houses. The rays of the morning sun pick out the road, the poplars between the houses, and the water pump in the foreground. The sky, with its variety of clouds, may be seen as an attempt at describing weather typical of Copenhagen.

The painting was Købke's most ambitious work to that date, and he did extensive preliminary work for it, first of all determining the composition of the picture in a couple of highly detailed drawings (S.M.f.K.). As an aid in drawing the subject he used a so-called perspectival octant (a wooden frame with the aperture divided into sectors by a wire mesh). This was also one of Eckersberg's preferred aids. The measurements and squaring of one of the compositional drawings correspond precisely to the measurements and mesh of the octant.

Every detail of the picture was then studied individually. For a considerable time, he went every morning to Østerbrogade in order to make the necessary sketches. He made everything the object of detailed drawings, from the buildings and trees along the road, to the shadows on it. In a letter to Jørgen Roed, dated 14 July 1836, Købke describes his work:

"I am sitting here among all my studies for my painting of Østerbro, which I laid out yesterday. I have changed a number of things, it having taken me quite a time to gather the necessary studies and to come to terms with myself. Now it will largely be, I trust, as it is. True, I have composed the figures for it

in my mind, but I lack the necessary studies which I hope to get soon, as I know how I want them. Since I feel the necessity for including animals, I have begun to study them quite eagerly. I do believe that I will have such a splendid chance to do so on the common, and I am sure to grab it by and by. Once I have gathered the studies for the figures for the said Østerbro, and arranged them on the canvas, I shall let them be for a while so that I may go ahead briskly when I begin painting, and work at speed."

Only in October 1836 had Købke reached the point where the final touches were all that remained to be done. On 15 October he wrote to Roed: "Professor Eckersberg has been here today, he was very pleased with the small as well as my large work. It also appealed to Freund."

When the painting was shown in the *Kunstforening* in January 1837, together with a number of Købke's earlier works, the *Dansk Kunstblad* critic wrote: "The observant viewer will be pleased to note the greater freedom in brushwork that Mr. Købke has achieved by and by. His view of Frederiksborg alone [the Hirschsprung picture] attracted wide attention; but his *View of a Street in Copenhagen, Morning Light* must be seen as the most splendid We see the road to Øster Allee illuminated by such fine sunlight as we have seldom seen painted by Danish artists. Both in the effect of the light and in the shadowed parts we find a clear sense of nature and of thorough study. The figures and animals are no less splendid This piece shows clearly how a masterly perception and a splendid execution may create a beautiful and interesting work of art from the most common subject."

The vanishing point of the perspective is remarkably low in the picture. It is intended to hang high, above a sofa, and it shows to its best advantage at that height.

In the background we see the building "Petersborg", where the painter's grandfather had established the bakery, continued by his father until it was burned down in 1807 during the English bombardment of Copenhagen.

The frame of the painting is the original, being made by Købke's friend Georg Hilker, a decorative painter.

REFERENCE: Krohn, 1915, no. 102

62 The Northern Drawbridge of the Citadel of Copenhagen (*c* 1837)

Paper on canvas, 24 × 34 cm
S.M.f.K., no. 3768

Almost four years after Købke moved from the Citadel he painted his last picture there. It was a painting of the northern drawbridge, intended for his mother — presumably as a souvenir of their former home. It was to be a thoroughly worked-out composition, and he did both a compositional drawing (Vejle, Kunstmuseum) and this painted study, before beginning on the final painting which he completed in December 1837 (private collection).

To begin with, the painter registered the subject in the drawing, where even the smallest details are accounted for. By means of squaring the drawing he loosely transferred the subject to paper on which he painted the oil study. (The squares can just be distinguished through the thin layer of paint in the sky.)

The loose, sketchy way of painting is typical of small oil studies of the Golden Age. In the final painting, given to the painter's mother, the subject is reproduced in the fine detail seen in the drawing. The soldier leaning against the railing was replaced by a sailor, and some citizens out for a stroll were added at the far end of the bridge — also a couple of boys standing in the grass and fishing in the moat. The effect of depth is stronger because of a dense strip of reeds which was added in the foreground.

After the death of Købke in 1848 his brother-in-law F. C. Krohn, a medallist, wrote his obituary and described his efforts in these words:

> "He did not seek his objects in the world of make believe; his works are true reflections of his life and of that Nature which was close to him with no artificial additions."

This was only entirely true of the small studies. In his large compositions he definitely made adjustments to his subjects. Ever since the time of the Impressionists the small, immediate, sketch-like studies have been appreciated more than his big paintings, in which fluidity was replaced by grandeur.

REFERENCE: Krohn, 1915, no. 113

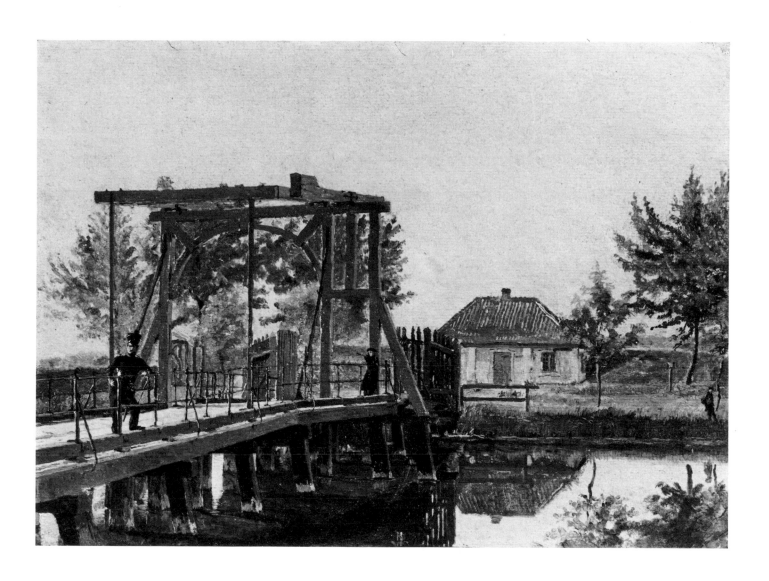

63 A View of One of the Lakes in Copenhagen (1838)

Canvas, 53 × 71.5 cm
S.M.f.K., no. 359
Illustrated in colour page 66

The painting shows a calm summer afternoon at one of the lakes just outside the ramparts of Copenhagen. Two women are standing on a boat bridge looking at a rowing boat on the lake. Above their heads the Danish flag is fluttering in a light breeze.

Købke found the subject close to his home at Blegdammen (the bleaching grounds) by the lake Sortedamssøen. The view is to the west from the edge of the lake. Købke's home was behind the point visible in the centre of the picture.

We can follow the creation of the painting step by step, and can determine that in the final painting Købke relied on his preliminary works, but refined the composition and infused the everyday subject with a certain stately quality. He also radically changed the colour scheme. The sky has been given a touch of green in its cold blue, and the lake a subtle reddish-purple (an optical contradiction, as the colour of the sky should be reflected in the water). The sunny day that we find in his earlier oil study has been replaced by a more atmospheric late afternoon, just before sunset – although the light still comes from the south (left).

Købke also added the flag in the final painting. One expression of reviving national pride in the early 1830s was that it became popular to fly the flag. But the monarchy opposed such popular manifestations and in 1834 the flying of flags by private individuals was banned. Købke shows that the ban was not respected.

In addition to the flag's compositional value, it indicates that this is a *Danish* landscape we are looking at. The painter linked the Romantic atmosphere to the nationalist movement.

This effort was also duly recognised by a contemporary critic who displayed no special understanding of Købke's art, but rather mirrored the general attitude that prevailed outside a small circle of admirers:

"In almost all his latest works, this artist has distinguished himself by conscientious truth and simplicity, but unfortunately also by a conspicuous indifference to his choice of subjects. The latter is highly regrettable, inasmuch as nature possesses much that is trivial and common that cannot serve as a worthy object for art. We are thus delighted in this painting to find a choice worthy of the artist's brush. The calm, twilit summer's evening is splendidly expressed, the sunlight falling on the trees warm and true to life; the figures are well depicted, and the dark shadows of evening appear to creep across the landscape. It is all a charming idyll, at which we are pleased to linger." (Exhibition review of 1839)

The painting was bought by the Royal Collection (now S.M.f.K.) in 1839, the first of two acquired during the painter's lifetime. It was on show in the public section of the collection for only a few years, before being moved to the king's private rooms in 1841.

REFERENCES: Krohn, 1915, no. 134
Fritz Novotny: *Painting and Sculpture in Europe 1780–1880,* 2nd ed., Harmondsworth, 1971, p. 209, pl. 143
The Age of Neo-Classicism. Exhibition catalogue. London, 1972, no. 169

64 Castel dell'Uovo, Naples (1839/40)

Paper laid down on canvas, 25 × 36 cm
S.M.f.K., no. 3467

In 1838 Købke went to Italy but not in order to repeat the Roman views of his teacher, as several of the slightly older Eckersberg students had done. This has caused some surprise among later art historians. His purpose was to paint nature in Capri, and to copy antique murals in Pompeii. He hardly painted at all in Rome, completing only one single portrait. In Naples he did several views, among them this study of the famous medieval fortress, the Castel dell'Uovo.

The closed building could resemble a massive sculpture. Købke depicts it bathed in a strong sunlight that almost suspends its volume. He was concerned solely with this effect, and with the reflections of the building and the sky in the sea – and with the variations in colour that this gave. He was not interested in life around the fortress. A comparison with the preliminary drawing (S.M.f.K.) shows that for once he has not added trappings to the picture. On the contrary he left out many of the rowing boats and ships that are seen on the drawing.

REFERENCE: Krohn, 1915, no. 139

65 A View towards Copenhagen (1841/5)

Paper laid down on canvas, 16 × 25 cm
S.M.f.K., no. 3144

After his return from Italy in 1840, Købke was primarily occupied with large paintings of Italian subjects. Occasionally, however, he did small oils in the vicinity of his home, as a diversion. He presumably made this study by the westernmost of the three linked lakes (St. Jørgen's Lake), looking towards Copenhagen. But the main motif in the painting is the sky.

Even when living in the Citadel, Købke was preoccupied with cloud formations, but at that time the trees in the foreground and the towers of the city always played an important part in his production (cat. no. 54). In the 1840s, during the second half of his period at Blegdammen, he was completely engrossed in aerial studies, and his landscapes were in many cases reduced to a narrow strip in the lower part of the picture. In the sky Købke found a subject of endless variety. In his depiction of the greyish-purple clouds he displays a freedom of handling that far exceeds that of any other Danish painter. He has almost blended his colours on the paper.

REFERENCE: Krohn, 1915, no. 163

66 The Garden Staircase to the Artist's Studio in his Father's House (*c* 1845)

Paper laid down on canvas, 22.5 × 33 cm
S.M.f.K., no. 6605
Illustrated in colour page 67

Købke lived with his parents at Blegdammen from 1833 to 1845. During at least the later part of that period he had a separate flat at one end of the house for himself, his wife and their two children. The death of his father in 1843 abruptly ended the artist's rather carefree life, the house being put up for sale in 1845. With his family, Købke moved to a modest flat, within the embankments, in Copenhagen proper. It was presumably only at this stage that Købke did some paintings of the house at Blegdammen. He selected some views, all of which related to his own everyday life, probably in order to have something to remind him of the house that was his home for twelve years.

In this picture he painted the steps leading to his studio. The viewpoint and the "close-up" composition may appear surprising in view of Købke's presumed intentions with the picture. The end wall and the steps are cut off at the edge, and the front of the house towards the road is foreshortened. The description is as non-representative as Constantin Hansen's *The Arch of Titus in Rome* (cat. no. 31). It would appear that the sunlight has determined the angle of view. The description of light falling on the wall, on the trees by the steps and through the french window, is masterly.

The roof tiles on the left of the picture have been left unfinished. Possibly the painter did not have time to complete his picture before moving. Like its companion piece, a corner of the house seen from the garden (S.M.f.K.), the picture has a dark green painted border, indicating that they would have been hung unframed, presumably in Købke's new home. On the hidden side of the stretcher it says in German script: "The garden steps by my studio."

REFERENCE: Krohn, 1915, no. 159

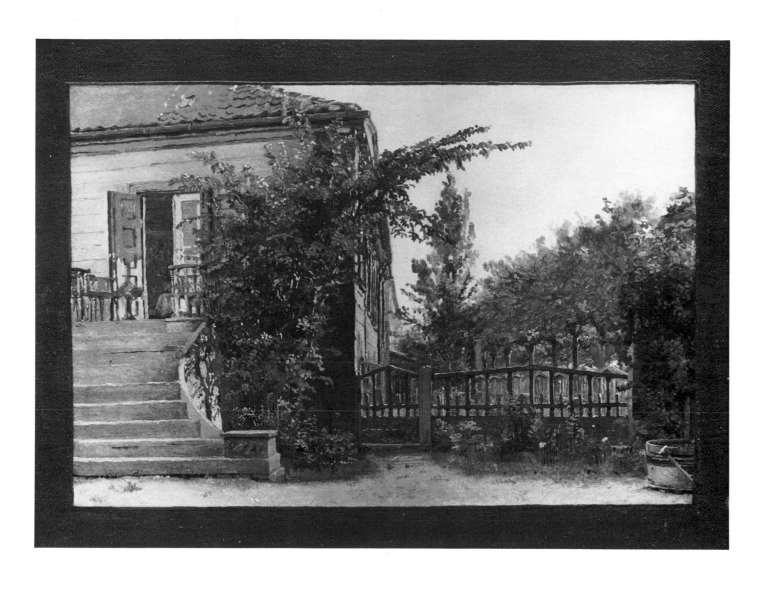

J. Th. Lundbye: *Self Portrait, 1841*

JOHAN THOMAS LUNDBYE 1818–1848

J. Th. Lundbye is considered the most important representative of Romantic-nationalist landscape art in the 1840s. His art often "processes" the immediate perception of nature, giving the subject a generalised character which met the demand for the typically Danish. Being a Romantic he worked far from towns, but always depicted the kind of nature which was hospitable to man. The evident feeling for nature in his pictures contrasts with the down-to-earth attitude of the Eckersberg school. Compared to the German and French Romantic artists, however, his art appears classically serene.

During his training, Lundbye, probably quite consciously, was never in touch with Eckersberg, but was taught drawing as early as 1832 by Johan Ludvig Lund (1777–1867), the painter and Academy professor, who in his youth had been closely in touch with Caspar David Friedrich and the German Nazarenes in Rome. From the very outset, then, it could be expected that Lundbye's art would be more emotional than Eckersberg's.

Lundbye was enrolled at the Academy in 1832, and during the following two years he appears to have been decisively influenced by Købke, from whose technique and sense of colour he learned much. Later, Friedrich and Dahl were undoubtedly of greater importance to him. Because of his interest in painting animal life, Lundbye also received tuition from the now almost unknown animal painter Christian Holm. He also studied seventeenth-century Dutch painting.

Lundbye's early works, painted in the mid-1830s, are determined by a perception that is true to nature. In 1837 his art took a clearly romantic direction, however, and the works he exhibited the following year show him emerging as a mature artist. In the following period Lundbye was to be strongly influenced by Høyen, and it was under his strong encouragement that in 1842 he created his most outstanding work, the huge and monumental painting *A Danish Coast* (S.M.f.K). He suffered severe artistic scruples while working on it, and Høyen appears not to have made the task any easier for him: "Købke is my solace whenever Høyen runs me

down. He can tell me how to build up that which Høyen has torn down," he wrote in a letter dated 11 August 1842. Much against Høyen's wishes, Lundbye went to Italy in 1845, but the journey had no significant effect on his art, and he returned to Denmark the following year. He never went to Dresden or Munich, where he would undoubtedly have found greater artistic nourishment.

Lundbye joined up as a volunteer at the outbreak of the Danish-German war in 1848, and was killed by an accidental shot before going into action.

Lundbye was of a far more literary bent than most painters of the Golden Age. From his meticulous diary, we know that he suffered strong changes of mood when he failed to carry out his ambitions. He seems to have been weighed down by his own aspirations, as was pointed out by N. L. Høyen in a lecture given in 1852, four years after Lundbye's death: "Jesting and playing, Lundbye had moved forward and tackled more important tasks in the sphere of landscape painting. As he no longer wished to continue doing what he had done so far, which had won him the acclaim of young and old, but wanted to go a step further . . . the difficulties grew, and he felt restricted where he wanted to be free, taut where he wanted to be loose, hard where he wanted to be airy and light."

Lundbye attracted considerable public attention, which indicates that the Romantic-nationalist school of landscape painting of the 1840s better interpreted the general sentiment of the time than did the art of the Eckersberg school. As early as 1838 a critic pointed out "a genuinely Danish, patriotic character" in his art: "This *national* element in Mr. Lundbye's paintings . . . gives them a loftier aim than most similar paintings in the exhibition." Lundbye himself was aware of this attention. In the spring of 1847 he wrote in a letter: "I am pleased that six pictures have been bought during the winter, no less than five by private persons, and a single one by the king. This has been a true and new pleasure to me, for it is clear to me that they were desired out of interest, and this knowledge is far dearer to me than if they had been bought for a far higher price."

REFERENCE: Karl Madsen: *Johan Thomas Lundbye*, 2nd edition, Copenhagen, 1949

67 A Sunken Road, Zealand, 1837

Paper laid down on board, 22 × 25 cm. Inscribed, bottom right: *Frdrksv. April 37 Joh Lundbye*
S.M.f.K., no. 6471

To begin with, Lundbye, like the somewhat older Købke, found his subjects close to home. In 1835 his father, an officer, had been transferred to Frederiksvaerk, a town in the north of Zealand. It was in the vicinity of this town, in April of the following year, that he painted this view from a sunken road towards the lake, Arresø. The painting clearly shows the influence of Købke, whom Lundbye had known from childhood, for they had both lived in the Citadel of Copenhagen. The handling itself, the light brushstrokes and the transparent colour are especially like Købke. The subject seems to be almost "random", like many of Købke's small sketches. At the same time we find an unfailing balance in the composition's areas of colour. Some indirect influence from Eckersberg is also discernible since the painting displays a certain cool objectivity, unlike Lundbye's more evocative later works.

Only during his early years was there an artistic and personal identity between Købke and Lundbye. Later on, Lundbye felt that there was a generation gap dividing them – "a separating difference in age", as he put it, and when he was informed of Købke's death in the early spring of 1848, he made the following strangely cynical entry in his diary: "Let me be honest in dealing with the noblest of feelings. There are only few – none but my mother in my family – and outside it not many, whose death would be a painful loss to me. Købke could not be counted among them."

REFERENCE: K. Madsen, 1949, no. 30A

68 Kalundborg Church (1837)

Canvas, 32 × 22.5 cm. Inscribed, bottom right in the black painted frame: *Johan Th. Lundbye Kallundborg 18(??)*
S.M.f.K., no. 6339

Lundbye often visited his home town, Kalundborg, in the west of Zealand, where his grandparents lived. Whenever he was there he went off to paint in the countryside, but he also painted the town's Romanesque church – the only architectural painting he ever did. Lundbye shows the church as it looked without its middle steeple, which collapsed in 1827 and was rebuilt only several years later. His choice of subject reveals the influence of Høyen, and of the Eckersberg school. But the presentation shows that Lundbye had avoided the Eckersberg school's limiting theory of perspective. The angle of view is such that the space effect of the building is not made up of diagonal lines of perspective. The fine gradation of sunlight and shade gives the steeples their volume. Lundbye's description of the landscape surrounding the church, too, shows that he was a painter of landscape, not of architecture. The date which he inscribed on the painting is illegible, but in July 1837 he did a couple of drawings of the church. The painting was presumably done at the same time.

REFERENCE: K. Madsen, 1949, no. 40

69 Open Country in the North of Zealand, 1842

Canvas, 94.5 × 127.5 cm. Inscribed, bottom right: *18 JTL (in monogram) 42*
S.M.f.K., no. 402

All of Lundbye's early landscapes can be located. But in the early 1840s he began to paint pictures which convey the general character of Danish nature rather than describe a particular site. The typical, rather than the specific and individual, was his aim. At the same time he wanted to show that Denmark's nature was as splendid as that of foreign places.

In 1841, the last summer he spent in Frederiksvaerk, he did a number of sketches in the region. On one of them he planned to do further work in a large composition. On 11 August he wrote to his good friend and supporter Christian Jürgensen Thomsen, the museologist: "I have composed a landscape that I want to paint next winter, and am doing studies for it; it is in a forest, with a view to a distant background. It is something quite new to me, and as such, I expect it will win your approval, as I am aware that you are not very satisfied with my usual choice." At this time Lundbye did a number of studies of forest subjects (one of them, dated 10 August 1841, is in Sorø, Kunstmuseet). But he did not go further with any of these, painting instead a couple of pictures of open country around Frederiksvaerk. The result was this painting which he finished back in Copenhagen in January and February 1842. He named it simply *Zealand Landscape* when it was exhibited at Charlottenborg in April 1842. Lundbye began his first diary on 24 March of the same year with a manifesto that in a sense sums up the painting that he had just finished: "My life's objective as a painter is: To paint our beloved Denmark with all the simplicity and modesty characteristic of her. What beauty is to be found in these fine lines of our hills,

so delicately undulating that they appear to have risen from the sea; in the vast sea, edged by steep, yellow cliffs; in our forests, fields and moors!"

Whereas in his two sketches for the painting Lundbye concentrated on the main characteristics of the subject, in the final painting he has added the details of the foreground, at the same time drawing up the lines of the composition. The most significant alteration is the addition of the road. Lundbye's paintings often include such a road, winding through landscapes with an indeterminable destination. Considering his troubled and searching mind and his many existential reflections, it is tempting to interpret the road as symbolic of his as yet unachieved aim in life.

In 1895 Karl Madsen, the painter and critic, wrote: "Every particle of it contains fine and genuine Danish nature poetry – the rhythmic arching of summerwhite cloudlets into the clear, pale blue air – the misty hills of the background with cool shades in the middle distance to the left – the individual half-withered trees whose dwindling power of life seems to be invigorated by the joy of being bathed in the light and warmth of a summer's day – the crossing lines of the hills – the cows comfortably plodding across the fields and lazily lying down to rest – the delightful bends of the road and the genuine exuberance of June in the lush foreground."

In the panoramic description of nature and the generous lines we can undoubtedly find the influence of the Danish-German painter Louis Gurlitt (1812–97), whose art was closely interwoven with Danish culture in the years 1832–43.

REFERENCE: K. Madsen, 1949, no. 112

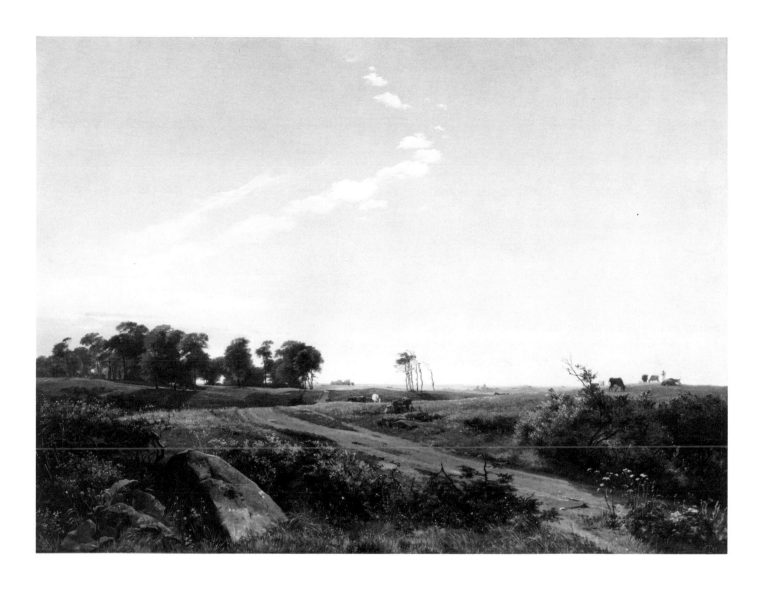

70 Cows being Watered at a Village Pond, Brofelde, 1844

Paper laid down on canvas, 25.5 × 41.5 cm. Inscribed, bottom left: *18 JTL (in monogram) 44 Brofelde*
S.M.f.K., no. 3370
Illustrated in colour page 68

Having finished his large painting *A Danish Coast* (S.M.f.K.) in 1843, Lundbye found that he had come as far as he could towards a definition of the character of Danish nature. In any case, pure landscape painting was put aside in the following period, and he concentrated on his original speciality, painting animal life. He did a number of sketches of animals, several paintings of cows in their shed or in the field, and one picture of some sheep near a barrow, all of them during the years 1843–5. In 1844, it seems, he considered taking part in an Academy competition on the theme of "A Herd of Cattle being watered". In mid-July he did a watercolour, and this sketch in oils of the village pond in the village of Brofelde, near the town of Holbaek, Zealand: "Tuesday, June 11, I began the sketch for the watering scene. Wednesday, June 12, I completed the same sketch" (Lundbye's travel book). Shortly thereafter he mentions the oil study,

"which has been submitted and will possibly be rejected by the Academy – which will not prevent me from doing it." The opinion of the Academy is not known; possibly the sketch was rejected because the cows are no more than a secondary feature in the picture. Lundbye treated the subject in a cartoon (Stockholm, Nationalmuseum), in which he gave greater emphasis to the cattle. But the subject was never done in a large painting, and Lundbye did not enter the competition. In the sketch it is the lines of the landscape that have caught the painter's attention. The picture is dominated by the curve that links the individual elements of the subject; from the foreground to the right it describes the perimeter of the pond and follows the road between the houses and up the hill, and then runs abruptly to the left side along the ridge of the hill. Similar effects are not found with Eckersberg, but rather in the work of his professorial colleague J. L. Lund.

REFERENCES: K. Madsen, 1949, no. 166
Fritz Novotny: *Painting and Sculpture in Europe 1780–1880*. Harmondsworth, 1960, p. 118, pl. 87

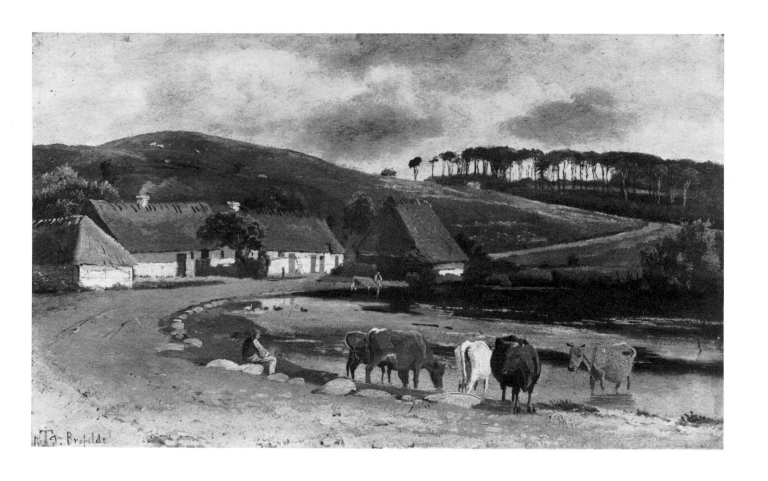

71 A Croft near the Manor of Vognserup, 1847

Canvas, 71 × 93 cm. Inscribed, bottom left on a stone: *4 JLT 7* (in monogram)
S.M.f.K., no. 1644

After his return from his journey to Italy in 1845–6, Lundbye once more took up the description of Danish nature. But it was not a return to his former large landscape views. The subjects were now given a more intimate character, although the nationalist principle was no less in evidence. The making of this landscape painting shows how conscientiously he worked.

In the summer of 1846 Lundbye did a study in oils of a sand road running between ripe cornfields towards a farmhouse in Zealand (S.M.f.K.). The picture gives an impression of a somewhat flat landscape, in fact a somewhat unimpressive subject. The following winter he worked up the subject in Copenhagen, and in the larger format it took on quite a different quality of grandeur and significance. He made a number of additions – the willows, the boulders, the docks and other plants in the wayside, a few swallows and a grazing cow. All of this belongs in a typical Danish peasant landscape. The farmhouse was moved from the right towards the centre of the picture, and elevated in relation to the fields to give it more prominence. The sky, indefinable in the sketch, was replaced by a more precisely described one, arching like a vault above the farmhouse and the fields. Lundbye was aware of the significance of these changes, as is evident from his diary entry for 16 January 1847: "I am so busy and content that I rarely feel the urge to confide to my book, even more seldom do I write therein. I am working on three or four pictures, none of them quite finished. I seem to detect a change in my technique, and note with pleasure that my works have more effect and colour than before. I try to make my drawing, for all its correctness, as unremarkable as possible; seem to understand better the difference between drawing and painting; find pleasure in the delights of working with the rich, supple oil colours. *The Croft near Lodskov* [the present picture] is almost complete and I hardly know how myself – since I have worked on all of it, letting it grow out of chaos, so to speak, for that was how the sketch appeared. In this manner I believe that far more completeness and variety are won, than if each object were first to be meticulously registered and during the painting held strictly within its established outline. My treatment in this picture had something perpetually exciting and surprising, creating the sustained interest."

Eckersberg did not approve of such "improvements" on nature. He said about Lundbye and Skovgaard that they "wanted to do it better than the Lord can; if only they could do it equally well, they should be content."

REFERENCE: K. Madsen, 1949, no. 231

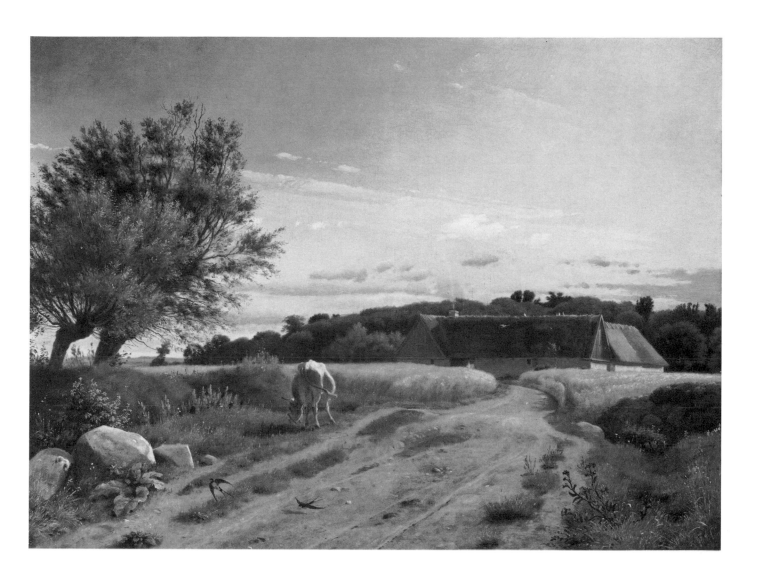

P. C. Skovgaard, c 1845, by Lorenz Frölich (1820–1908)

PETER CHRISTIAN SKOVGAARD 1817–1875

Among the Romantic-nationalist landscape painters, Peter Christian Skovgaard is one of the most prominent. His art was more understated than Lundbye's, but gradually acquired a serene monumentality. He is especially noted for his depictions of typically Danish beech forests.

Skovgaard grew up in a village in the north of Zealand, entering the Academy in 1831. He did not become one of Eckersberg's students, but like Lundbye took classes from J. L. Lund, the Danish Nazarene, a history and landscape painter.

His earliest paintings from 1835 to 1840 are very diverse, displaying artistic uncertainty and doubts as to which direction to take. But even at this stage J. C. Dahl's influence is very much in evidence. An exhibition review of 1838 emphasises the painter's "vivid sensibility, that perceives nature poetically", and it was said that "the artist's talent shows great promise". His first monumental painting of 1830, *Landscape from the North of Zealand*, possesses a dramatic and turbulent nature quite uncharacteristic of him. The painting, which shows the influence of Jacob van Ruisdael, was bought the same year by the Royal Collection (now Statens Museum). It marks the beginning of a separation in his work between sketches and monumental compositions.

Skovgaard came to attention through the annual exhibitions held during the years 1843–5. At this time Lundbye and he were close friends, as their works clearly show. Around 1845 Skovgaard arrived at his final form of expression, establishing a calm and classically serene depiction of Danish nature. He more or less continued along these lines the rest of his life. Only in 1854–5 did he go to Italy, in the company of N. L. Høyen. By then he was a mature artist, but his meeting with Claude Lorrain's paintings nevertheless left their mark on several pictures, in which the Danish countryside was lent a timeless, Arcadian quality. Skovgaard himself is said to have regretted not having been acquainted with Claude's art at an earlier stage.

Lundbye gave this very precise characterisation of his friend in 1844: "Plant life is what Skovgaard prefers to paint, and what he has lovingly identified himself with, from the greatest of trees down to the finest little grassy plant. He *belongs* in woodland nature. Truthfully and naturally he renders the character of our forests, and I am aware of no other of our painters who is his equal in this. The early works of Skovgaard are on occasion somewhat severe, but an earnest eye could only be pleased at seeing such a winter forest, with the hill, for instance, covered with ice, and the young beeches standing with red leaves; how delightfully he could create chaffinches and other small birds with a few strokes of the brush! At an early stage he acquainted himself with the particular physiognomy of different kinds of trees, rendering them if not with the skill of [the now almost forgotten landscape painter Heinrich] Buntzen [1803–92], then at least with far less noticeable effort, so the spectator did not merely have to admire the oak, the beech, the birch and so on, but might find pleasure from the entire forest. His upbringing in a village school gave him a great deal that is useful to him in his art, inasmuch as he received strong, lasting impressions of country life; what he later was to see and derive pleasure from was not new to him."

REFERENCE: Henrik Bramsen: *Malerier af P. C. Skovgaard*. Copenhagen, 1938

72 The Outskirts of the Village of Vejby. By the Roadside, Lundbye Sketching (1843)

Paper laid down on canvas, 27.5 × 40.5 cm
S.M.f.K., no. 1305

In summertime, Lundbye and Skovgaard often took trips into the North Zealand countryside to make sketches in preparation for their winter work on their big compositions back in the studio. In the summer of 1843 they spent a couple of months in Skovgaard's birthplace, the village of Vejby close to the Kattegat coast. On their daily walks both of them did a great number of sketches and drawings. They often picked the same subject, and from the slightly varying angles of view we can make out how they were placed in relation to one another.

Thanks to Lundbye's conscientious dating of his work, we can follow them almost day by day. Artistically, there was much mutual influence. Both their perception of subject and their painting technique are strongly related. When this picture was being painted, the two painters had found a spot in the village outskirts, and Skovgaard painted the dusty road running between a thatched farmhouse and a stone wall. At some distance Lundbye is sitting at work, surrounded by interested children. In his choice of view Skovgaard followed the classical tradition, but it is obvious that he dealt far more lightly with perspective than the faithful Eckersberg students did. Nor is the rendition of shadows as severe as theirs. Skovgaard meant to capture a warm summer's day in the countryside, with the hot rays of the sun penetrating the light cloud ceiling. He also stressed the reflections from the sunlit bushes on to the broken plaster on the farmhouse. The withered elder flowers and the dark green leaves of the elder bushes to the left indicate that the picture must have been painted in July.

Lundbye and Skovgaard's co-operation in the early 1840s was described by the art historian Julius Lange in 1866: "They did their nature studies together; on occasion, they would collaborate on a picture, Skovgaard painting the landscape, Lundbye the animals; they were united in a confident and close friendship that stopped only with Lundbye's early death. They had influenced one another greatly; . . . From the very start they viewed nature in highly different ways. Skovgaard had a preference for views that were rounded off, cut off at the edges; Lundbye's eye preferred the open and free; Skovgaard preferred to see things in back-light; Lundbye had a preference for broad incident light. What Skovgaard really owed to Lundbye was the opening of his eyes to mass and line . . . Skovgaard had a particularly keen eye for the near at hand as well as the distant; but he was thus in danger of letting his eye linger too much on detail. Lundbye's vision was far less keen; but this was itself a natural gift to him, enabling him to see mass and line on the grand scale."

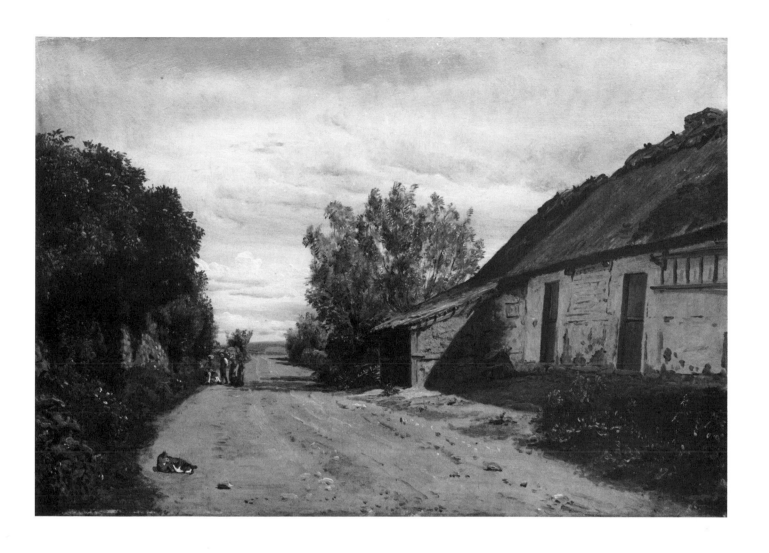

73 An Oat Field, 1843

Canvas, 25.5 × 28.5 cm. Inscribed, bottom left: *1843*
S.M.f.K., no. 4950
Illustrated in colour page 69

In the summer of 1843, while staying in the village of Vejby, Skovgaard did several studies in which he is so close to the subject that the field of vision is filled by a very limited section of it. This is not a study of a detail for a bigger painting, as is the case with Dankvart Dreyer's *Foreground Study with Docks* (cat. no. 78). The study was done as an end in itself. Skovgaard was simply attracted by the lush vegetation at the edge of an oat field. With supreme brushwork and innumerable shades of green he gives an impression of the profusion of flowers and cornstalks. The farmhouse and trees beyond the field serve purely as background, and their distance serves to stress the proximity of the foreground.

A related study by Lundbye, also done in Vejby in 1843 (Copenhagen, Ny Carlsberg Glyptotek), is unfinished and shows that the artist painted the background first, even when the foreground had all his attention. Skovgaard presumably did the same in this painting.

This immersion in the rich vegetation in the foreground goes back, in the Danish context, to a painting by J. C. Dahl of 1814, *A View from Praestø in Zealand, as seen from the old Highway* (Oslo, Nasjonalgalleriet). Here, too, there is a leap from the rich foreground to the background. Lundbye's painting *Open Country in the North of Zealand* from 1842 (cat. no. 69) is more or less composed according to the same principles. Depth in this picture has not been created by Eckersberg's classical diagonals either.

It seems that Skovgaard to a great extent devoted himself to detailed studies, as his own son Joakim Skovgaard, also a painter, recounted: ". . . during the summer of 1843, he and Lundbye went to Vejby together, the latter getting down to work immediately, while father merely looked around for the first few days, and then started to paint a grindstone in the yard; to which Lundbye commented, 'Well, you spent a long time doing nothing, and finally you select a grindstone. But it will be good.' Nor was it an ordinary one, it was very picturesque, far more than the pincers and awl handles and the common grindstone that father gave his students for them to try their hand on and practise their patience, before they continued along art's uneven road. . . . That bit of oat field from 1843 I had long seen as a small masterpiece, with brushwork that with a sure and playful hand renders the green oat, with ears and stalks; in truth not an easy task for anyone."

Skovgaard's immersion in detail is reminiscent of several of John Constable's detail studies from the early 1820s, for example *Study of the Trunk of an Elm Tree* (London, Victoria & Albert Museum). But there is nothing to indicate that the Danish painter knew the Englishman's work.

74 View from the Artist's Dwelling in Copenhagen on a Winter Day, 1854

Canvas, 35 × 36 cm. Inscribed, bottom right: *9 Jan: 1854*
S.M.f.K., no. 3369
Illustrated in colour page 70

Only rarely did Skovgaard paint Copenhagen subjects. Apart from a couple of paintings from his youth – two very Dahl-like moonlight views of the harbour from about 1835 (both of them in Københavns Bymuseum) – he found his subjects in more rural surroundings. When he spent the winter in the capital he used the sketches done during the summer for his large compositions. This painting of the artist's dwelling is thus an exception. On an overcast and slightly misty winter day in early 1854 – more precisely 9 January – he could not resist painting the view from where he lived, with the two dark figures against the snow, the red house on the other side of the canal in contrast to the other subdued colours, and the spire of the rococo church, half visible through the mist.

As a winter view the painting is also quite rare among the works of Skovgaard.

75 Bleaching Linen in a Clearing, 1858

Canvas, 44.5 × 36.5 cm. Inscribed, bottom right: *PS (in monogram) 1858*
S.M.f.K., no. 3772
Detail illustrated in colour on back cover

In his many paintings of typically Danish forests, Skovgaard stressed a serene, classical calm. The tall, erect tree-trunks with their enormous crowns often create a space reminiscent of huge Gothic cathedrals. The pictures are also marked by something of the same undisturbed, sacred atmosphere. People are seen in this inspired nature, but they definitely play a secondary part in the whole, their function being to throw the overwhelming dimensions of nature into relief. This is most evident in his great monumental compositions, but it is also felt in a smaller picture like this one. In a forest clearing a couple of women have laid linen out to bleach in the sun, and are chatting while the shadows from the trees are approaching the outspread linen. Skovgaard did not record the location. Like other romantic landscape painters he did not strive to render definite places, more the typically Danish, although many of his forest pictures show that he often painted in the manorial parks of Zealand. Nature is, after all, controlled by man.

The subject is shown at an unspecified time of summer, the preferred season of the Golden Age. Only a few winter landscapes were painted, and almost no spring or autumn pictures. In a letter dated 14 September 1848, Skovgaard declared that he was most fond of spring, but refrained from painting it, "for I have yet been unable to catch the spring." After 1850 other seasons gained ground in art. In 1857 Skovgaard exhibited his major monumental work, *A Beech Forest in May* (S.M.f.K.) along with the equally monumental *A Beech Forest in October* (Viborg, Skovgaard-Museet). During the years 1861–3 the landscape painter Gotfred Rump (1818–80) painted the four once-famous paintings *The Four Seasons* (private collection), apparently the first series of this kind in Danish art.

Dankvart Dreyer: *Self Portrait, 1838*

DANKVART DREYER 1816–1852

Among the landscape painters in the Romantic-nationalist tradition, it was Dankvart Dreyer who truly introduced the countryside of Funen and Jutland into art. His large carefully wrought paintings are marked by excitement and drama to a far greater extent than Lundbye's and Skovgaard's. Vast panoramas of windswept nature were his special contribution to the Danish landscape tradition.

Dreyer was born in the country town of Assens in Funen, enrolling in the Academy in 1831 at the age of fifteen. Like Lundbye and Skovgaard he became a student of the Danish Nazarene J. L. Lund, although in the spring of 1835 he was taught perspective by Eckersberg.

Influenced by Lund, Dreyer tried his hand at history painting but with little success, and he came to turn more and more towards landscape painting. In the mid-1830s he was influenced by Købke's small sketches, but in the long run the Danish-Norwegian painter J. C. Dahl's view of nature had the decisive influence on him.

Dreyer found it hard to gain recognition, and he never reached a position corresponding to that of Lundbye and Skovgaard. At best, contemporary critics praised his pictures with reservations. In 1838 N. L. Høyen wrote about a panoramic landscape from Funen (an oil sketch for it is in the Statens Museum): "The undulating ploughland, splendidly crossed by plantations and woods, offers beautiful variations that the artist, as far as lines are concerned, has taken as much advantage from as possible; but his colour, especially in the middle distance and the foliage areas, is too monotonous; the more distant levels do not really separate one from the other, and the hazy air with the low drifting clouds lack depth and softness in shape." On the other hand, Høyen laid emphasis on the detailed foreground of plants and trees.

The following year, 1839, was to be Dreyer's most fortunate. The Royal Collection, the *Kunstforening* and Thorvaldsen each bought one of his paintings. After that he had no success. The Academy never gave him a travel scholarship, and in the end he gave up his career as an artist, buying a farm in Funen where he lived with his mother and sister. Here he died in 1852, lonely and forgotten. Only at the turn of the century was he rediscovered, finding his place in Danish art history alongside Lundbye and Skovgaard.

In 1844 his friend Lundbye offered this description of Dreyer: "He has the true soul of an artist and a trained eye, but feels somewhat hurt by the critics; although they have often treated him badly, an artist should be able to bear this . . . Dreyer previously took great delight in painting historical pieces, but I consider it fortunate that he has given this up for landscapes; he lacked the force for it, although several of his attempts bore witness to his sensitive, poetic nature. It was as if he needed to express more than landscape is able to say."

"By no means does Dreyer possess Skovgaard's gravity and skill in accomplishing individual details, but he has his own grace in the choice of landscapes – they are generally more open, with wide views, whereas Skovgaard tends to stay in the loneliness of the deep woods. Dreyer's brushwork is not beautiful, often unpleasantly broad and woolly, but on the other hand light; and in his colours great delicacy is often found. Dreyer has mostly painted Funen and Jutland, and his paintings are always filled with poetry; his graceful rendering of hills, lakes and woods is such as to evoke a ballad tone But he is weak, and lacks the power to use his material to the full."

REFERENCE: Leo Swane: *Dankvart Dreyer*. Copenhagen, 1921

76 A Footbridge over a Brook in Assens, Funen (1842)

Wood, 24.5 × 37.5 cm
S.M.f.K., no. 1690
Illustrated in colour page 71

During the summer of 1842 in Assens, his native town, Dreyer stopped at a footbridge crossing a brook at the lower end of the churchyard – and his rendering of it evokes in many ways memories of Købke's small sketches from the early 1830s. The subject is seen close to and the view is so limited that little of the surroundings can be seen. What awoke the painter's interest was not the subject but the purely pictorial effects – the bridge leading the spectator into the middle distance, the hot sunlight falling on the bridge and on the flowering bush, and its contrast to the shady brook. The painting is most of all related to Købke's *A View from a Store-House in the Citadel of Copenhagen* (cat. no. 50), which has several of the same characteristics.

In early March 1843, when Dreyer exhibited the study at the *Kunstforening*, one critic wrote: "In the study of a sunlit bridge, we were pleased to find evidence that this artist is able – there had been some doubts as to this – to grant nature its immediate beauty." As usual, it was not pure praise for Dreyer. About sixty years later Karl Madsen, the painter and critic, mentions the same sketch but with far greater enthusiasm: "Just look at the shade beneath the flowering rosebush that leans out over the sun-brown water. This impression of summer nature has been rendered with strange intensity." Paintings like this were later to act as vehicles of introduction to the painted sketches of the Golden Age. When writing about a large exhibition in 1901, Karl Madsen took his point of departure in Dreyer's art: "The Town Hall Exhibition informs that the Gallery's [Statens Museum's] representation of older Danish pictorial art among other shortcomings has one very serious drawback. It has felt the obligation, and rightly so, to purchase those pictures that appeared to be the painters' principal works. It has through the years and very unjustly considered all studies and sketches to be of such little significance that they did not deserve space. But among those very works are to be found some of the best and the most significant produced in Danish art. Only in his sketches is Marstrand the great and perfect master; only there does he completely unfold his spirit and his wit. And however well P. C. Skovgaard's finished pictures may be done, his studies are a hundred times better. They have no trace of the craftsmanlike dryness which we see in the over-assured treatment of the foliage in his large pictures, and none of their weighty colouring. They have great lightness, fineness, freshness and beauty, in handling and in colour – that is where the painter's joy and knowledge of nature and his marvellous sense of form come out, unclouded by any sort of mannerism."

In this century, Dreyer has been particularly recognised for his studies.

REFERENCE: Swane, 1921, pp. 89–90, cat. no. 119

77 A Low Beach with Dunes: the West Coast of Jutland (1843)

Canvas, 28 × 37.5 cm
S.M.f.K., no. 4860

For a long time Jutland remained unexplored by artists. Several painters were born there, mainly in the southern region. Yet it was first and foremost Zealand's country-side that was cultivated by landscape artists throughout the Golden Age. Prior to 1830 pictures from Jutland were few and far between. In that year Martinus Rørbye travelled through that part of the country en route to Norway, making a number of sketches on the way.

The first of the Golden Age painters to take up Jutland seriously was the Danish-German Louis Gurlitt (1812–97). (During the 1830s and 1840s he was considered Danish.) He first visited Jutland about 1832–3, and was followed in 1838 by Dankvart Dreyer. During the next few years Gurlitt painted several pictures of the moors of Jutland that make it look as grand and overwhelming as the Campagna. To Dreyer, as to the other Romantic-nationalist landscape painters, it was a question of depicting Danish nature so that it could compete with that of foreign lands. In 1843, Dreyer became the first Danish painter to draw and paint subjects from the West Coast, among them this study.

On a relatively calm day, Dreyer has rendered the windswept coast. It was important to him to stress the many nuances of the sand and stones, and the interactions of sun and shade over the beach and the waves. The fine sense of light and air that the painter displays here makes the sketch one of the best works of the Golden Age.

Given Dreyer's predilection for impressive and harsh nature, it is surprising that he has chosen to paint the West Coast on such a peaceful day. Many contemporaries were surprised when, in 1844, he exhibited the subject in a larger, more finished version. Lundbye, the painter and a friend of Dreyer, wrote in his diary: ". . . it possesses fine colour, well selected, and a silver tone of its own; but it lacks the imposing quality that this species of nature (according to descriptions) possesses, and that even this picture shows that it must have. This is not the coast that has cost hundreds of brave seamen their lives, not the sea that can be a foam as far as the eye can see, or else be at rest in unutterable majesty. Why show it in common triviality?" A contemporary critic, apparently linking the North Sea with Dahl-like pictures of ships in distress, was far harsher in his judgement: "Dreyer's depiction of *The West Coast of Jutland at Bovbjerg and Trans* must unfortunately be declared unsuccessful. Whosoever has seen the magnificent cliff at Bovbjerg is likely to hold a different inner vision of it. Dreyer's impression of it leaves much to be desired. It holds no lyrical atmosphere other than sinister cold. We are given an impression of neither the odd lines and colours of the cliff, nor of the vast lyrical nature of the North Sea. Had Dreyer taken the cliff from the south side, with the sea to the left, then the extra-ordinary lines of this cliff would have been apparent to him; had he furthermore imagined to himself a sky covered with *dark* clouds . . . had he let the setting sun stand behind these, act through them and cast its rays on the cliff through a rent in the curtain of cloud; had he finally shown the brave inhabitants of Trans out in their ships, or a vessel trying to steer clear of the coast: in that case his work would have held poetry, then it would have been marked by loving and intense observation of the place."

Dreyer's rendition of the light, air, clouds and beach has an international parallel in John Constable's *Weymouth Bay* from 1816 (London, The National Gallery). But this could only be a matter of kinship, not of direct influence.

REFERENCE: L. Swane, 1921, pp. 91–3, cat. no. 139

78 Foreground Study with Docks

Board, 20 × 29.5 cm
S.M.f.K., no. 6780

Probably during preparation for a larger picture, Dreyer did this study of some docks for the foreground. The Romantic-nationalist landscape painters did such studies of detail with great eagerness. Behind these small pictures was not only the wish to work out the subjects for the large pictures in the finest detail; there was also a love of nature, even in its most modest forms. Docks are as typically Danish as beech trees. There are many examples of paintings where the artist has relied on studies such as this, for example Lundbye's paintings *Open Country in the North of Zealand* (cat. no. 69) and *A Croft near the Manor of Vognserup* (cat. no. 71). It is not known, however, whether Dreyer used these docks in a larger painting.

It is an open question to what extent the faithful Eckersberg students relied on similar studies for their landscapes and architectural views. Their approach to nature differed from the Romantic-nationalists. Painters such as Constantin Hansen, Rørbye, Roed and Marstrand drew many studies of details. Hansen painted studies of each of those present in *A Group of Danish Artists in Rome* (cat. no. 29). But otherwise there are apparently no known painted studies of details from their hand, although unknown work may exist in private collections.

But it would appear that Købke, at any rate, relied on paintings of this kind, at least while working on his large painting of *Frederiksborg Castle* (see cat. nos. 59 and 60). When he had painted the sketch of the castle and was about to begin the large version, he wrote to Jørgen Roed on 25 August 1835: "but I cannot begin to paint immediately, as I must first work out some colour studies for it." It remains unknown whether he actually did these "colour studies" and if so, whether they still exist.

Both in choice of subject and in rendition, Dreyer's docks are reminiscent of the plant studies John Constable did in the 1820s, for example *Plants growing near a Wall* and *Study of Foliage* (both London, Victoria & Albert Museum). It is out of the question, however, that the Danish painter could have known his works.

REFERENCE: L. Swane, 1921, cat. no. 178

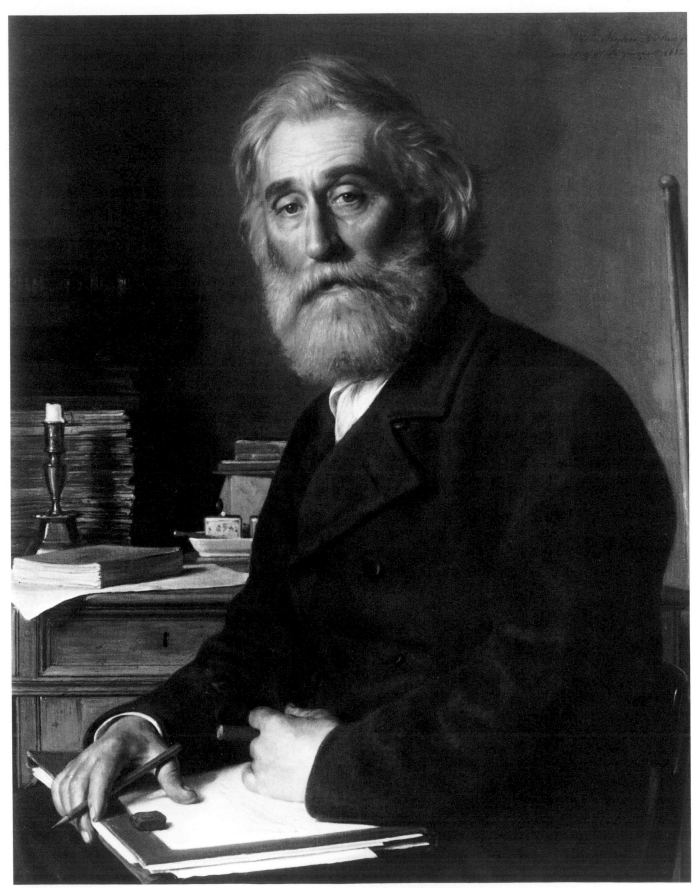

Vilhelm Kyhn, 1882, by Herman Siegumfeldt (1833–1912)

VILHELM KYHN 1819–1903

Vilhelm Kyhn's place is in the group of Romantic-nationalist landscape painters. One of the youngest of the Golden Age artists, he was about the same age as Lundbye and Skovgaard, but matured later, and his major works were done after the end of the actual Golden Age. His pictures are marked by an idyllic lyricism, and are totally without effects of drama. He was especially fond of the atmosphere just after sunset, and is remembered widely today for adhering to the style of Romantic-nationalism throughout his long life.

Kyhn entered the Academy in 1836, taking classes until the mid-1840s. In the spring of 1844 he spent three months doing perspective drawings with Eckersberg. In 1849 he was given the Academy travel scholarship, and the following year travelled via Holland and Belgium to Paris, where he spent six weeks. He then went via Savoy to Rome, visiting Naples, Florence and Venice. In 1851 he returned home *via* Munich. Dutch seventeenth-century painting and Claude Lorrain's landscapes seem to have been most important to him. He summarised the impressions formed during his journey in a letter to the painter Lorenz Frölich in 1851: "My ideal . . . is nature; not material, but *spiritual* nature. I thus reject French art for being both real and affected, for generally appearing self-assured, talented, exciting, seductive and sensuous in technique and colour . . . and I reject the German for being too literary, second- or even third-hand art —

blustering or drooling sentimentally with insufficient technique and abominable colour. I readily confess that there are many great talents; but as I have said before: Talent is not enough." His attitude towards foreign art was typical of the Romantic-nationalist painters.

Vilhelm Kyhn remained loyal to the ideas of his youth all his life, and in the 1870s and 1880s he was clearly in opposition to the young realists of that time, among them P. S. Krøyer. Through his school of draughtsmanship for women, though, he was important to such painters as Anna Ancher.

His artistic attitudes are evident from his correspondence with the painter Lorenz Frölich. Mentioning his latest work, he writes in 1854: "I have taken the liberty of composing it." This statement is supported by some thoughts which he noted a couple of decades later: "In my studies I suppose I try to abandon what I find less important; but I do so with full loyalty. In my large compositions I seek to render an atmosphere as well as I might, to render what essence in nature found an echo in me; . . . I might admire the purely realistic, but it does not warm me; I lack the mastery fully to control the realistic, through which the loftiest is expressed . . . I naturally can, and must, admire also the detail of nature, and who can not; but I utterly forget it when nature bursts into wondrous song." (Letter to Lorenz Frölich, dated 12 January 1878)

79 A Fjord in the North of Zealand, 1849

Canvas, 49.5 × 68 cm. Inscribed, bottom left: *V. Khyn 1849*
S.M.f.K., no. 7103

Kyhn has rendered a quiet, sunlit summer day in one of the Zealand fjords, conveying the impression of summer heat by backlighting the subject, and by emphasising the smooth surface of the shallow water. There is no wind to set the warm air in motion.

Kyhn was very preoccupied with light – not in its interplay with shadows, as Eckersberg and a number of his closest students were, but with powerful sunlight in itself. Consequently he often chose to show his subjects strongly backlit. "I think I have achieved a radiant air, the sun – as most often – shines straight into my eyes from above the frame." He wrote this about one of his paintings of the mid-1850s in a letter to Lorenz Frölich.

This painting was done before Kyhn travelled abroad and saw Claude Lorrain's pictures full of backlight.

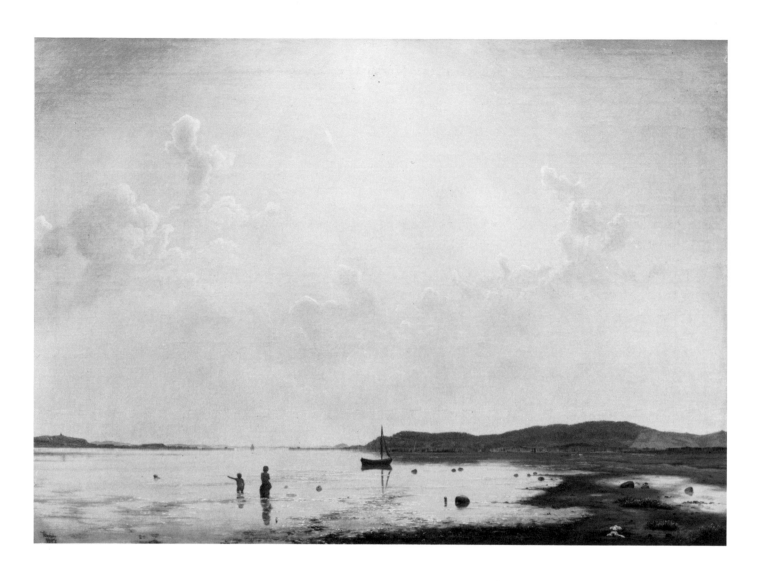

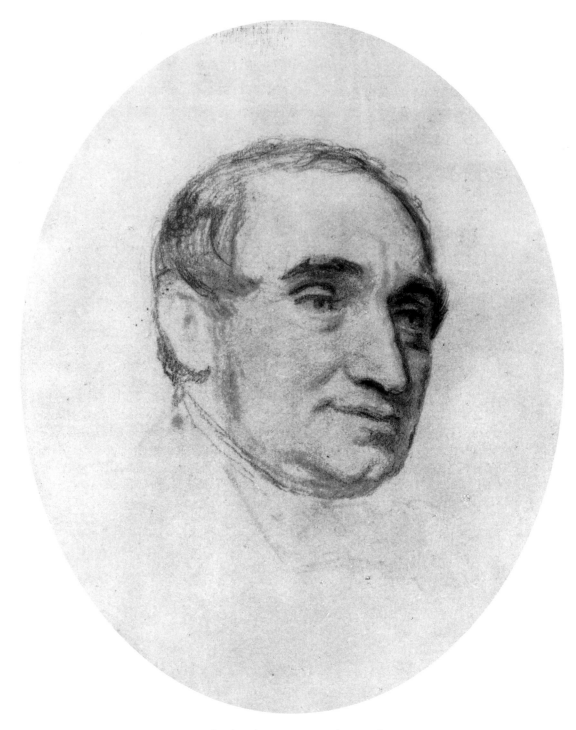

F. Th. Kloss, by J. V. Gertner (1818–71)

FREDERIK THEODOR KLOSS 1802–1876

The painter F. Th. Kloss, of German origin, acted as a link between Eckersberg and the younger generation of Danish marine painters. With his German background he brought a significant element of Romanticism to Denmark, which had been totally absent from Eckersberg's work. It was his function as an intermediary that made him important. He was no great artist, but produced a number of competent pictures.

Kloss was born in Brunswick, entering the Berlin Academy in 1819 as a student of Carl Schumann. Even then he had decided to specialise in marine painting. During a stay in Dresden in 1827 he saw one of Eckersberg's marine pictures at J. C. Dahl's, and, encouraged by this Danish-Norwegian artist, he went to Copenhagen in 1828 to learn from Eckersberg. From then on he belonged to the art life of Denmark. On 7 December the same year, he is mentioned for the first time in Eckersberg's diary: ''Visited the painter Klose [sic] who wants to paint seascapes. Lent him a drawing of the brig *Møen*.'' This was to mark the beginning of a long and close friendship between the two.

Kloss went on several long sea voyages, bringing back a number of paintings of relatively unknown places. In 1834, he visited Iceland with Crown Prince Frederik VII, one of the first painters to go there. (He taught the prince drawing.) The following year he was able to show the unusual countryside of Iceland to the Danish public, partly through paintings, partly by means of his book *Icelandic Views* (with lithographs by Asmus Kaufmann after original designs by Kloss). In 1844 he once more travelled with the Crown Prince, this time to the Faroes. Here, he witnessed the hunting of pilot whales, scenes that he used in a couple of paintings (1845 and 1847). In one of them, the painter's royal travelling companion is seen standing in a boat with a lifted harpoon. The Crown Prince, who was not renowned for being always truthful, was apparently satisfied with Kloss. All in all, his friendship with the Crown Prince was very rewarding to the painter, the Royal Collection (now the Statens Museum) buying ten of his paintings prior to 1850.

Kloss's choice of subjects was of great importance to the younger marine painters. In 1845, for instance, Emanuel Larsen was inspired to make a voyage to Iceland.

REFERENCE: Olaf Klose and Lilli Martius: *Skandinavische Landschaftsbilder. Deutsche Künstlerreisen von 1780 bis 1864.* Neumünster, 1975, pp. 78–85, Abb. 84–91

80 Danish Men-of-War in Copenhagen Harbour, 1837

Canvas, 51 × 73 cm. Inscribed, bottom right: *TKLOSS 1837*
S.M.f.K., no. 338

In the harbour of Copenhagen a squadron is seen ready to set to sea, firing a parting salute. The rays of the early morning sun fall on the top sails. The subject is seen from the Sound, with Copenhagen in the distance.

The painting was possibly done in connection with a voyage that Kloss took together with Eckersberg in 1837. On Thursday 5 May Eckersberg wrote in his diary: "Went to the Customs House with Kloss at 6 am. At seven we sailed from there in a slight wind, in a ferry to the corvette *Galathea* which was together with two smaller corvettes *Diana* and *Flora* (the latter being a cadet-ship), and the brig *St. Thomas*. At 11.30 am we set sail with a slight SSW breeze that soon died . . ."

There was a mixed reception to the painting when it was shown at Charlottenborg in 1838. N. L. Høyen found the painting "interesting", but also wrote in his review: "Here we lack the sure hand and perfection of Eckersberg, and the cloud masses are a little too heavy; yet there is an effect that leaves a pleasant impression, and one's eye gazes across the calm, smooth surface of the sea, far away to distant ships. This delightful painting shows us that the artist is indeed able to avoid the decorative element that miscarries to an extent in his other exhibited works." Another critic wrote: "It is a nice view; the sun has a fortunate effect in the sails; the small ripples on the water are beautifully reproduced; but how could the clouds be so spread and torn in such calm weather?"

In his book about Danish marine painting (1962), Henrik Bramsen placed the picture in an art-historical context: "The gentle, slightly melancholy rendition of the Danish navy in Copenhagen Harbour by F. T. Kloss is a pastiche, an imitation of a Dutch marine painting, by Willem van de Velde to be precise, the most copied of the older marine painters. Kloss's artistic education inclined him more towards studies in museums than in nature. He was no great artist, although much beauty may be found in the colours and composition of the picture, particularly in the group of men-of-war gliding slowly forward. Here, too, we find something not found in Eckersberg – the ships are given a spiritual dimension. To Eckersberg ships were merely wonderful machines, in his pictures equally wonderful spatial expansions, form and light and colour becoming one. They were not symbolic figures. The younger painters were inclined, on the pattern of Dutch marine painting, to let them be bearers of human feelings, like longing, comfort or courage. In Kloss's picture, the effect of the sunlight upon the sails has great significance. It must, incidentally, according to the topography, be early morning sun, which also corresponds best to the theme."

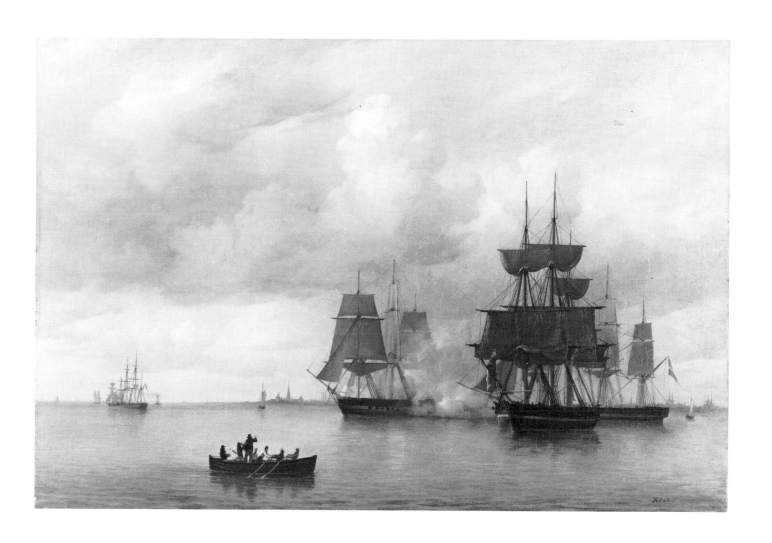

Emanuel Larsen, by J. V. Gertner (1818–71)

EMANUEL LARSEN 1823–1859

Emanuel Larsen devoted himself entirely to marine painting. He belongs to the last generation of Golden Age painters, and was strongly influenced by Eckersberg. At the same time, however, his work signals the advent of a new generation among Eckersberg's students, breaking with his teacher's material attitude, to paint highly emotional marine pictures.

Emanuel Larsen entered the Academy in 1839, but ceased to attend classes at the end of 1844. From the beginning he had chosen marine painting as his speciality, receiving tuition from Eckersberg and F. Th. Kloss. He left on his first journey abroad in 1845, for the Faroe Islands and Iceland (then virtually undiscovered). In 1852–4 he went via Holland and Belgium to London, and then on to Paris where he stayed for six months. He then travelled on to the French Mediterranean coast, doing a number of studies and several large paintings. Until his early death in 1859 he exhibited subjects from this journey, along with Danish subjects, mainly of the Sound by Kronborg Castle at Elsinore.

Even in his first exhibition of paintings in 1845 he showed that, in addition to studying Eckersberg, he had also profited from Dutch seventeenth-century marine painting. A critic wrote about a painting bought the same year by the Royal Collection (now Statens Museum):

"Emanuel Larsen exhibits a beautiful painting, *A Zealand Coast, Morning*, showing much talent. The sleepy morning air is successfully rendered, as well as the clarity in the foreground. It is boldly painted, bearing witness to the young artist's true sense of colour."

At this time Eckersberg was too widely respected for anyone to openly criticise the almost scientific thoroughness in his marine pictures, but indirectly the critics showed their reservations when one of the young marine painters (Carl Frederik Sørensen, 1818–79) in 1846 was praised for "a worthy and successful attempt to render a certain atmosphere in his pictures, to express an action that gives them life and freshness". The same could be said of Emanuel Larsen, but was contrary to Eckersberg's efforts. In a recommendation to buy one of Larsen's pictures for the Royal Collection, the museologist Christian Jürgensen Thomsen in 1856 wrote to N. L. Høyen: "Since the time when Eckersberg supplied us with his best works in this field, we are unaware of having seen a seascape that to the same extent as this picture bears evidence of the artist having an open eye to the fresh, strong life at sea, and to the peculiar manner in which nature reveals its form and colour, in the air and the waves. His ships are not merely *placed* but are truly in movement."

81 A Ship of the Line at Anchor (1847)

Paper laid down on board, 30.5 × 50.5 cm. Inscribed, bottom left: *Emanuel Larsen Juli 1847* (The date is indistinct)
S.M.f.K., no. 3857
Illustrated in colour page 72

While Eckersberg in his marine paintings stressed the precise rendering of the ships themselves, their cordage and sails, and the light, wind and other climatic conditions, his students were also anxious to add to the surroundings, often choosing to paint coastal views. Their subjects thus took on the aspect of topography, and in domestic subjects the special Danish characteristics of the landscapes were stressed.

This applies to this painting of a ship of the line at anchor. Although only the tip of a pier is visible, nobody could have been in any doubt that this was a Danish subject. It is presumably taken from the Danish coast at the Sound, and in the distance to the left the coast of Sweden can just be made out. The intense light of the midday sun glittering on the water reveals a perception of the instantaneous, far removed from Eckersberg.

Emanuel Larsen was undoubtedly influenced by Romantic-nationalist landscape painters a few years his senior, mainly Lundbye. The ship was previously identified as a frigate, but is, in fact, a ship of the line.

82 Copenhagen Harbour, Morning Light (1850)

Canvas, 56 × 86.5 cm. Inscribed, bottom right: *Emanuel Larsen*
S.M.f.K., no. 4281

Like Eckersberg, Emanuel Larsen occasionally went to Copenhagen Harbour to find a subject for a painting. But where Eckersberg concentrated on the individual ships (see cat. no. 16), Larsen settled for more panoramic views. The artistic approach in this picture corresponds more with Købke's *A View of a Street in Copenhagen, Morning Light* (cat. no. 61). In both pictures everyday subjects have been given a quiet grandeur. Like Købke, Larsen chose to depict the subject in the early morning, but he renders it far more emotionally.

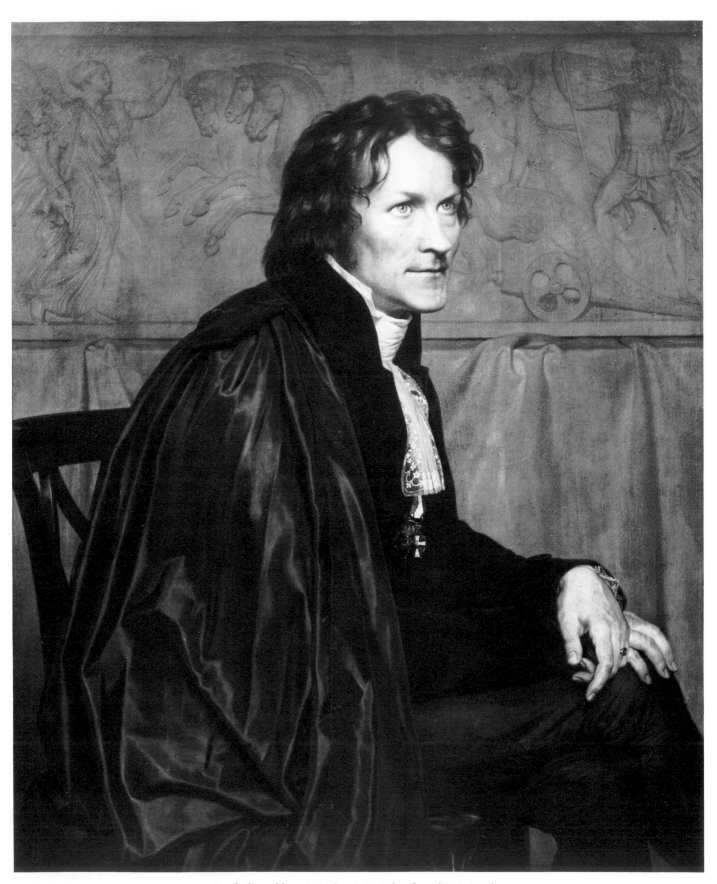

Bertel Thorvaldsen, 1814, by C. W. Eckersberg (1783–1853)

BERTEL THORVALDSEN 1770–1844

The sculptor Bertel Thorvaldsen was the most famous artist of the Danish Golden Age – and the only one to win international recognition during his lifetime. His antique-inspired neo-classicism won him a place in international art circles in Rome, and to Danish painters he stood as the unattainable ideal. The older generation of Golden Age painters undoubtedly received considerable inspiration from Thorvaldsen, but to the younger painters he meant more as a central figure in Danish-German art circles in Rome.

Thorvaldsen was the son of a wood-carver, and entered the Academy when he was no more than eleven. Initially, he was influenced by the sculptor Johannes Wiedewelt (1731–1802), who during his stay in Rome in 1754–8 had enjoyed a friendship with Winckelmann. After winning the Academy gold medal in 1794 Thorvaldsen assisted Abildgaard in decorating one of the Amalienborg palaces.

He was, however, to receive his decisive influence only when he came to Rome in 1796. Here, he was inspired by the Danish-German draughtsman and painter Asmus Jacob Carstens, and the Danish archaeologist Georg Zoëga gave him a thorough introduction to ancient art. In 1802–3 Thorvaldsen created the sculpture *Jason*, which was to act as his passport to international fame. The early classical influence on the statue was in sharp contrast to Antonio Canova's more Hellenistically inspired art. This work also marked the beginning of a lifelong competition between the two artists. *Jason* paved the way for a great number of commissions for antique figures and portraits from patrons all over Europe, the clientele being mainly English, Polish and Russian. Among his most important commissions are the *Alexander Frieze* (1812, Rome, Palazzo Quirinale), *Christ and the Twelve Apostles* (1821–7, Copenhagen, Church of Our Lady), *Schiller* (1825, Stuttgart), *Prince Jozef Poniatowski* (1826–7, Warsaw), *Pope Pius VII*'s sepulchral monument (1824–31, Rome, St. Peter's Basilica), and the monument to *Lord Byron* (1831, Cambridge, Trinity College).

After the death of Canova, Thorvaldsen was considered Rome's leading artist. Apart from one journey to Denmark in 1819–20, Thorvaldsen remained in Rome right up to 1838 when he was to return to Copenhagen as a national hero. But his studio in Rome continued its activity, and he went there for the last time only in 1841–2. He donated his works and his huge collection of art to his home town and during his final years he eagerly acquired contemporary Danish art for the museum planned in his memory. He died in 1844 in the Royal Theatre of Copenhagen, four years before the opening ceremony of the Thorvaldsen Museum in 1848.

REFERENCES: *Apollo,* Vol. XCVI, No. 127, September 1972 (Special issue on Thorvaldsen and his museum)
Gerhard Bott (ed.): *Bertel Thorvaldsen.* Exhibition catalogue and research manual (2 vols). Cologne, 1977
Jörgen Birkedal Hartmann: *Antike Motive bei Thorvaldsen.* Deutsches Archäologisches Institut, Tübingen, 1979

83 Shepherd Boy (1817–28)

Height, 148 cm
London, The Drapers' Company

Thorvaldsen is said to have got the idea for this sitting shepherd boy in 1817 while working on the sculptural group *Ganymede and the Eagle*. Thorvaldsen's biographer J. M. Thiele gives this account: "While Thorvaldsen was modelling the group with a handsome boy modelling for Ganymede, it happened, so it is said, that when the model was resting for a moment, Thorvaldsen suddenly shouted to him: 'Sit still! Don't move!' As it happened, the boy, unconsciously, had taken up such a beautiful pose while resting that the artist on seeing it wished him to hold it in all its innocence. As the boy complied and remained motionless, Thorvaldsen seized the clay and soon formed a sketch for his famous statue." But Thiele also adds an important comment to this account: "This anecdote is common knowledge and often repeated. But in the name of truth, without thus rejecting the story as fabrication, it must be noted that among the drawings left by the artist there is a leaf of a book containing no less than eight different sketches in pen and ink for the sitting shepherd boy." The myth of Thorvaldsen supposedly stumbling on his masterpieces like another Aladdin, is also disproved by the fact that many sources for the figure may be found in art, first and foremost the antique Sciarra *Hermes* (Copenhagen, Ny Carlsberg Glyptotek) and Canova's *Theseus and the Minotaur* (London, Victoria & Albert Museum), both of which he was able to see in Rome.

The anecdote, however, draws attention to a decisive change in Thorvaldsen's art at this stage. His severe and heroic classicism now received a strong measure of naturalism, his art occasionally taking on a touch of genre, thus to some extent following the general development in art.

The sculpture was modelled in July–October 1817, and was later done in marble in at least five versions. Two of these came to England; one of them was presumably done in 1825–6 for the philanthropist William Haldimand, who sold it at an auction in 1835, where it was bought by Thomas Hope's son, Henry (now City of Manchester Art Galleries). The other was done between 18 November 1820 and 12 January 1828, for Lord Cranley (the present sculpture); it was inherited by Arthur George Earl of Onslow, from whose estate it was auctioned at Christie's in 1893, where it was bought for the Drapers' Hall in London. According to tradition, the dog is Thorvaldsen's own dog, Teverino.

REFERENCE: *The Age of Neo-Classicism*. Exhibition catalogue, London, 1972, cat. no. 445

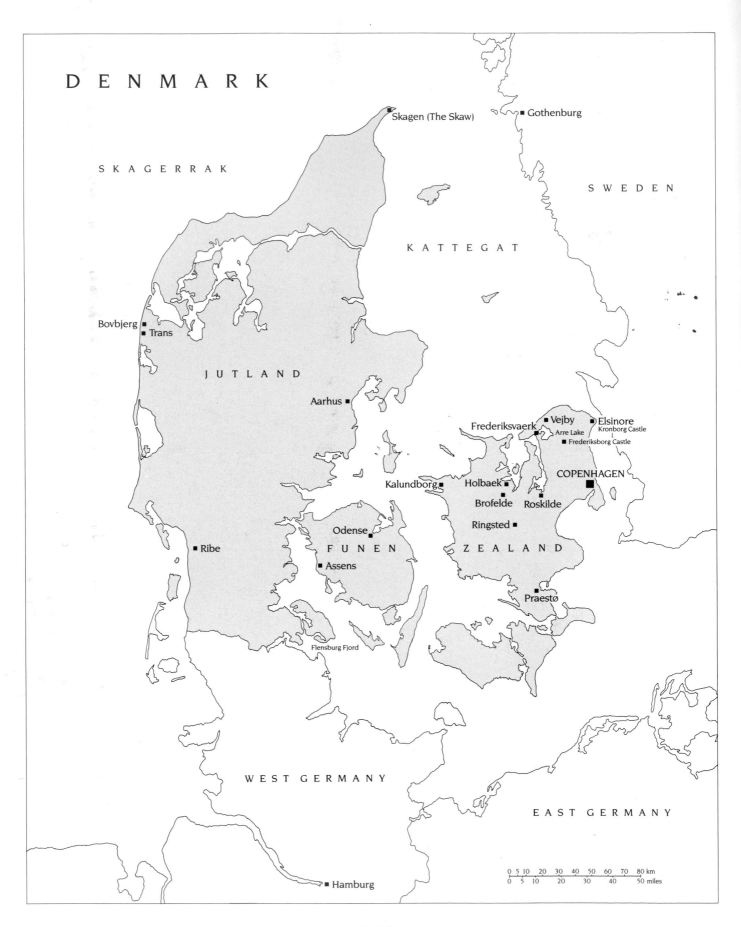

DENMARK

SKAGERRAK

KATTEGAT

SWEDEN

■ Skagen (The Skaw)

■ Gothenburg

Bovbjerg ■
■ Trans

JUTLAND

Aarhus ■

■ Vejby
Frederiksvaerk ■ ■ ■ Elsinore
Arre Lake Kronborg Castle
■ Frederiksborg Castle

COPENHAGEN ■

Kalundborg ■

Holbaek ■

Brofelde ■ Roskilde ■

Odense ■

FUNEN

ZEALAND

Ringsted ■

Ribe ■

Assens ■

Praestø ■

Flensburg Fjord

WEST GERMANY

EAST GERMANY

0 5 10 20 30 40 50 60 70 80 km
0 5 10 20 30 40 50 miles

■ Hamburg